MASTERING **BLACK** & **WHITE**

PHOTOGRAPHY

JOHN WALMSLEY

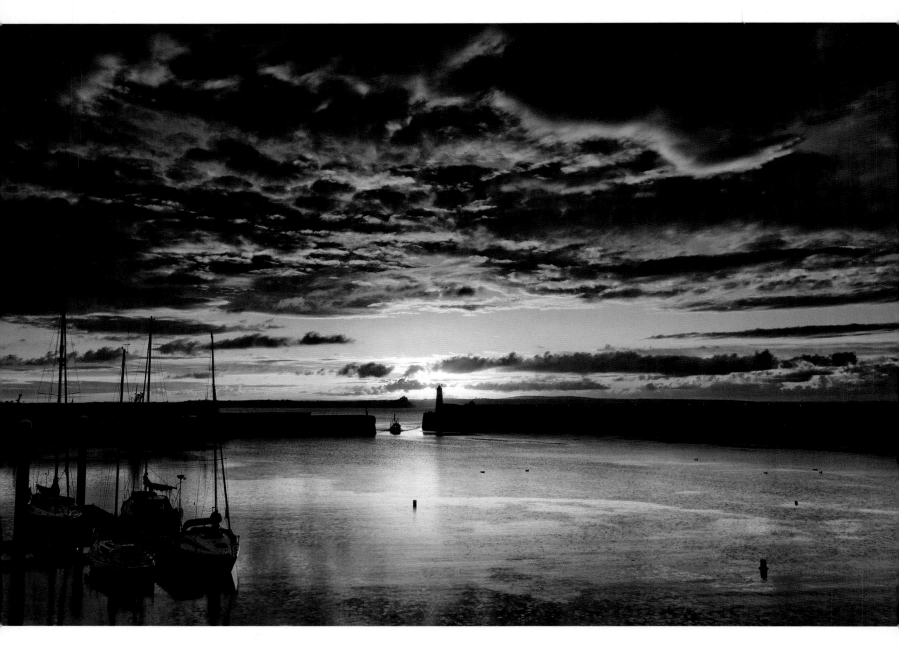

Above: The light has done all the hard work here: all I had to do was press the shutter at the right moment and keep the rain off the lens. Shooting straight into the light suits black-and-white photography well.

Focal length: 22mm

Aperture: f/11

Shutter speed: 1/13 sec.

ISO: 100

MASTERING BLACK & WHITE
PHOTOGRAPHY

JOHN WALMSLEY

AMMONITE
PRESS

First published 2015 by
Ammonite Press
an imprint of AE Publications Ltd
166 High Street, Lewes, East Sussex, BN7 1XU, United Kingdom

Reprinted 2018

ISBN 978-1-78145-087-1

British Library Cataloging in Publication Data: A catalog record of this
book is available from the British Library.

Editor: Chris Gatcum
Series Editor: Richard Wiles
Designer: Robin Shields

Typeface: Helvetica Neue
Color reproduction by GMC Reprographics
Printed in China

Right: Once you understand how to use your camera's
light meter you can quickly analyze a scene and see how it
is going to be recorded. This is important in difficult lighting
scenarios when there is more than one way of interpreting
the light.

Focal length: 50mm
Aperture: f/8
Shutter speed: 1/250 sec.
ISO: 100

Contents

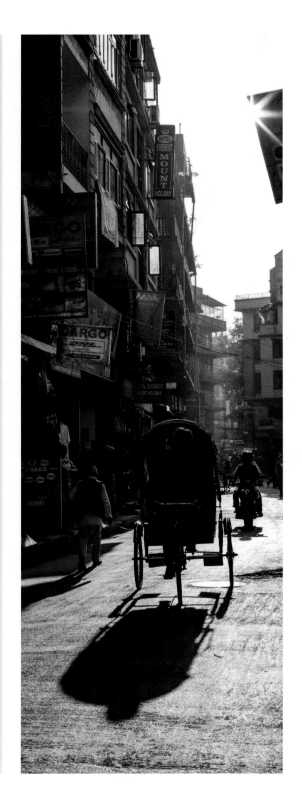

Introduction

There is something about a black-and-white photograph that just looks good: a landscape can become timeless and a portrait can be turned into a thing of beauty. It is testament to the medium that, through the evolution of photography, the black-and-white photograph has lost none of its charm. In the world of fine-art photography, black-and-white photographs still remain the popular choice amongst collectors; a good black-and-white print will always have an intrinsic appeal.

The level of manipulation you can perform on a correctly exposed digital negative gives a creative freedom that has, in the past, only been associated with drawing or painting. It is this "painting with light," stripped of color to present a world made up of black, white, and different tones of gray that can transform the ordinary into the extraordinary.

With the advent of digital photography, everyone can now enjoy black-and-white photography. You no longer need to convert a spare room or garden shed into a darkroom, and nor do you need to fumble around in the dark, dealing with noxious chemicals and wasting piles of paper to produce a single print. Now, you can experiment in the digital darkroom, where even the most basic equipment makes it possible to obtain a good-quality print.

Technology may have changed the way you capture a black-and-white photograph, but the fundamentals are the same as they always have been. The aim with this book is to help you see the world in black and white. You will be shown how to walk into any situation and—regardless of how challenging the lighting is—be able to tell the camera how you want it to be recorded.

This means learning to take control of the camera and make all the decisions yourself. Mastering these skills is not a hard thing to do. Although having to slow down can be frustrating at first, with practice it becomes liberating when you realize just how much creative freedom you have when you are fully in control of your camera.

Right: No matter how photogenic the subject is, it is the lighting that will transform a photograph from a simple "record" to an artistic image.

Focal length: 50mm

Aperture: f/4

Shutter speed: 1/250 sec.

ISO: 100

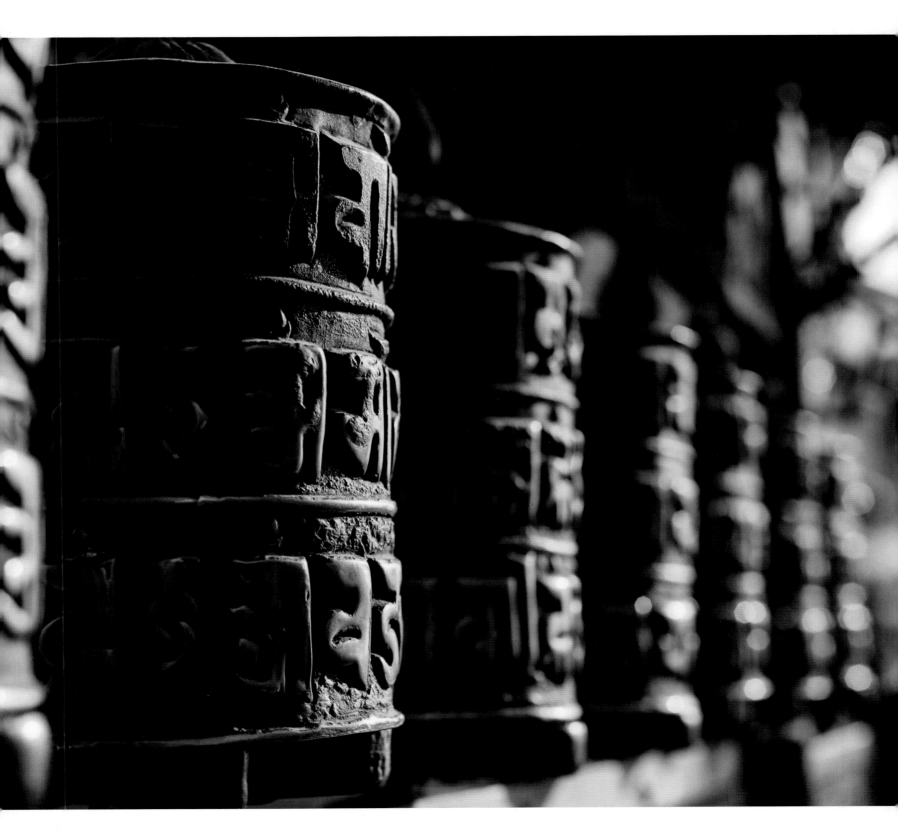

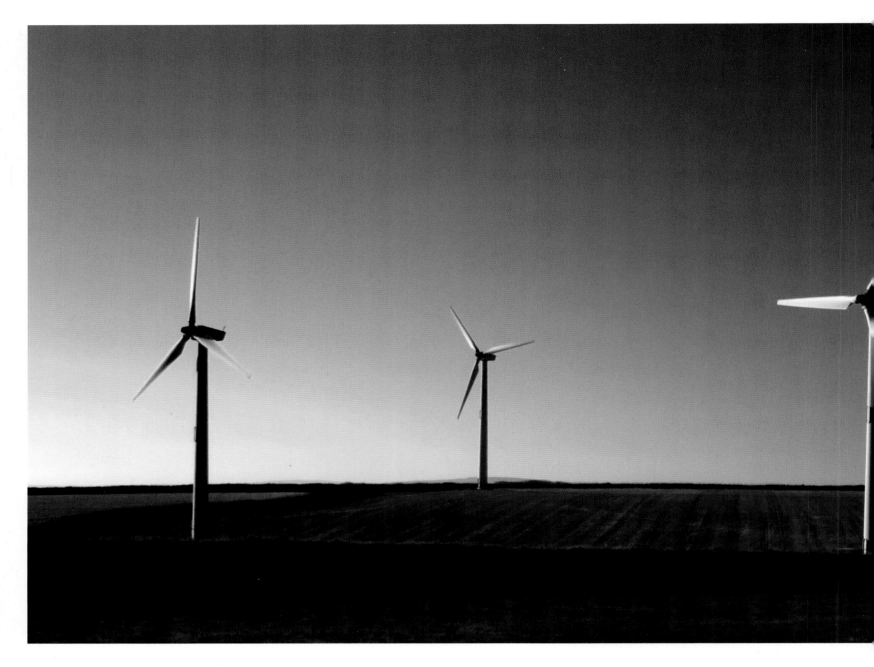

There is a misguided belief amongst many photographers that if a color photograph hasn't worked out, converting it to black and white will make it look good.

Although this might "save" the occasional image, more often than not you will be left feeling disappointed. This is because black-and-white photographs have different requirements to color images. Black-and-white photography is more about contrasts: strong, bold compositions that embrace areas of high contrast work equally with a minimalist approach when there is almost nothing in the frame. The key to success is not just being able to recognize a good black-and-white composition when you see one, but also being able to pre-visualize how the final image will look.

The opportunities that black-and-white photography present can also occur in some of the most unlikely places: the shadow of a repeating pattern in the middle of the day, for example, or silhouette made up of pure black against pure white. These are the kind of situations where black-and-white photography comes into its own. It is not simply that a color photograph will

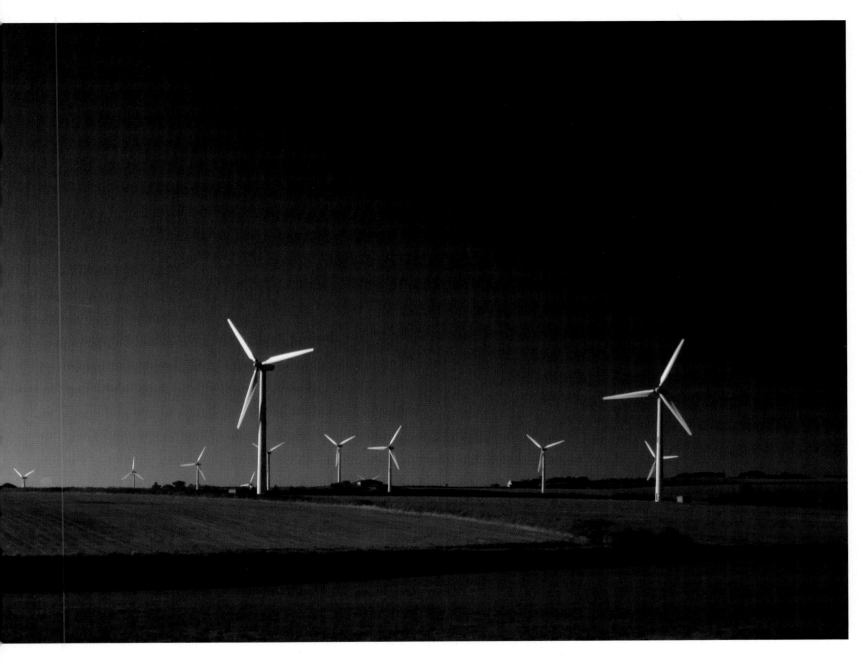

look better in black and white, but that a moment in time is best captured in black and white from the outset. In these moments, the distraction of color is never a consideration: the intent is always for a monochrome treatment.

Above: This could be nothing other than a black-and-white image. The uneven brightness in the sky is a result of using a polarizing filter with a wide-angle lens. In color this can look unusual, but in monochrome it can add something special to an image.

Focal length: 25mm

Aperture: f/13

Shutter speed: 1/50 sec.

ISO: 100

Control Your Camera

With digital cameras becoming ever more sophisticated and offering multiple ways of speeding up the photographic process, it might seem slightly strange to suggest that you should do everything yourself and shoot fully manually. However, when you hand the decision making over to the camera you are becoming a machine operator, not a photographer. You might have a good eye for a composition, but you are not thinking about how you want the tones to be recorded in your photograph.

The majority of good professional photographers shoot manually: they decide how they want the image to look and then they tell the camera to record it that way. With a little practice it can be a very fast way of working. Most of the time, the process works something like this:

1 Decide how much of the scene you want in sharp focus. Select the aperture that will give you the appropriate depth of field.
2 Identify the brightest part of the scene where you still want detail to be recorded. Take a spot meter reading from this area and adjust the shutter speed so it will be exposed in the way that matches your creative vision.
3 Focus and take the photograph.

That is a simplified (but nonetheless accurate) description that will work in the majority of situations. If you really want to improve your photography you need to think like a photographer. This means thinking about the light: What light is your subject in? Is the contrast within the range of your camera's sensor? How do you want the image to look? This is all part of the creative vision, with the next step being to edit the digital negative.

Beside each image in this book you will see the relevant technical information, which gives an insight into some of the thought processes involved when the photograph was taken. For example, if the sun is in the frame it is more than likely the aperture chosen was f/11 or f/16; this is because of the starburst effect created by using a narrow aperture.

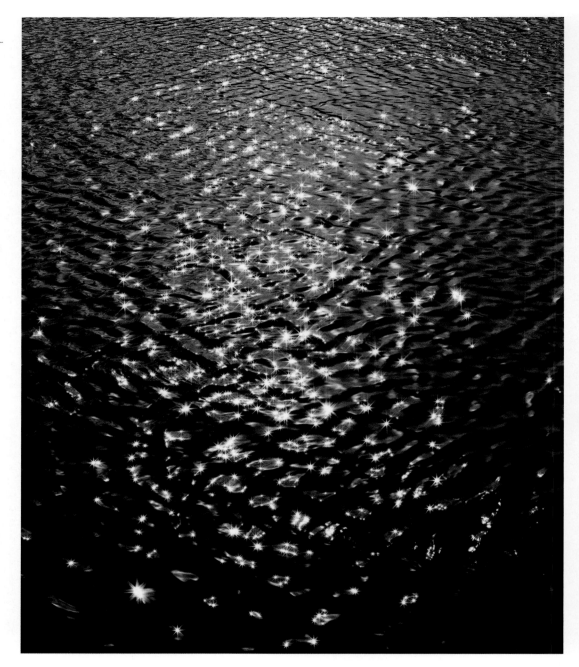

As this suggests, a major part of the creative process comes at the point of capture. It should give you great satisfaction knowing that an image looks that way because of the way in which you interpreted the light, rather than how your camera thought it should be recorded.

Above: Low-contrast scenes will not trouble a camera's exposure metering system, but when the light is really interesting—as in this image—it will struggle.

Focal length: 50mm

Aperture: f/11

Shutter speed: 1/500 sec.

ISO: 100

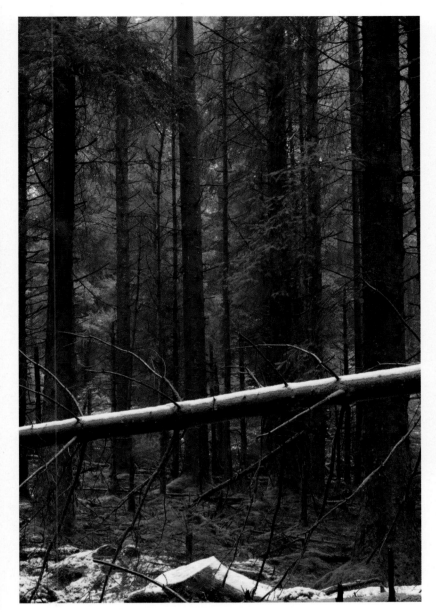

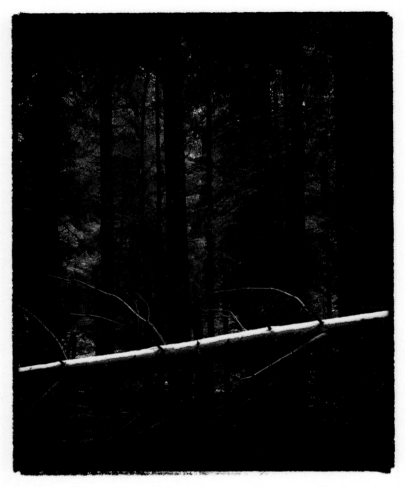

Left & Above: The strong contrast between the snow and the trees, and the diagonal break in the flow of the image, suggested this scene would naturally suit a black-and-white treatment. The end result is far removed from the original Raw file.

Focal length: 90mm

Aperture: f/16

Shutter speed: 1.3 sec.

ISO: 100

The Digital Darkroom

There is no such thing as an unmanipulated black-and-white photograph—the removal of color is itself a form of manipulation. Unlike the days of film, when you used black-and-white film if you wanted a black-and-white photograph, with a digital camera it is best to record the scene in color and convert it to monochrome on your computer, as this gives you much greater flexibility.

Image manipulation is in no way unique to digital photography. For years people have been combining black-and-white negatives, selectively lightening and darkening areas, and creating prints that are so far removed from the original scene they can look like a completely different photograph. This was happening long before digital photography came about and it is this

creative freedom that was—and still is—part of the attraction of black-and-white photography. While a heavily edited color photograph will always draw comments about the (over) use of image-editing software, with a black-and-white photograph it is a matter of course.

Chapter 1
Equipment

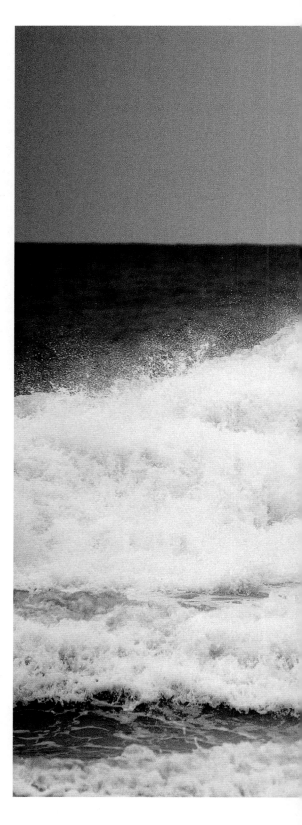

As a black-and-white treatment is relevant across all genres of photography, deciding what equipment to buy depends on where your interests lay. However, although there is always a "right tool for the job," you also need to be able to make the best of a situation using what you have at your disposal—a competent photographer should be able to take a good picture whatever equipment they are using. By far the most important tool a photographer has is their eye. After all, modern cameras might be very clever with regards to calculating the exposure, but they still cannot tell you where to point it.

Right: Practice using your equipment so that it becomes second nature. Then, when you have to work quickly, you won't miss that all-important shot.

Focal length: 400mm

Aperture: f/6.7

Shutter speed: 1/750 sec.

ISO: 400

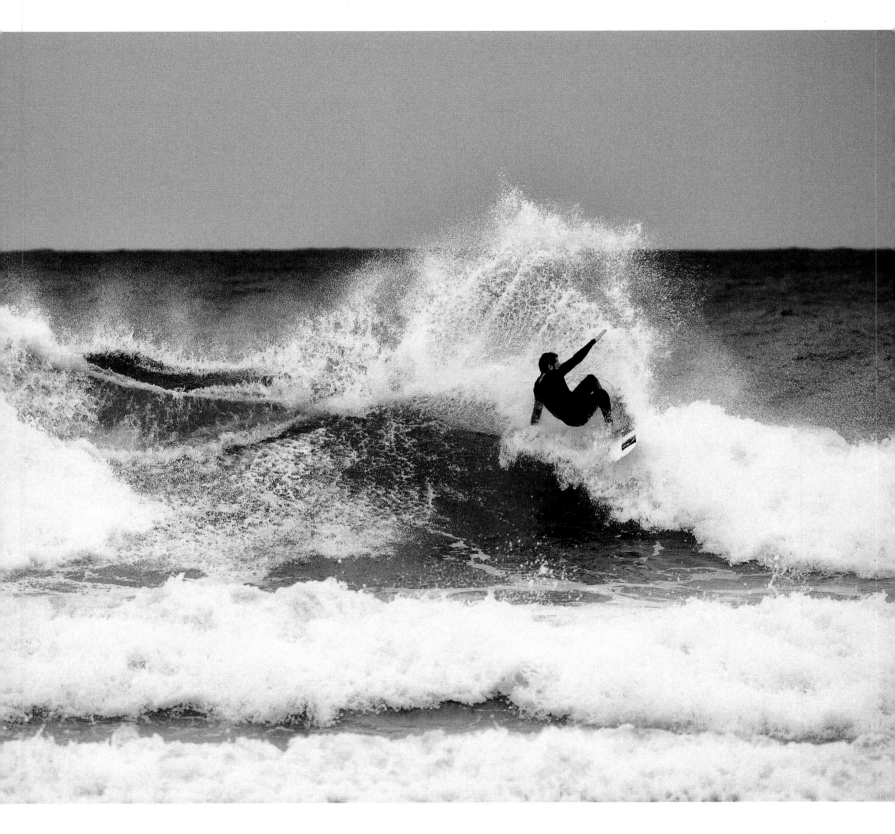

Cameras

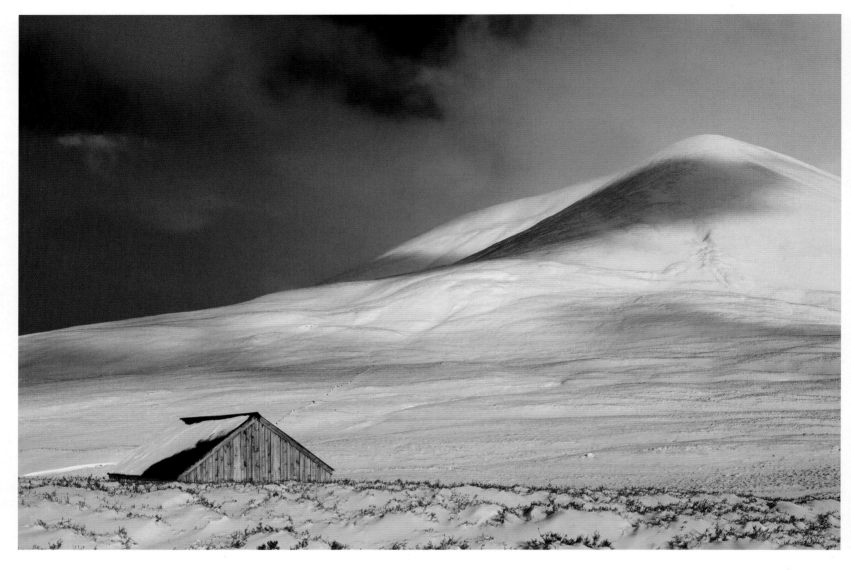

There is no "best" camera for taking black-and-white photographs—every camera system has both positive and negative attributes. For most people, budget will likely be a contributing factor when deciding what to buy, but you do need to be realistic about what you need—a compact camera will not be suitable for wildlife photography, for example, while a DLSR is probably not your camera of choice if you want something small that you can carry around with you all the time. For black-and-white photography, the key criteria is to be able to make creative choices for yourself, so it is strongly recommended that you equip yourself with a camera that allows you to do this.

Above: If you want to make large prints of your work, a camera with a high pixel count—coupled with a high-quality lens—will give you the best results. You will also need lots of storage space on your computer for all those massive digital negatives.

Focal length: 50mm

Aperture: f/11

Shutter speed: 1/200 sec.

ISO: 100

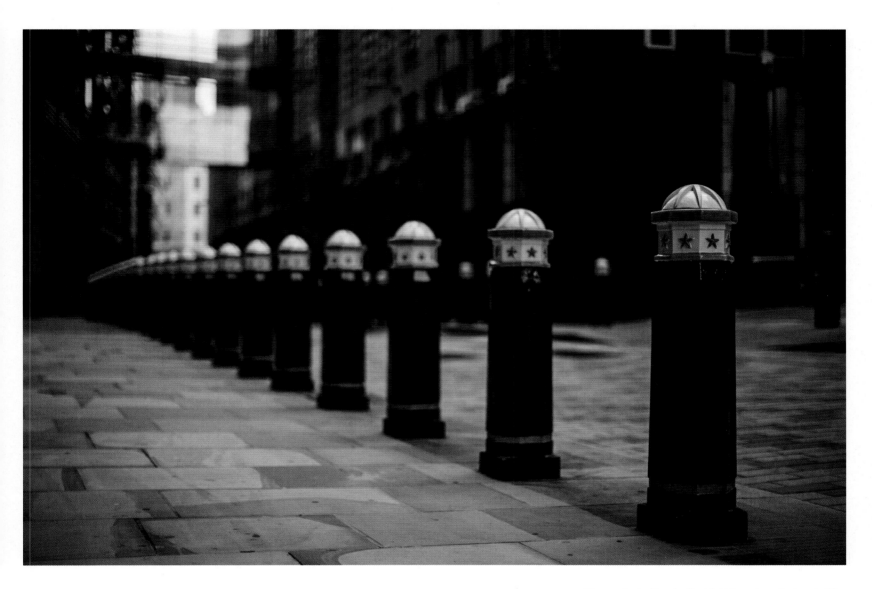

Above: Controlling depth of field is an important part of the creative process in black-and-white photography. This was one of those situations that called for either an "all in focus" or a "very little in focus" approach. I opted for the latter, using a shallow depth of field.

Focal length: 50mm

Aperture: f/1.2

Shutter speed: 1/2500 sec.

ISO: 100

Compact Cameras

Otherwise known as "point-and-shoot" cameras, compact cameras are typically small, lightweight, and inexpensive. They have a fixed lens (normally a zoom lens) and all but the most sophisticated models offer limited control over the functions.

Although a compact camera might have a high-resolution sensor, because of its small size and the pixels being very close together, they do not perform well in low light and images are noisy.

The small sensor size also means that the lens has to be a short focal length (otherwise known as a wide-angle lens). A wide-angle lens delivers an extensive depth of field, so unless you are really close to something, everything in the photograph is likely to be in focus. This makes it very difficult to take certain types of photograph: a portrait of a person with a blurred background, for example.

Mirrorless Cameras

This type of camera uses the same sized sensor as a DSLR, but lacks the pentaprism and mirror used in a DSLR's viewing system (hence the name). This allows the camera body to be significantly smaller and more compact, but also means that images are framed and viewed through an electronic viewfinder or on the rear LCD screen.

As with DSLRs, mirrorless cameras have interchangeable lenses, but they also enable you to use lenses from other manufacturers via an adaptor ring. With old prime lenses delivering good optical quality, this means you can buy inexpensive, pre-owned lenses whose sharpness rivals some of the best modern prime lenses.

DSLR Cameras

With interchangeable lenses, excellent autofocus, and high ISO capabilities, a DSLR (digital single-lens reflex) camera is the camera of choice for the serious black-and-white photographer. Images are viewed through an optical, eye-level viewfinder and you have full control over all aspects of taking a photograph. Most pro spec (and some enthusiast) DSLRs have excellent weather sealing, enabling you to take photographs in all but the worst weather conditions.

The downside to this type of camera is its size (particularly if you are trying to be discreet) and weight (especially if you a carrying it along with a number of lenses for extended periods).

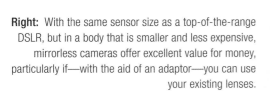

Right: With the same sensor size as a top-of-the-range DSLR, but in a body that is smaller and less expensive, mirrorless cameras offer excellent value for money, particularly if—with the aid of an adaptor—you can use your existing lenses.

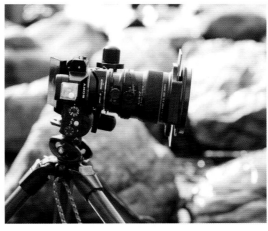

Right: The performance of a modern DSLR is staggering, particularly in low light. Being able to get a usable image at ISO 3200—which also stands up to heavy editing—is one of the wonders of digital technology.

Focal length: 105mm
Aperture: f/5.6
Shutter speed: 1/50 sec.
ISO: 3200

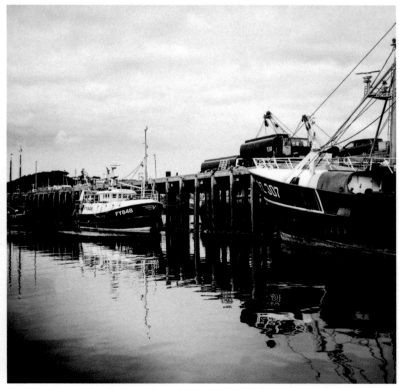

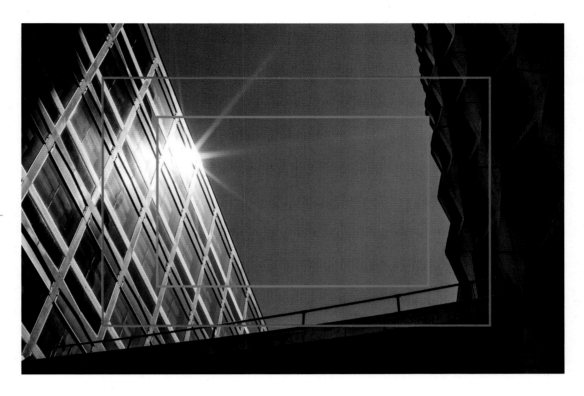

Left: The Hipstamatic app gives a retro look to an image that is reminiscent of using a vintage film camera. The shot can then be converted to black and white: the combination of the square format, vignette, and vintage look suits black-and-white photography well.

Focal length: 4.3mm

Aperture: f/2.4

Shutter speed: Various

ISO: 50

Cell Phone

The best camera is the one you have with you, and even if you don't have a dedicated camera with you, there's every chance you will have your cell phone. Some photographers feel that camera phones are not "proper" cameras, but they definitely have their place in a photographer's arsenal. You might be limited to a small print size due to the resolution of the sensor and the quality of the lens, but many cell phones can still deliver good results. It can also be something of a liberating experience—all you need to think about is framing the image.

Sensor Size

The size of a camera's sensor and its pixel count—in conjunction with the quality of the lens placed in front of it—will dictate the overall image quality. The greater the distance between the individual pixels, the less noise is present in the image, but it is not always a case that a higher pixel count is better. There are currently three sensor sizes in common use with DSLR and mirrorless cameras:

- **Full-frame** sensors are the size of a traditional 35mm film frame (36 x 24mm), and are considered to deliver the best results. These sensors are found in the most expensive DSLRs, and some mirrorless cameras.

- **APS-C** sensors are approximately 30% smaller than full-frame sensors, although there is no standard size used (the size is usually either 22.2 x 14.8mm or 23.5–23.7 x 15.6mm). They are the most common sensor size found in DSLRs and mirrorless cameras.

- **Micro Four Thirds** sensors are half the size of a full-frame sensor (nominally 17 x 13mm), and are typically found in the smaller mirrorless camera systems.

Crop Factor

As APS-C and Micro Four Thirds sensors are smaller than full-frame sensors, they have what is known as a "crop factor." The crop factor is the ratio of the camera's sensor compared to a full-frame sensor (35mm film frame) and is used to determine the effective focal length of a lens, compared to its actual focal length.

For example, a full-frame sensor does not have a crop factor (or, rather, the crop factor is 1x), so any lens will deliver its full angle of view. However, if the same lens is fitted to a camera with a smaller sensor size, the angle of view is narrowed; the sensor effectively "crops" the image projected

Above: This photograph was taken using a full-frame camera. If the same lens had been used on a camera with an APS-C-sized sensor, the area within the red box would have been recorded; with a Micro Four Thirds camera, only the area inside the green box would have been imaged.

Focal length: 50mm

Aperture: f/16

Shutter speed: 1/200 sec.

ISO: 100

by the lens. This will give the impression that the lens has a longer focal length, so wide-angle lenses become less wide, and telephoto lenses gain even greater magnification.

The figure quoted for the camera's crop factor is the amount that the sensor effectively magnifies the focal length by. So, if you fitted a 50mm lens to a camera with an APS-C-sized sensor with a 1.5x crop factor, the effective focal length would be 75mm (50 x 1.5). However, if you fit a 50mm lens to a Micro Four Thirds camera, which has a 2x crop factor, the focal length will effectively become 100mm (50 x 2).

Lenses

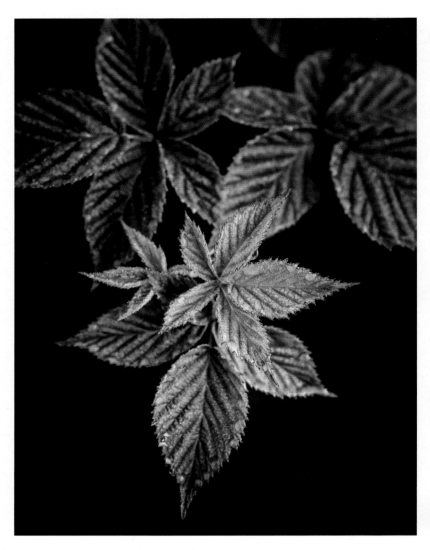

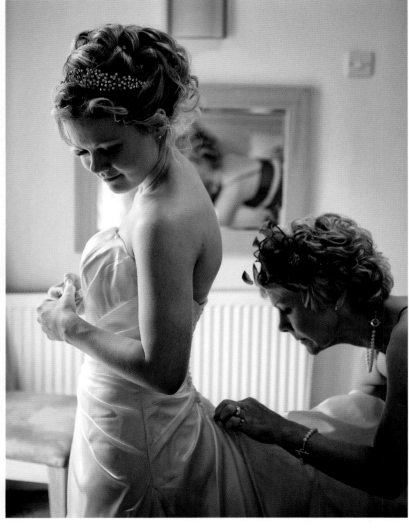

You should always invest in the best lenses you can afford. With modern sensors delivering such good results, any optical imperfections in a lens will be immediately obvious: chromatic aberration, barrel distortion, vignetting, diffraction, and softness (particularly around the edges) are all traits of a cheap lens. The good news is that you really do get what you pay for; a good lens will hold its value, and will last for many years if properly looked after.

Above Left: Framing with a prime lens can be tricky, and it may take longer to get your composition right. However, the extra time you spend will be worth it in the end.

Focal length: 90mm

Aperture: f/5.6

Shutter speed: 1/13 sec.

ISO: 100

Above: A good quality zoom lens with a wide and constant maximum aperture is the lens of choice for the working photographer. Optical quality is excellent, and they are perfect for when you don't want to miss anything—you could photograph perhaps 80% of a wedding with a 24–70mm f/2.8 lens, for example.

Focal length: 50mm

Aperture: f/2.8

Shutter speed: 1/125 sec.

ISO: 800

Zoom or Prime Lens?

The main thing a zoom lens offers is versatility, as it will cover a range of focal lengths. However, this typically comes at the expense of optical quality (especially with low-cost zoom lenses).

Unless you own an expensive zoom lens with a fixed aperture you could also be unwittingly changing the aperture as you zoom. For example, a typical 18–200mm zoom lens may have a variable maximum aperture of f/3.5 to f/6.3. This means that f/3.5 is the widest aperture you can choose at a focal length of 18mm, while f/6.3 is the widest available aperture at a 200mm focal length. Consequently, if you set the aperture "wide open" and zoomed from a focal length of 18mm to 200mm the aperture would change automatically from f/3.5 to f/6.3. If you were working manually and had determined the exposure at f/3.5, this could result in an underexposed image.

An often-quoted argument against using a prime lens is the opportunities you will miss by not being able to change focal length. However, there will always be missed opportunities, no matter what lens you are using, and quality—with a prime lens—is always better than quantity. By going out and photographing with just the one focal length you will also start to "see" compositions that you would otherwise have missed and this will make you a better photographer.

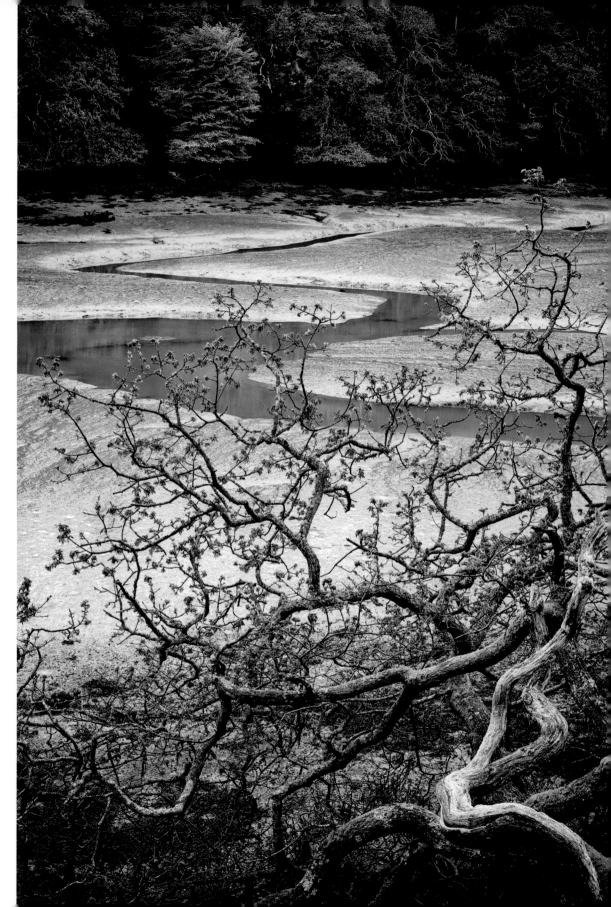

Right: A prime lens offers excellent optical quality at the expense of versatility: with a fixed focal length lens you have to zoom with your feet, which forces you to think more about your composition.

Focal length: 50mm

Aperture: f/11

Shutter speed: 1/6 sec.

ISO: 100

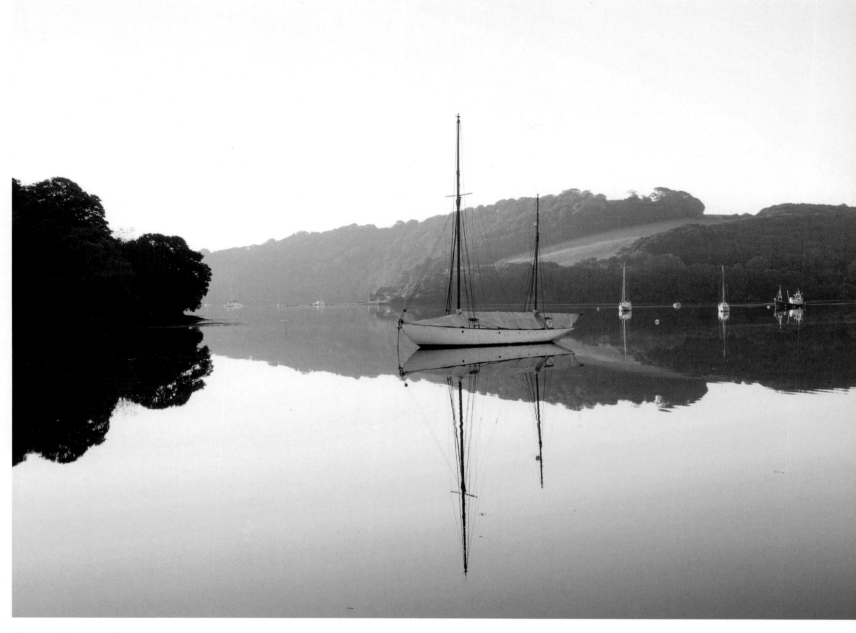

Focal Length

The focal length of a lens is the distance—usually given in millimeters—between the camera's sensor and the optical center of the lens when it is focused at infinity. The effective focal length of a lens is always quoted for a full-frame sensor, so if you are using a camera with a cropped sensor (APS-C or Micro Four Thirds) the crop factor needs to be taken into account (see page 19). As the focal length of a lens is inversely proportional to its field of view, a lens with a wide field of view will have a small focal length, and a lens with a narrow field of view will have a large focal length.

Left: Covering a huge focal length range, Sigma's 50–500mm f/4–6.3 DG OS lens offers incredible versatility in a single optic.

Above: The capabilities of today's image-editing software mean that even using a fixed focal length opens up other opportunities: this is a stitched panorama comprised of five different images taken with a 40mm prime lens.

Focal length: 40mm

Aperture: f/8

Shutter speed: 1/20 sec.

ISO: 100

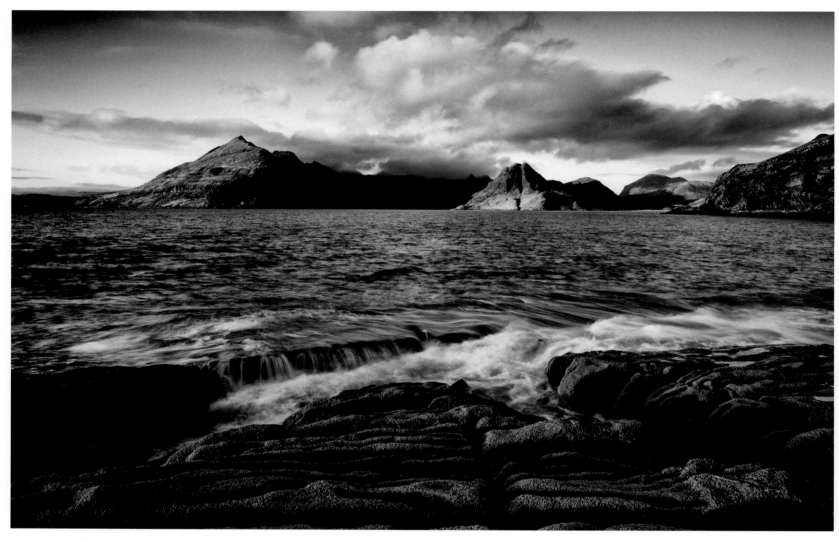

Wide-Angle Lenses

A wide-angle lens has a focal length of 35mm or less (after the camera's crop factor has been taken into account). Offering a wider field of view than the human eye, this type of lens appears to exaggerate perspective and is the lens of choice for landscape and architectural photographers. This is because you can fit more in the frame, allowing the foreground to dominate a picture, whilst showing it in context with the background.

It is also easier to keep everything in sharp focus throughout the image. This is because depth of field increases as focal length decreases—a 24mm lens set at f/16 will deliver a greater depth of field than a 100mm lens set at f/16, for example.

However, wide-angle lenses can also introduce barrel distortion, which is where a line that should be straight in the scene (the horizon or a wall, for example) starts to bow outward. The wider the focal length, the more pronounced the distortion will be, although it usually only affects the edges of the image. The most extreme example of this is a fisheye lens, which offers a 180-degree field of view and can deliver a circular image with extreme barrel distortion.

Above: With a wide-angle lens showing so much of a landscape, your choice of foreground is always important.

Focal length: 24mm

Aperture: f/16

Shutter speed: 0.8 sec.

ISO: 100

Above: Canon's EF-S 24mm f/2 lens is a compact, "pancake" style wide-angle lens designed specifically for cameras with an APS-C-sized sensor.

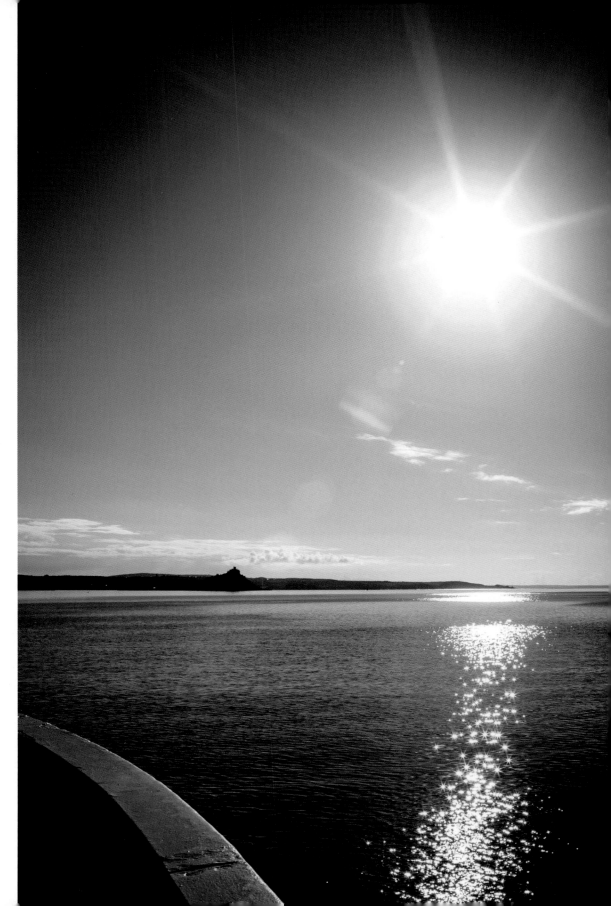

Right: Taken with a 35mm prime lens, the feeling of depth has been accentuated by including something in the immediate foreground. It serves as an anchor point to come back to—if it hadn't been included, the image would have looked empty.

Focal length: 35mm

Aperture: f/16

Shutter speed: 1/320 sec.

ISO: 100

Standard Lens

A standard lens has a focal length that delivers a similar field of view to the human eye. As the lens records objects approximately the same as the human eye sees them, there is no distortion.

The "standard" focal length is equal to the diagonal measurement of the sensor in the camera it is being used on, which is 43mm on a full-frame camera (although 50mm has historically been accepted as "standard"), 28–35mm on an APS-C camera (depending on the crop factor), and 22mm on Micro Four Thirds cameras.

There was a time when all 35mm film SLRs came with a 50mm prime lens, but this is no longer the case, with low-cost zooms supplied with DSLRs instead. However, a standard prime lens still makes an excellent addition to a photographer's kit bag, as this type of lens is typically inexpensive, small, and very sharp. They also have a much wider maximum aperture than a "kit" zoom, so are excellent in low light and for minimizing depth of field.

Left: Taken using a wide aperture, the background is nicely out of focus, but still recognizable. You will not achieve results like this with the standard zoom lens that comes with a new DSLR camera kit.

Focal length: 50mm

Aperture: f/1.4

Shutter speed: 1/640 sec.

ISO: 100

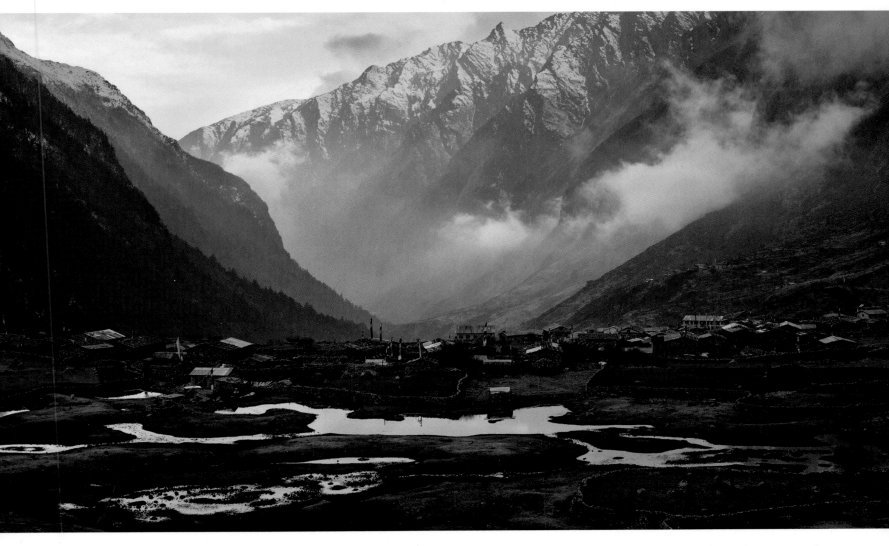

Above: A standard lens has its uses in every genre of photography, so cannot be recommended highly enough. In fact, for the creativity it offers, you could go as far as saying that this is the lens of choice for the serious black-and-white photographer.

Focal length: 50mm

Aperture: f/8

Shutter speed: 1/10 sec.

ISO: 100

Above: Like many standard prime lenses, Sigma's 50mm f/1.4 lens features a wide maximum aperture.

Telephoto Lenses

A telephoto lens has a focal length greater than 50mm (in full-frame terms). The longer the focal length, the smaller the area you can isolate and the greater the magnification will be. As the depth of field is reduced with long focal length lenses, telephoto lenses can enable you to isolate your subject and make it stand out, even when using a mid-range aperture setting, such as f/8 or f/11. Because of this, they are excellent for blurring a distracting background.

Telephoto lenses also appear to compress perspective, making the foreground and the background appear closer together (although this is purely a function of the camera-to-subject distance, and not the focal length). This effect is known as "foreshortening."

Above: If you use a telephoto lens for abstract shots of small details, the focal plane must be kept parallel to the sensor. If it isn't, you won't be able to get sufficient depth of field to keep everything sharp in the frame, even if you are using a small aperture setting.

Focal length: 100mm

Aperture: f/8

Shutter speed: 1/15 sec.

ISO: 100

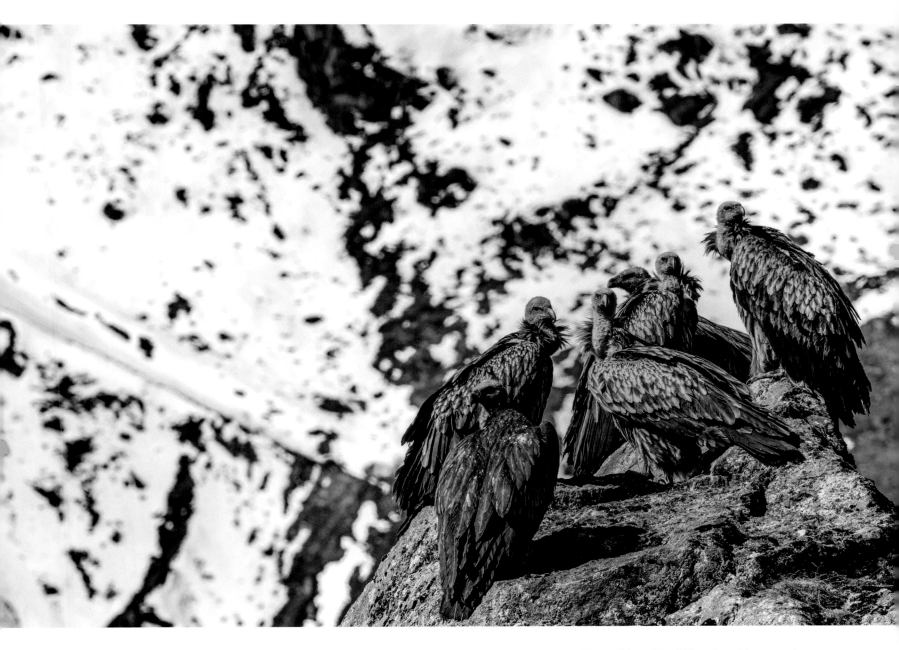

Above: Taken with a 300mm lens, this was as close as I could get to my subjects before they flew off. You don't have to have frame-filling shots of wildlife—you just have to make the best of the tools you have at your disposal.

Focal length: 300mm

Aperture: f/11

Shutter speed: 1/320 sec.

ISO: 100

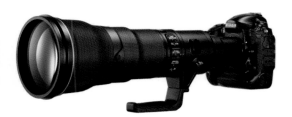

Left: Nikon's 800mm f/5.6E AF-S FL ED VR lens is at the extreme end of the telephoto focal length scale, with a price to match.

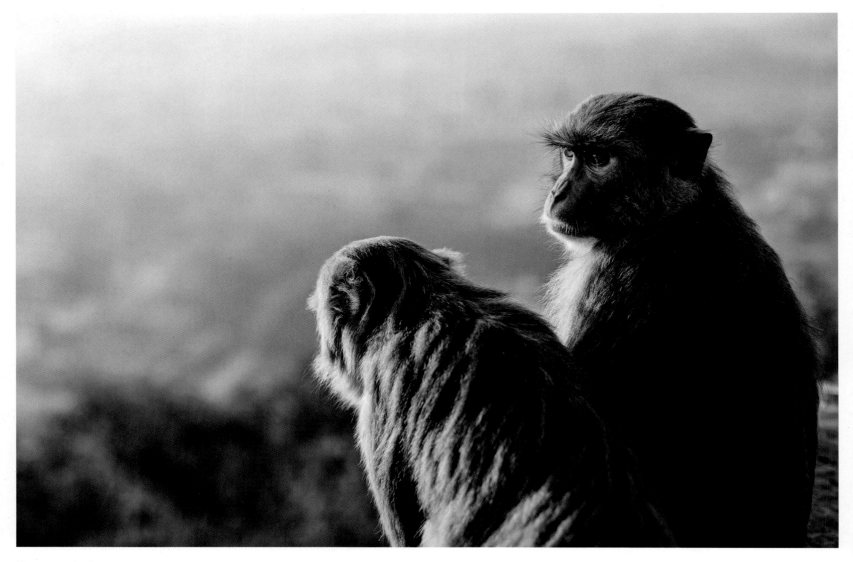

Portrait Lenses

Although any lens can be used to take a portrait, a mild telephoto lens with a focal length in the range of 85–100mm is the preferred choice for portrait photography. This is because a mild telephoto allows a comfortable working distance—you aren't up close to your subject, or a long distance back from them—which delivers a flattering perspective. A 50mm prime lens on a camera with an APS-C camera is an excellent choice for taking portraits.

Above: You don't have to take frame-filling portraits; being able to show your subject in its surroundings can sometimes tell more of a story.

Focal length: 85mm

Aperture: f/2.8

Shutter speed: 1/320 sec.

ISO: 100

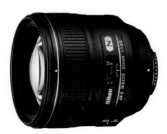

Above: An 85mm focal length is ideal for portrait photography. This Nikon 85mm f/1.4G lens also has a fast maximum aperture, which is ideal for throwing the background out of focus.

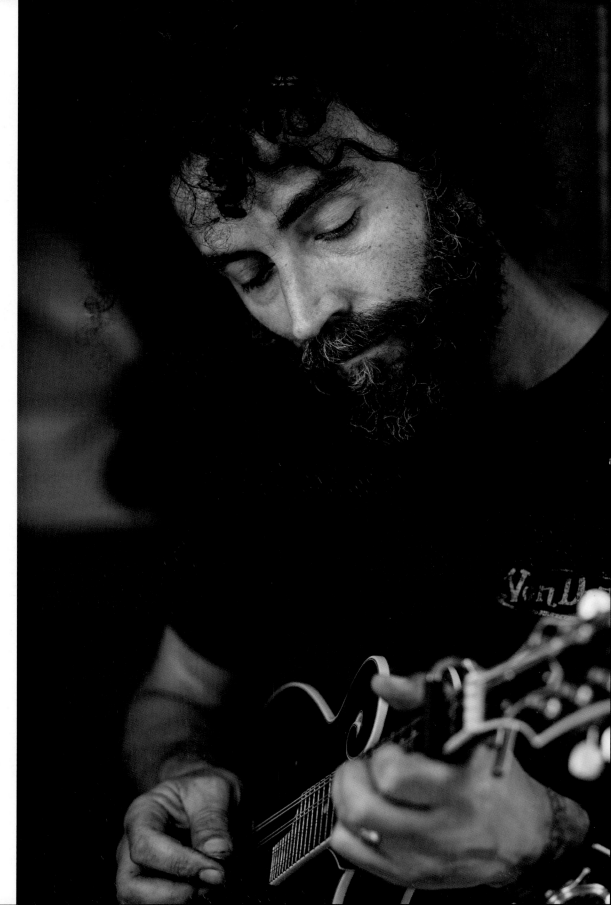

Right: The shallow depth of field that can be delivered by a good portrait lens is excellent for making your subject stand out.

Focal length: 85mm
Aperture: f/2.8
Shutter speed: 1/250 sec.
ISO: 1600

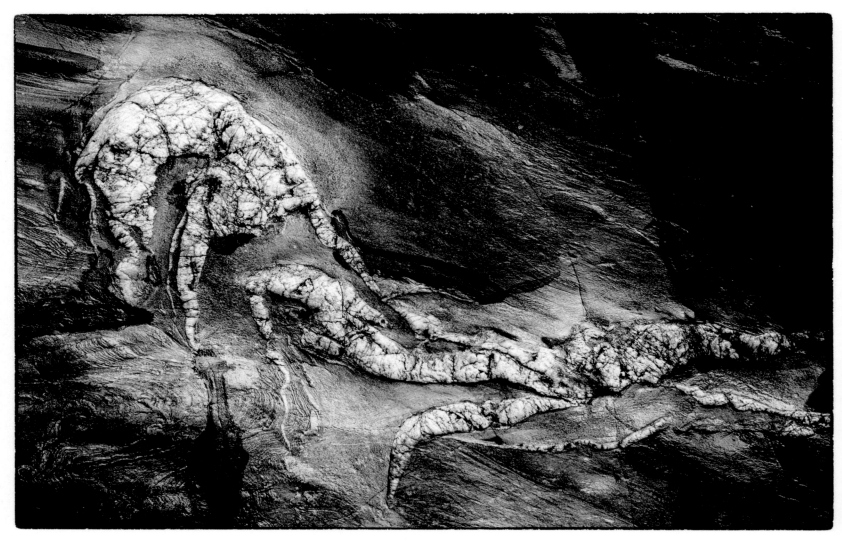

Macro Lenses

A true macro lens gives 1:1 (life size) reproduction. Although macro lenses range in focal length from 40mm to 200mm, lenses in the region of 90–105mm are the most popular. This is because the longer the focal length, the further away from your subject you can be while still achieving a 1:1 reproduction ratio. This is particularly useful with living subjects that might run, fly, or crawl away should you get too close.

Although a lot of zoom lenses enable close focusing (and many of these have a "macro" setting) they are not true macro lenses unless they give 1:1 reproduction—many only allow 1:2 (half life size), or even 1:4 (quarter life size) reproduction.

Above: A macro lens opens up a whole world of possibilities. This is a small rock detail, exposed from under sand after a storm, and then covered again the next day.

Focal length: 100mm

Aperture: f/16

Shutter speed: 5 sec.

ISO: 100

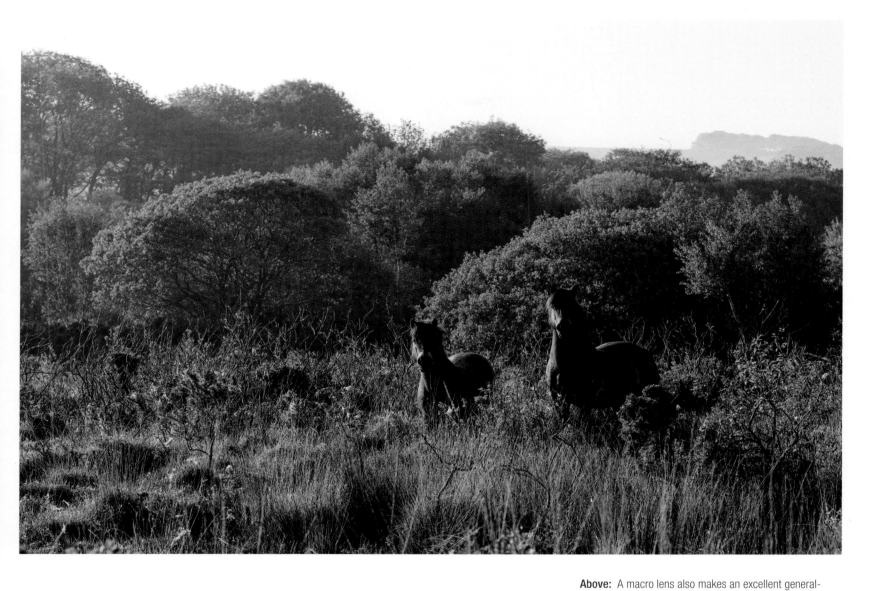

Above: A macro lens also makes an excellent general-purpose lens. This was taken using a 100mm macro lens and is extremely sharp.

Focal length: 100mm

Aperture: f/8

Shutter speed: 1/200 sec.

ISO: 250

Left: Macro lenses with a medium telephoto focal length, such as Canon's EF 100mm f/2.8L IS USM lens, are among the most popular.

Accessories

There are countless accessories that camera manufacturers would like you to believe you cannot live without, but you actually need very few of them. The main exceptions to this are a tripod and a shutter-release cable or wireless remote.

Tripod

With the exception of street photography, a tripod is an essential piece of kit. It not only helps to eliminate camera shake, but the additional time needed to frame your image will automatically encourage you to think more about your photograph and allow you to fine tune your composition.

Tripods are available in a bewildering range of sizes and several materials, but the most important thing is that the tripod you choose is capable of supporting your camera and (heaviest) lens. Although a small, lightweight tripod is easier to carry around with you, it still needs to be sturdy.

With regards to materials, carbon fiber tripods offer the best weight-to-stability ratio, but they are also the most expensive—aluminum tripods are just as stable and less expensive (although they are comparably heavier).

Your choice of tripod head is also important, and there are two main types to choose from. Pan-and-tilt heads have three different controls for moving the camera up and down, side to side, and for tilting it between the vertical and horizontal axis. The best of these are geared, allowing very precise adjustments to be made, although this is the heaviest and most expensive option.

A ball-and-socket (or just "ball") head has a single release control that allows you to position the camera any way you want. This is much quicker than using a pan-and-tilt head, but it is also less precise. However, for wildlife and sports photography a ball-and-socket head will allow you to both support your camera and quickly track your subject.

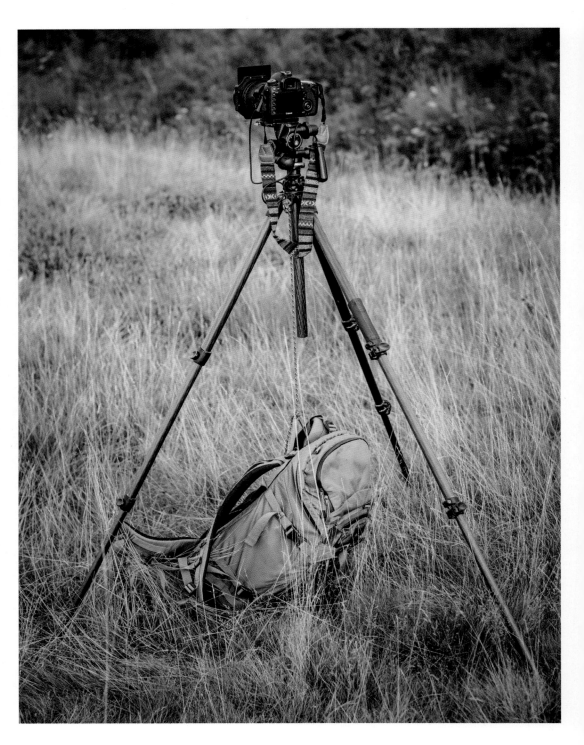

Left: To give your tripod extra stability, hang your camera bag underneath it. Make sure the bag is touching the ground (you don't want it swinging in the wind), but is still under tension.

Focal length: 50mm

Aperture: f/2.8

Shutter speed: 1/200 sec.

ISO: 100

Above: A tripod should be used whenever possible, as it can offer a multitude of creative opportunities, as well as improving your compositions. This abstract shot of a river in spate would have been impossible to create without the camera mounted on a tripod.

Focal length: 300mm

Aperture: f/11

Shutter speed: 1/5 sec.

ISO: 100

Remote Release

Although having your camera on a tripod will make it more stable, you should also use a remote release to prevent camera shake caused by the physical act of pressing the shutter-release button. The options here are a remote cable release, which is effectively a shutter-release button on a cable that plugs into the camera, or a wireless remote that triggers the shutter wirelessly.

You can also use the camera's built-in self-timer to take a shot without touching the camera, but there will always be a delay between pressing the shutter-release button to the picture being taken (usually 2 or 10 seconds, depending on your chosen camera setting). This may not be a problem with static subjects, but it is far less practical if you need to take a photograph at a precise moment.

Tip

To fully eliminate camera shake with a DSLR, enable the camera's mirror lockup feature—if it has one. This negates the risk of the mirror creating minor vibrations as it flips up out of the way of the sensor to make an exposure. With mirror lockup activated, the first press of the shutter-release button raises the mirror and the second press makes the exposure. The mirror then returns to the "down" position.

Camera Bags

Although you will need something to put your camera and lenses in, there is no such thing as the "perfect" camera bag (because of this I own an embarrassingly large collection of different bags!). Instead, you have to determine which bag is right for your needs.

As a general guide, camera bags based around a backpack design are the most comfortable to carry for long periods, but it can be awkward to access your gear quickly. If you are working in a confined space, changing lenses can be especially difficult, as you have to first find somewhere to put everything down before you can get to your gear.

By comparison, a shoulder bag gives easier access to your gear without having to put anything on the floor. However, they are uncomfortable to carry for any length of time.

A third option is a belt-and-pouch system, which has the benefit of allowing you to create a custom carrying solution based on the equipment you own. However, it can prove expensive to assemble, and as it is worn, rather than carried, it is much harder to "put down" than a bag.

Regardless of the bag you choose, it is important to remember that you have to carry everything you put in it. For this reason, a lot of photographers will have one "main" bag or case in which they store their entire camera kit, and then a smaller bag that can be taken on location with the essential items that are needed. It's important to understand that you don't necessarily need to carry every single piece of equipment all the time.

Filters

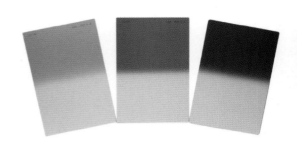

In the past, filters placed over the lens played an essential part in creating an image, manipulating the light before an exposure was made onto film. Today, many filters can be emulated using image-editing software, which often provides much greater control as well. However, there are some filters that may still prove useful, especially to landscape photographers.

The first type is neutral density (ND) filters, which simply reduce the amount of light passing through the lens without affecting the color. ND filters are typically used to extend exposure times by a specific number of stops (depending on the density of the filter), transforming moving water and clouds into a silky blur, for example.

As well as plain ND filters, graduated ND filters may also prove useful for outdoor photographers. Here, half of the filter is coated with a neutral density material and the other half is clear, allowing you to balance the exposure for two parts of a scene—usually a bright sky and darker foreground—so that detail can be retained in both in a single exposure. Again, graduated ND filters come in a range of densities, and you can also choose how abrupt the transition is from neutral density to clear—soft, hard, and very hard (or "razor") are the usual transition options.

Finally, polarizing filters cannot be emulated using software. This type of filter polarizes the light as it enters the lens, reducing reflections and/or deepening a blue sky, creating greater contrast (and separation) between the sky and clouds.

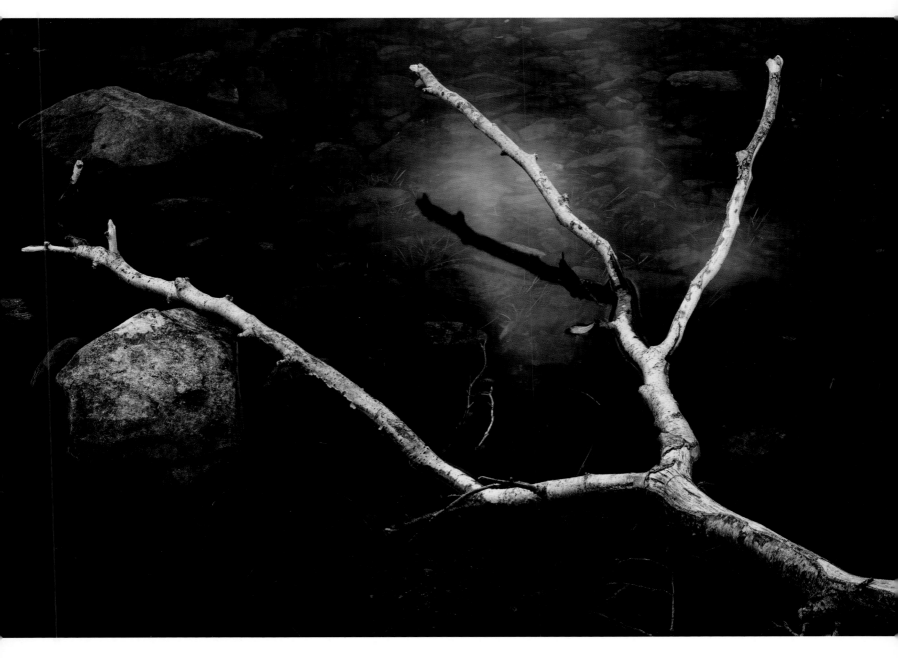

Above: A polarizing filter reduces reflections and is a useful addition to your camera gear. For this shot, I waited for a cloud to be positioned in the right place for the branch's shadow to be highlighted.

Focal length: 90mm

Aperture: f/16

Shutter speed: 1.6 sec.

ISO: 100

Chapter 2
Monochrome Essentials

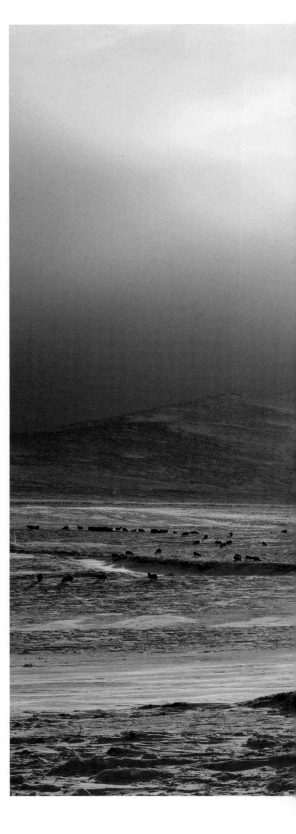

When you take a black-and-white photograph, how do you know that the colors will translate well into monochrome? What the eye sees and how it is recorded on the camera's sensor are unfortunately not the same. A red ball on green grass stands out well in color, for example, but if they are the same brightness they will just blend together when they are converted into shades of gray. Because we see the world in color it can take time to develop a monochrome mind-set, but learning to see in black and white is critical in mastering this challenging medium.

Right: Areas of high contrast always catch the eye. Although they might seem tricky to expose correctly, it is easier than it looks—simply work your exposure back from the brightest part of the scene.

Focal length: 50mm

Aperture: f/11

Shutter speed: 1/400 sec.

ISO: 100

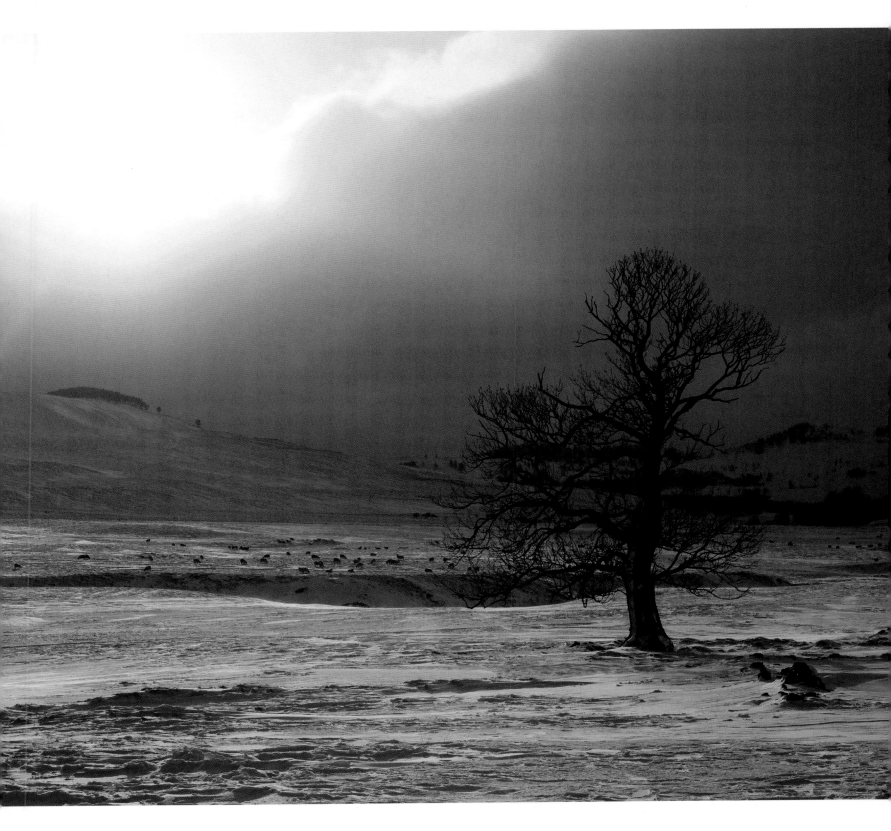

Color to Black & White

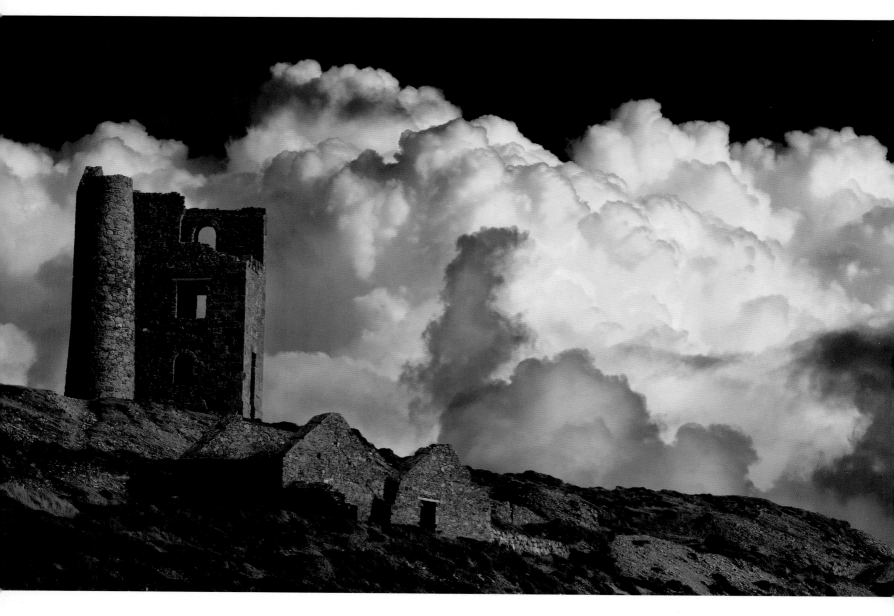

There is a lot more to creating a black-and-white image than simply removing the color from a photograph: you also need to understand how colors translate into tones.

Contrast is a major factor in black-and-white photography. This is the difference in brightness between the highlights and the darkest tones: the greater the difference between the two, the stronger the contrast. Although you can add contrast to an image in the digital darkroom, a scene with naturally high contrast will have done most of the hard work for you. Because of this, prominent areas of high contrast in a scene can be one of the first signs that it might work well as a monochrome image.

As well as the contrast between bright and dark areas, there is also contrast between colors. However, while contrasting colors might look good

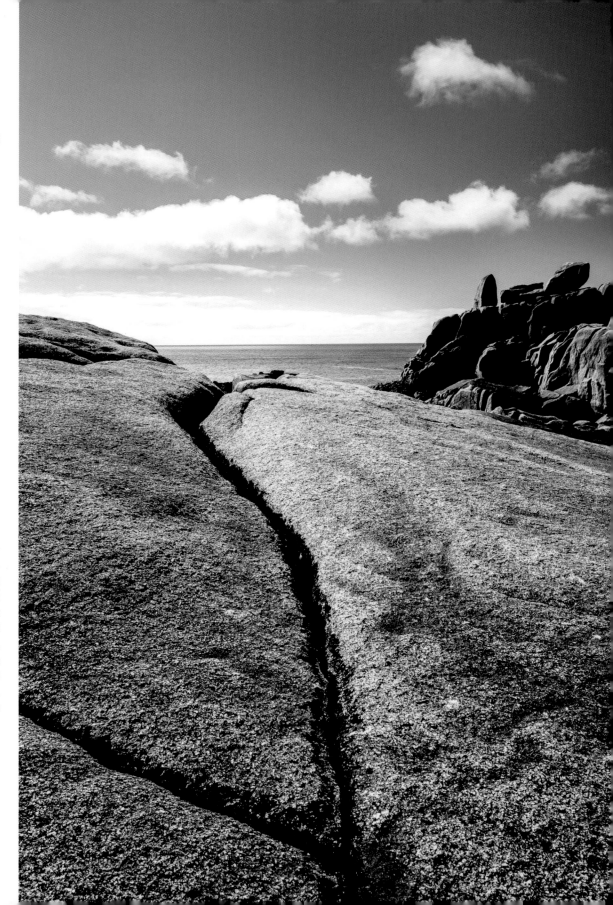

Left: As soon as I saw this scene I knew it could be nothing other than a monochrome image. The bright clouds against the dark sky were the backbone of the composition, with the strong side lighting helping to model the scene and give further depth.

Focal length: 100mm

Aperture: f/8

Shutter speed: 1/500 sec.

ISO: 200

Right: A lot of landscape photographers don't bother taking pictures when the light is harsh. However, black-and-white photography is so well suited to high contrast that it can positively excel in this type of extreme lighting. Here, a 3-stop ND graduated filter was used to reduce the contrast between the sky and the rocks—without it the scene would have exceeded the camera's dynamic range.

Focal length: 24mm

Aperture: f/16

Shutter speed: 1/13 sec.

ISO: 100

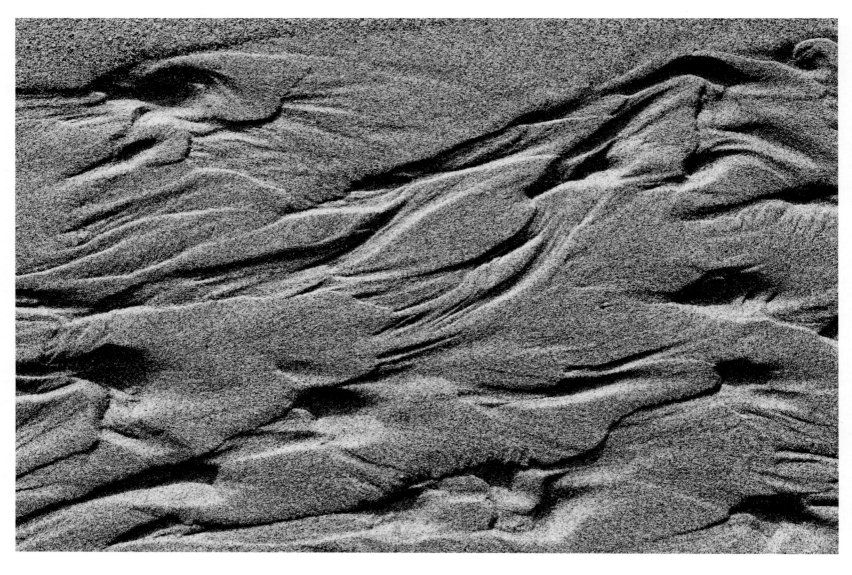

in color—a red ball on green grass, for example— they will not stand out in monochrome if they are the same brightness. Being similar tones of gray means there will be no tonal separation between them, so they will simply blend together. However, as you will come to see later in the chapter, all is not lost; a colored filter can be used to affect how the colors in your scene translate into gray tones.

Without the use of colored filters, you need to rely on the light to create separation; if one area of the frame is illuminated differently to another it will naturally stand out, even if everything in the frame is a similar color. Therefore, understanding and using light is one of the biggest tools at a photographer's disposal. This might mean doing something as simple as moving slightly to one side so the subject is positioned in front of a darker background; all of a sudden it will naturally pop out of the frame, with a degree of tonal separation that makes it well suited to a monochrome treatment.

Although contrast, lighting, and tonal separation all play an important part in the creation of a successful monochrome image, there are also other things to look out for. Repeating shapes and patterns translate well into black and white, while bold lines that create simple, strong compositions can have real impact. There is often no need to overcomplicate things—simplicity works well.

Textures can be hard to see when they are photographed in color, but in black and white these hidden textures can be made to really stand out. They can offer more of an insight into a subject, even though it has been stripped of its color. A rusty chain can take on a whole new look, for example, as can the grain of weathered wood. It makes the viewer think differently, and as a photographer you will start to see the world in a different way as well.

Left: An abstract shot such as this will make the viewer question what they are looking at. All sense of scale is lost and the image becomes a collection of shapes, patterns, and textures. This photograph is a very small section of sand on a beach. Although all the same color, the strong sunlight has created areas of dark shadow that have increased the contrast. The texture of the sand has also been brought out in the monochrome conversion.

Focal length: 40mm

Aperture: f/16

Shutter speed: 1/100 sec.

ISO: 200

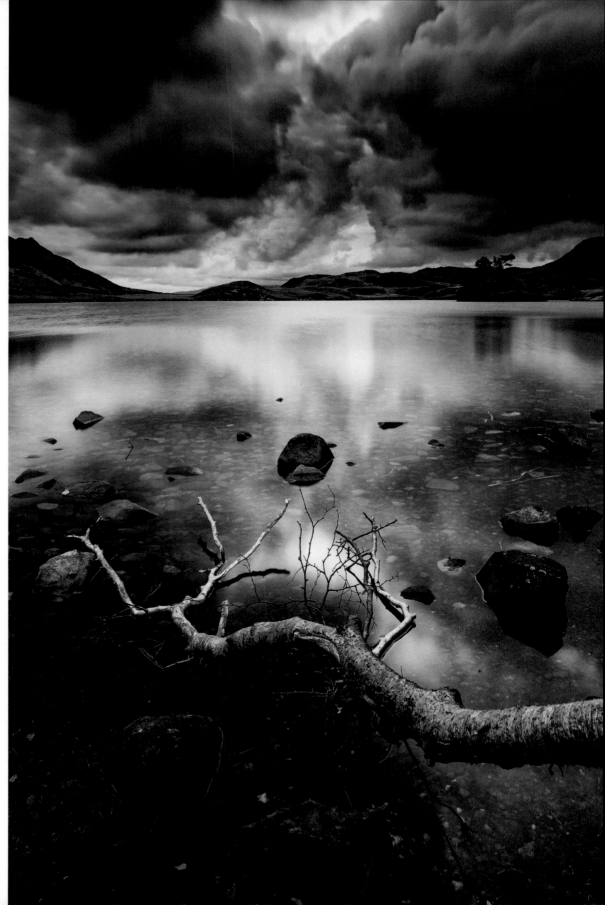

Right: Some scenes are just made to be photographed in black and white; this moody early morning scene was one of them. I remember the feeling of excitement I felt when I saw the image on the back of the camera.

Focal length: 24mm

Aperture: f/16

Shutter speed: 6 sec.

ISO: 100

Raw or JPEG?

Most digital cameras give you the option of recording your images as Raw files, JPEG files, or both simultaneously. But which is the better choice for black-and-white photography?

In the days of film, there were many black-and-white photographers who would take their film to a photo lab for someone else to develop and print, so the photographer's input ended at the moment of exposure. This is roughly parallel to shooting monochrome JPEGs, where the images are processed in-camera. This means JPEGs can be printed directly from the memory card, so you don't have to learn how to use specialist software, or spend time working on your photographs on your computer if you prefer not to. There is also a wide range of effects that can be applied directly to the image as well (the downside is that the effects have to be selected before you take the image).

Conversely, a Raw file records all the raw data from the sensor in color, leaving it up to you to convert it to black and white on your computer. In this way, a Raw file can be thought of as a negative ready for processing in the darkroom: the decisions you make when you take a shot are only the start of the image's journey to fruition.

Even if you select monochrome on your camera and get a black-and-white preview, the color information is still present in a Raw file. This means you can adjust the individual colors during postproduction, which gives you far greater control over the final black-and-white image. It also means you don't need to commit yourself to anything at the point of capture.

Another benefit to shooting Raw is that a Raw file captures more information than a JPEG file. Because of this extra information, it stands up better to being edited, particularly if the exposure needs correcting.

Indeed, the only real downside with a Raw file is that you need specialist software to convert it to a monochrome image and each and every Raw file needs to be processed and converted to a

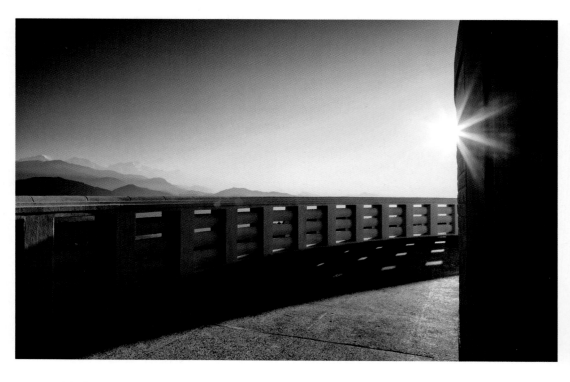

more usable file type (such as TIFF) before you can print it. However, this is a small price to pay—because of its flexibility, increased dynamic range, and the extra information recorded, a Raw file is by far the best format to use for your black-and-white work. Put simply, it offers the greatest versatility in regards to how the image looks, and it will also give you the highest quality print.

Above: Recording as much information as possible is very important, especially when faced with a high-contrast situation such as this. It might take you a little longer to edit Raw images, but that is all part of the creative process.
Focal length: 24mm
Aperture: f/16
Shutter speed: 1/125 sec.
ISO: 100

Colored Filters

Before the advent of digital photography, colored filters were used to change the way colors were recorded on black-and-white film. By lightening colors similar to the filter's color, and darkening others, photographers could control how colors translated into shades of gray. Red filters were commonly used by landscape photographers to darken a blue sky and make the clouds stand out, for example, while portrait photographers favored yellow filters for the way they softened skin tones and gave a more flattering look. As such, colored filters were a vital and powerful tool in the black-and-white photographer's arsenal.

In the digital age, there is little need to use colored filters over the lens. In fact, they can adversely affect the way the camera's sensor records information—with a colored filter over the lens, one color channel can end up overexposed, with the other channels underexposed and noisy.

Instead, the effect of colored filters is better applied digitally, either in-camera (if shooting JPEGs) or during postproduction (for Raw files). If you are shooting JPEGs, then most cameras have the option of applying a yellow, orange, red, or green filter to the image. If you are using live view you can see how the filter affects the image on the preview screen before you take the photograph, otherwise you can review the results on the playback screen after you have taken it.

If you are shooting Raw, then the options available in Raw conversion programs and image-editing software tend to be far more expansive. Not only do you have much greater control over the intensity of the digital filters, but there is likely to be additional color options as well. Indeed, the possibilities offered in the digital darkroom exceed anything that could be achieved traditionally.

FULL COLOR

RED FILTER

GREEN FILTER

BLUE FILTER

YELLOW FILTER

All Images: Colored filters are essential for determining how a color scene translates into a black-and-white photograph. A filter lightens colors that are the same (or similar) color to it, and darkens those that sit opposite it on a standard color wheel.

Focal length: 24mm

Aperture: f/8

Shutter speed: 1/125 sec.

ISO: 100

In-Camera Effects

If you are shooting JPEGs, the in-camera options are not just confined to applying colored filters. You can also alter the way the camera applies contrast, sharpens the image, and even add a sepia, blue, or cyan tint. These are all excellent tools for black-and-white photography and can really help to add punch to an image. You can also apply the effects to a Raw file, although they can be easily undone and/or applied during postproduction.

Adding contrast—darkening the dark tones and brightening the bright tones—can really help to reinforce the drama and mood in an image. This works particularly well with a scene that already has quite high contrast, and is well suited to black and white.

While sharpening might not immediately spring to mind when it comes to applying an in-camera effect, all images need some sharpening before they are printed. If you are printing JPEGs directly from the camera it is something that should definitely be applied when you shoot. However, it's a good idea to take some test shots at different settings and then have them printed at a range of different sizes to gauge the extent of the sharpening you need to apply—over-sharpening can ruin an image.

Toning is a traditional black-and-white darkroom technique, with sepia and cyan tones being the most popular options. Applying a sepia tone gives an image a warm, aged feel, while a cyan tone gives a harsh, cold effect. These tones can be applied to images in-camera or during postproduction, but if you apply them in-camera you can only use one tint at a time (split toning isn't possible). As with all in-camera effects, a JPEG is permanently altered, whereas a Raw file is easily undone and re-edited.

If you have a love of black-and-white photography, but don't want to use a computer, then you will find the in-camera effects provide you with a great deal of flexibility. However, you will need to experiment with the various settings to see what works well (and what doesn't). You will also have to spend more time thinking about how you want the shot to look before you take it, as the effects you apply to a JPEG are largely irreversible.

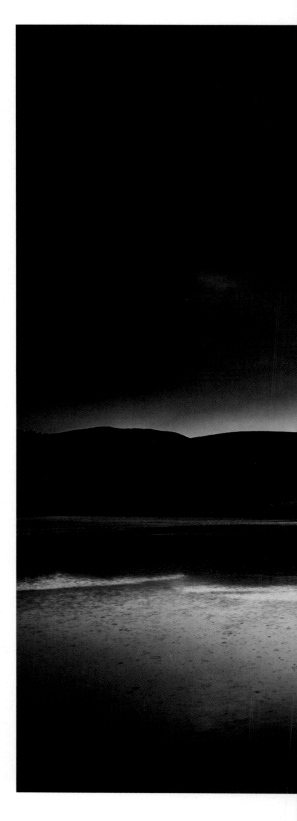

Right: The blue tint added to this image suits the conditions it was taken in: it was very early in the morning, cold, and raining. The cool blue tint reinforces this.

Focal length: 24mm

Aperture: f/8

Shutter speed: 1/6 sec.

ISO: 100

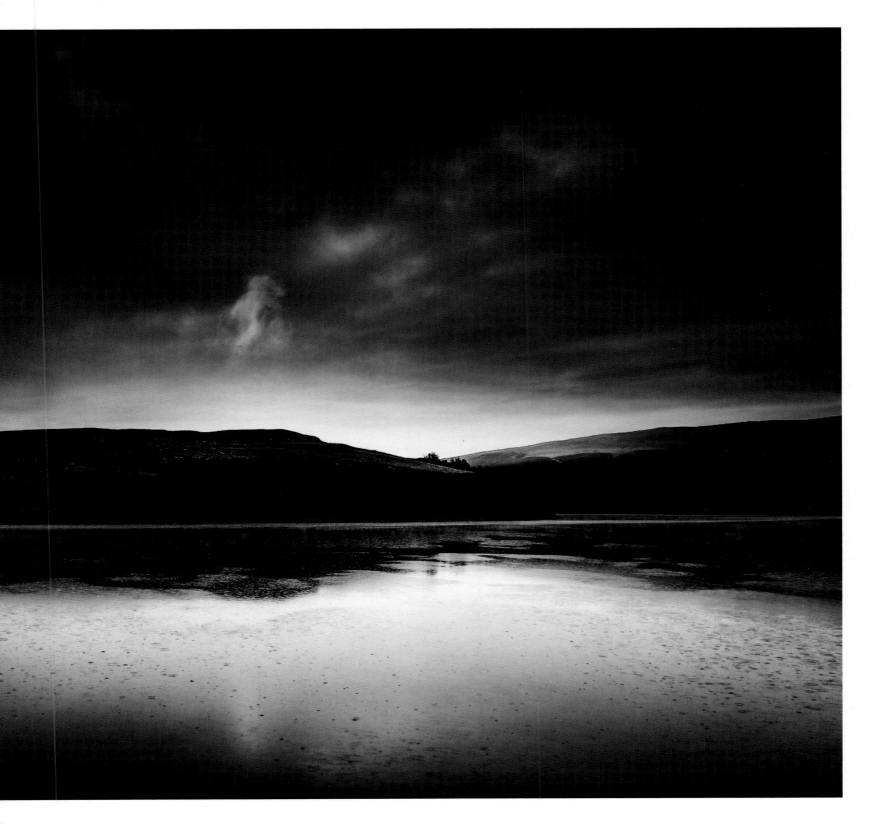

Chapter 3
Light & Exposure

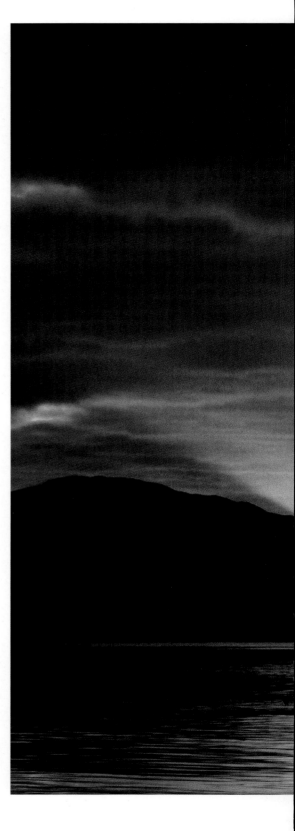

Light is the language of photography, and there is no substitute for good light; it is how you transform the ordinary into the extraordinary, so you should always be looking out for it. However, it could be argued that there is no such thing as "bad light"—it is just a case of finding the right subject to match the light you are faced with.

When we talk about light in this book, we are principally talking about natural light, and when you go to take a photograph you need to ask yourself these questions: What direction is the light coming from? What is its intensity? Is it the best light for the subject? If not, can it be modified? Can you move your subject to light it better? If your subject cannot be moved, can you move around your subject to make best use of the light? For any given subject there will be "perfect" light, but with everything else it is about making the best of the situation.

Right: It might seem strange to consider the color of light in the context of black-and-white photography, but it is still relevant. In fact, color and quality could almost be thought of as the same thing, and this quality translates perfectly into monochrome. For many subjects, the more golden the light, the better its quality.

Focal length: 60mm
Aperture: f/16
Shutter speed: 1/13 sec.
ISO: 100

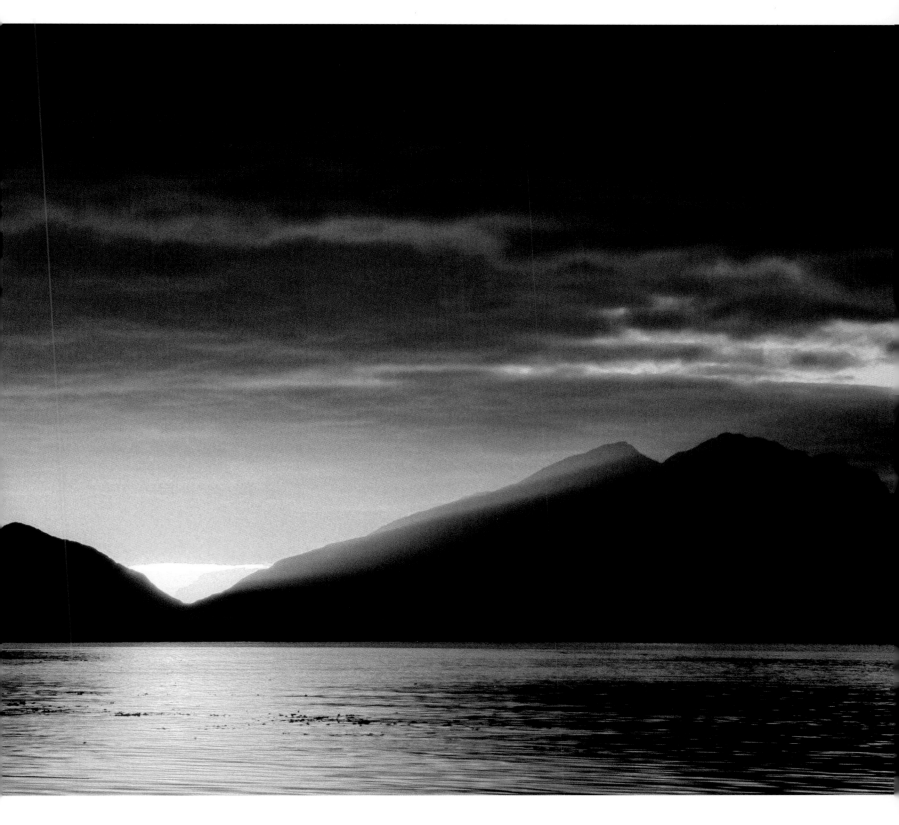

Direction of Light

When describing the direction of light it is always from the perspective of your subject. For example, front light means the subject is lit from the front, so if you were taking someone's portrait and they were front lit, they would be looking straight at the light source.

Front Lighting

When the light source is directly behind you it will illuminate your subject from the front, without creating any shadows. Without shadows it is hard to convey depth in an image, so this is generally considered to be the least useful of light sources. You will also need to be careful that your own shadow does not appear in the photograph.

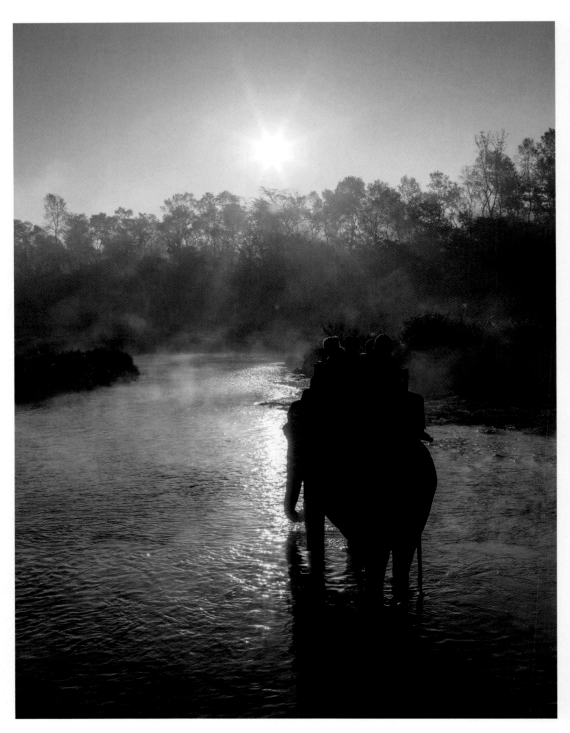

Right: The position of the light source will dictate both the extent of any shadows and the direction in which they will fall. If the sun is in your frame you can create a starburst effect by using a small aperture setting. However, the sun needs to be either low in the sky or partially hidden behind something for this to be effective.

Focal length: 35mm
Aperture: f/11
Shutter speed: 1/640 sec.
ISO: 100

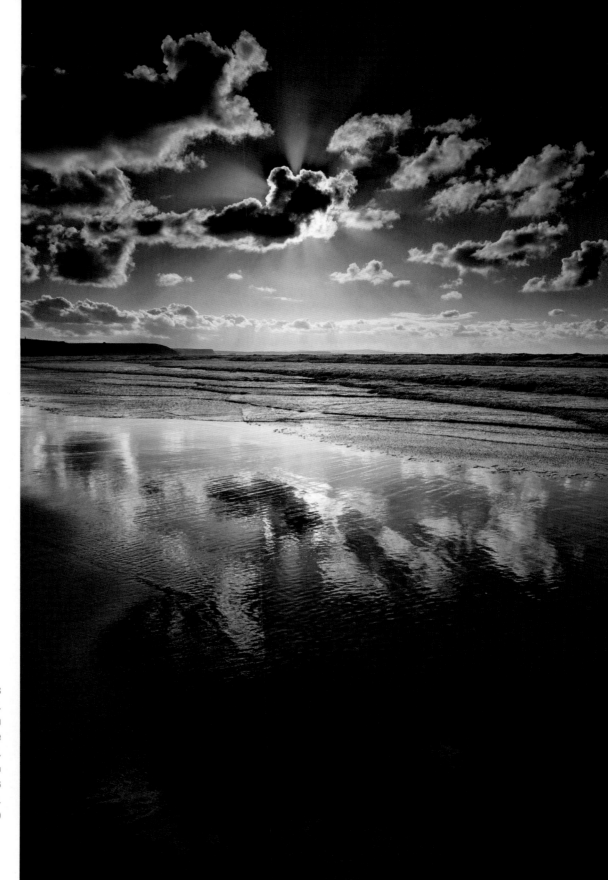

Right: Shadows are an important part of an image, as they reveal texture and help to create a sense of depth. Dark shadows also create mood and tension, and can instil a sense of mystery. By definition, black-and-white photography suggests a need for black, not just dark gray.

Focal length: 21mm

Aperture: f/16

Shutter speed: 1/125 sec.

ISO: 100

Side Lighting

Having the light source at 90-degrees to one side of your subject is one of the most commonly used lighting directions, as it reveals texture and gives photographs a three-dimensional feel. If the shadows created by the side lighting are too harsh, reflecting some of the light back onto the subject can soften them. Of course, this depends on the size of your subject and whether or not it is possible—you are not going to get anyone to volunteer to go and hold a reflector next to a lion to help fill in the shadows for you...

Back Lighting

Also known as "contre-jour" (from the French, "against daylight"), this can be the most difficult light to take photographs in, but it can deliver some very impressive results. The high contrast is particularly well suited to black-and-white photography. With the camera's dynamic range typically being unable to cope with the extremes of contrast that back lighting presents, how you choose to interpret the light will have a big impact on the final look of the photograph.

Left: Here there is a combination of side and back lighting. It is always worth looking out for the sun's reflection and seeing if it can be included as part of the composition. The strong angular shapes and high contrast perfectly suit a monochrome image, as does the subject matter.
Focal length: 50mm
Aperture: f/16
Shutter speed: 1/200 sec.
ISO: 100

Right: Using the camera's spot meter is essential when you are faced with a high-contrast situation like this. By telling the camera where you want the brightest part of the scene to be, everything else will fall into place.
Focal length: 35mm
Aperture: f/8
Shutter speed: 1/100 sec.
ISO: 100

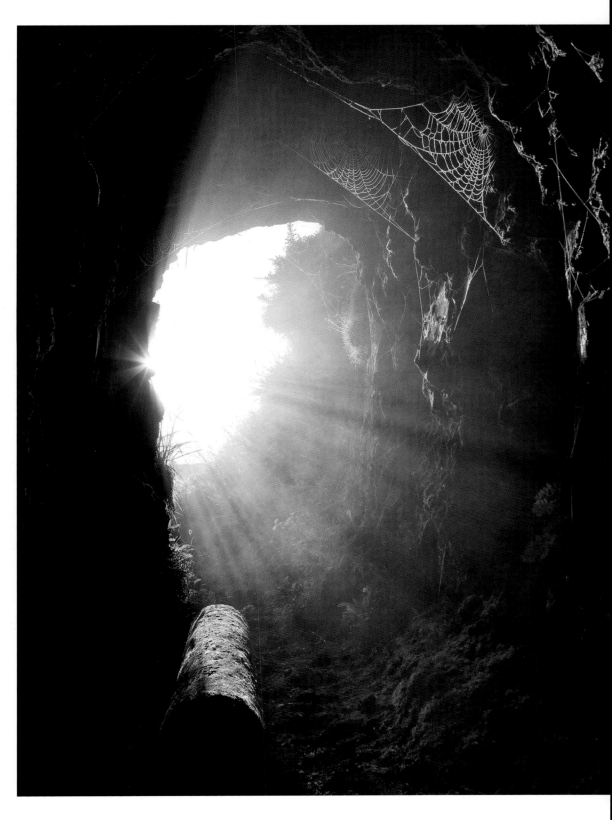

Quality of Light

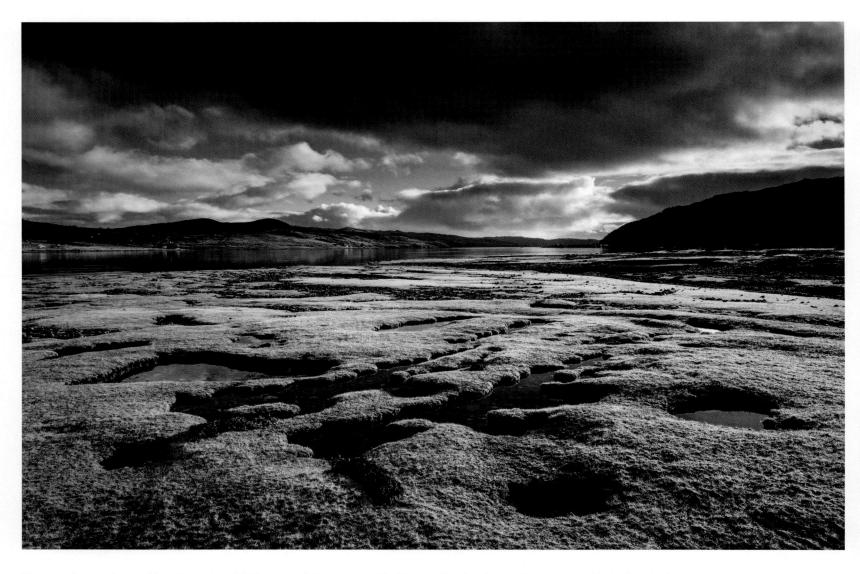

There are two main considerations when thinking about how the light changes during the day. The first is the angle of the sun: the lower the sun is in the sky, the longer the shadows will be, and the better the quality of light. The second is whether or not the light can be manipulated to suit your subject. For example, if you are taking someone's portrait and the light is too harsh, causing them to squint, simply turning them around and having the light source behind them will solve the problem. As long as you take this into account when you calculate your exposure you will have made the best of the situation.

One of the best things about black-and-white photography is that there will be opportunities at any time of day, even in the harsh light of midday. This is arguably truer than it is with color photography, which doesn't let you play with the light in the same way as monochrome. Consequently, photographing the world in black and white means you get to use your camera more, which can only be a good thing!

Left: The "golden hour"—the hour after sunrise and before sunset—is the time of day revered by landscape photographers. This golden light is also identifiable in a black-and-white photograph due to the way the shadows fall. These long shadows help to give the landscape depth.

Focal length: 24mm

Aperture: f/16

Shutter speed: 1/8 sec.

ISO: 100

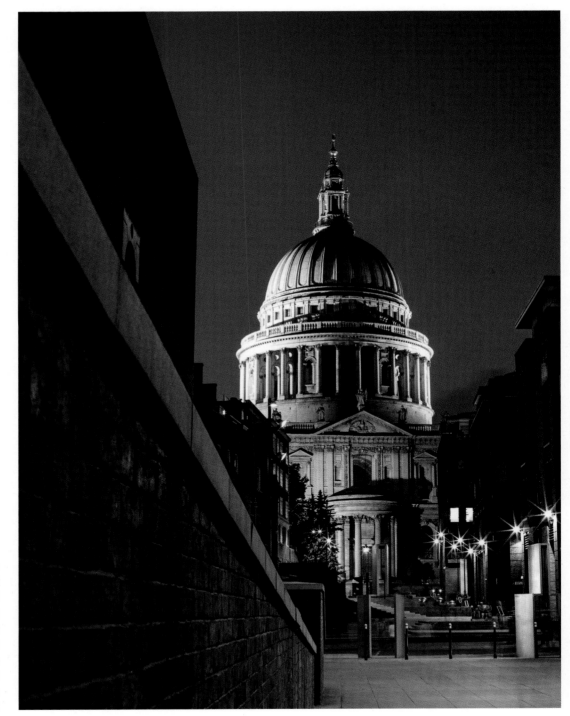

Right: Twilight—otherwise known as the "blue hour"—is the hour after the sun has set, while there is still some light in the sky. This is the favored time of day for architectural photography, as the internal lights of buildings have the same luminance as the sky, allowing the two areas to be balanced easily.

Focal length: 50mm

Aperture: f/16

Shutter speed: 30 sec.

ISO: 100

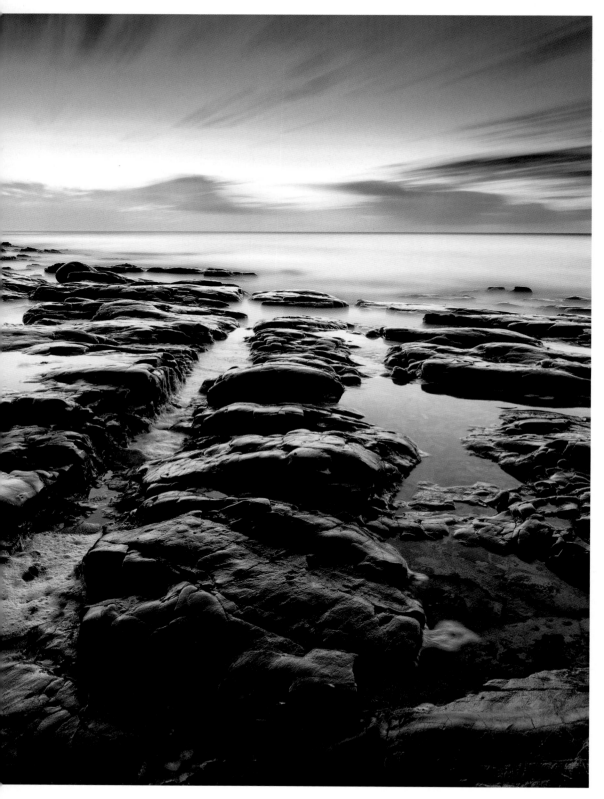

Hard & Soft Light

Regardless of the time of day, the quality of the light is very important. It is not always practical to come back later when the light is better, so you may just have to make do with what you have got. In this situation, the trick is to find subjects suited to the light you have at your disposal.

Hard light adds drama, with dark shadows and bright highlights. With the extremes of contrast being outside the range of the camera's sensor you will need to decide how you want the image to look. As a general guide, deep blacks add mystery, leaving the viewer guessing as to what is there, while burnt-out highlights look like you made a mistake with the exposure. Don't forget, however, that all rules are meant to be broken—portraiture can look very good when it's given a high-key treatment, with plenty of bright highlights.

Soft light can also be excellent to work with. On a cloudy or misty day the clouds act like a giant "softbox," diffusing the sunlight. As a result, there are no harsh shadows and the lighting is even. With these reduced contrast levels everything is typically within the range of the camera's sensor, making it easy to record all of the detail in a scene.

Left: Taken at twilight, this was a 10-minute exposure that captured the last of the day's light. Working on the edge of the light can deliver some spectacular results. Here, a falling tide has left the wet rock to reflect the light, helping to lift the bottom half of the image.

Focal length: 24mm

Aperture: f/16

Shutter speed: 10 min.

ISO: 100

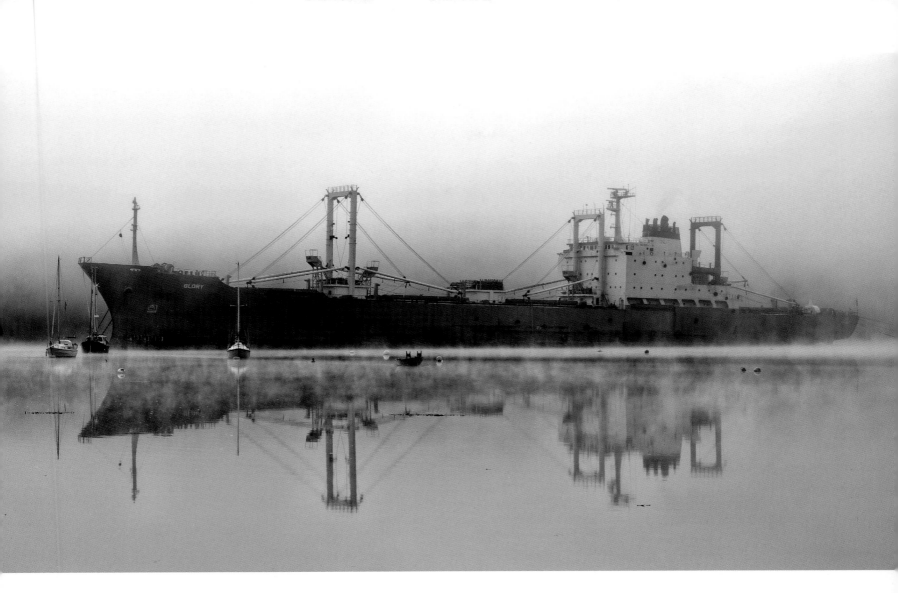

Above: Taken in very soft light on a misty morning, the reduced contrast suits the subject well. Black-and-white photography isn't always about high contrast and drama.

Focal length: 78mm

Aperture: f/22

Shutter speed: 1/8 sec.

ISO: 100

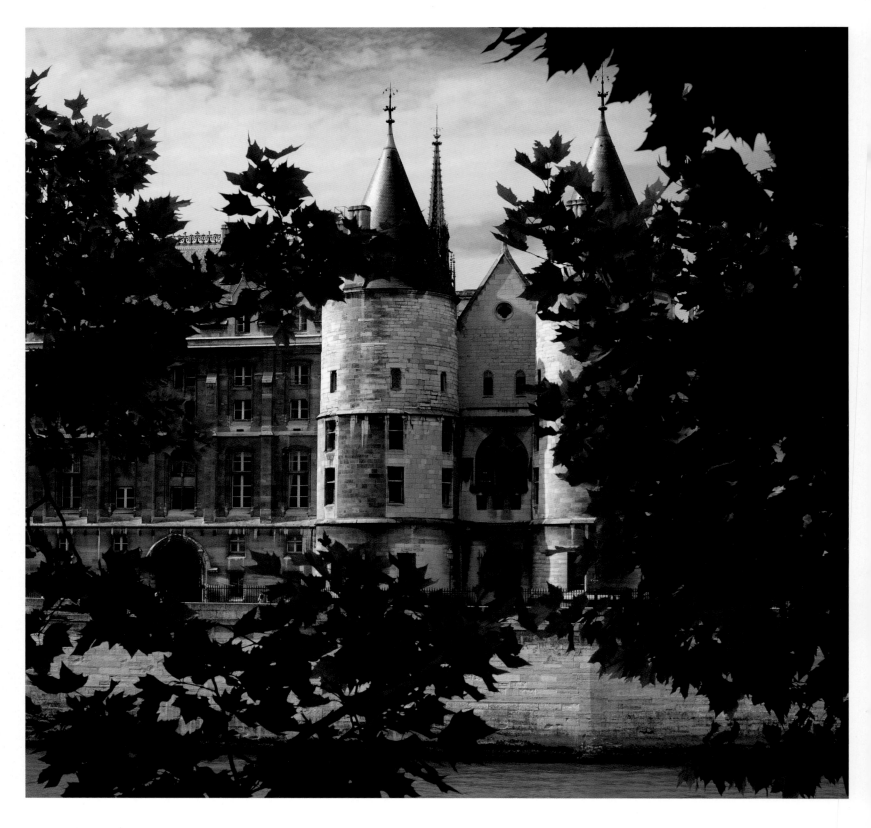

Left: Due to the harsh light I chose to hide most of the building behind the leaves. You will often read about avoiding harsh sunlight, but black-and-white photography provides opportunities at all times of the day.

Focal length: 50mm

Aperture: f/11

Shutter speed: 1/125 sec.

ISO: 100

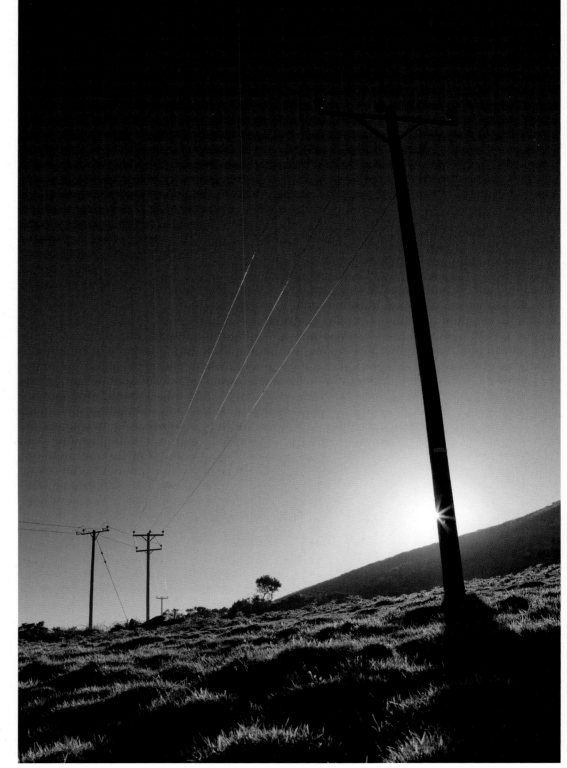

Right: Modern digital cameras are very clever, so why would you want to override the settings the camera chooses in favor of your own? Ask any good professional photographer and they will tell you about working with the light and choosing how they want the image to look. Your camera might be clever, but if you are not deciding on the settings to use, you are essentially just a machine operator.

Focal length: 27mm

Aperture: f/11

Shutter speed: 1/320 sec.

ISO: 100

Above: Shooting manually takes some getting used to, and it can be a frustrating way of working when the light is changing quickly. However, because it forces you to think about the light and how you want the image to look, it is ideally suited to black-and-white photography. Once you are "in the zone" you will never want to do it any other way.

Focal length: 50mm

Aperture: f/5.6

Shutter speed: 1/500 sec.

ISO: 100

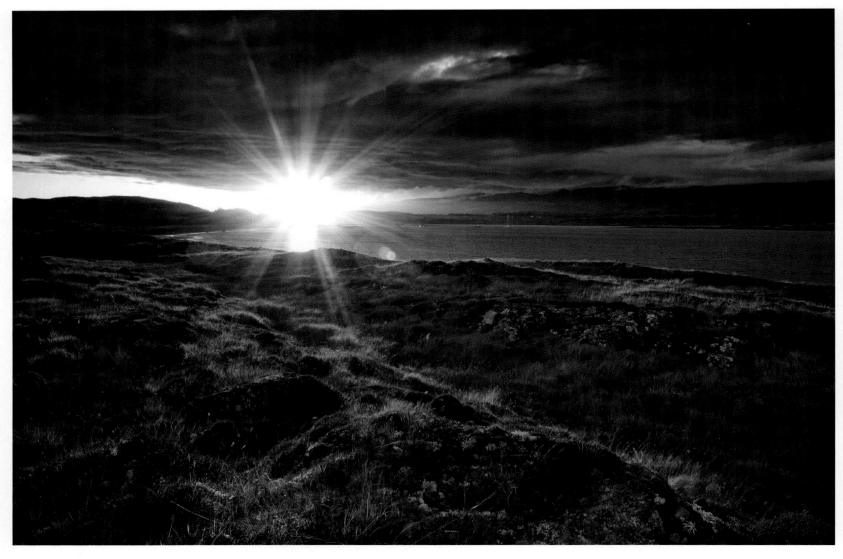

Lens Flare

If you shoot straight into a light source—even without it being directly in the frame—you are in danger of lens flare spoiling the photograph. Sometimes it can add an extra something to a photograph, but most of the time it should be avoided. There is a number of steps you can take to avoid lens flare:

1 Keep your lens clean. Even the smallest dust particles can catch the sun and create additional flare.

2 Use a lens hood or shield the lens to prevent direct light from hitting it, especially if you are using filters. Neither of these techniques works if the sun is in your photograph, but they work well if it is very close to the edge of the frame (not directly in it).

3 Hide the sun almost totally behind an element in the scene.

4 Wait until the sun is very low in the sky.

Left: The sun is not partially hidden behind the cloud here, so the lens flare has become obvious. In this situation, you just have to accept there is nothing you can do to avoid it, and hope it adds to the shot.

Focal length: 21mm

Aperture: f/16

Shutter speed: 1/3 sec.

ISO: 100

Above: The lens flare adds an extra "something" to this image. Ideally, I would have liked the two main carriages to have been clear of the branches, but it wasn't until I was editing the photograph that I noticed this was not the case.

Focal length: 35mm

Aperture: f/16

Shutter speed: 1/100 sec.

ISO: 100

Exposure Essentials

With the extra level of creativity that a black-and-white photograph can offer, it is important to ensure the camera gauges the correct exposure. It really shouldn't be a case of leaving it to the camera to get it right; although very clever, it won't be able to see the potential in a scene and expose the image creatively. So what is the best metering mode to use?

Multi-Area Metering

Known by different manufacturers as evaluative, matrix, multi-segment, and multi-pattern metering, multi-area metering calculates the exposure from the whole image. It does this by dividing the image into lots of segments or zones, analyzing the brightness of each zone, and using sophisticated algorithms to determine the overall exposure.

Above: When shooting manually, you need to be thinking about the light all the time. If you were to walk from a very dark area into bright sunlight, the "Sunny 16" rule will enable you to change the settings on your camera quickly, and without having to take a meter reading.

Focal length: 24mm

Aperture: f/11

Shutter speed: 1/200 sec.

ISO: 100

Speed is the argument typically used when advocating the use of multi-area metering, but you need to be aware that the camera is taking a major part of the creative process away from you when this metering mode is selected.

Center-Weighted Metering

With center-weighted metering, the camera also analyzes the entire scene, but the exposure is biased toward the center of the image. This is useful when you are faced with a backlit subject, but it assumes that your subject will be placed at the center of the frame. Although it can yield better results than multi-area metering, center-weighted metering is still having a say in the creative process, and this inevitably means that sometimes the camera will get the exposure wrong.

Spot Metering

As you will see on pages 68–69, spot metering is the most accurate way of determining your exposures, especially when the lighting is challenging. The camera measures the brightness from a small area (typically just 1–3% of the frame), which is normally at the center of the frame. Some cameras allow you to link the spot meter area to a focus point for greater versatility.

Right: Spot metering gives you the most control in terms of placing the tones and determining how your black-and-white images will look.
Focal length: 35mm
Aperture: f/16
Shutter speed: 1/100 sec.
ISO: 100

Histograms

A histogram is a graphic representation of how the tones have been recorded, with white at the far right side of the graph and black at the far left. The camera's histogram is the most useful and important tool on a digital camera. Forget how the image looks on the back of the screen—what you need to check is how the histogram looks. This will tell you if the image has been properly exposed, by which we mean whether or not you have recorded as much of the raw data as you possibly can.

Exposing to the Right

A camera's sensor records more data in the highlights than it does in the shadows, which means that the information is biased to the right side of the histogram. "Exposing to the right" (ETTR) simply means that you shift your exposure to the right hand side of the histogram to ensure you record as much of this data as possible.

To understand exposing to the right properly, you first need to appreciate how the camera records its information. If you divide the histogram into five equal parts, the far right "block" is where 50% of the information is recorded. The next block

records 50% of the remaining information; the third block records 50% of the remainder, and so on.

Now, let's assume your camera has a dynamic range of 10 stops. This means it can record 10 stops of light, and the sensor will be able to record 10,000 tones from pure white to pure black. An exposure reduction of 1 stop will halve the amount of light reaching the camera's sensor, which halves the number of tones that it can record. Consequently, if you underexpose an image by just one stop you will have lost almost half of all the information that the camera can possibly record. This means the tonal graduation between the brightest and darkest areas will not be as smooth as it could have been and the shadow areas will have unwanted noise in them.

It is for this reason that you should always base your exposure on the histogram, not on how the image looks on the preview screen. If you are looking at a dark, moody image on the preview screen you have more than likely lost at least half of all the information that the camera can record.

Although the Raw file will have captured the maximum amount of data when you expose to the right, it will need some editing. Reducing the exposure is usually enough to "normalize" an image, but remember that black-and-white photography is as much about your personal interpretation of the digital negative, as it is about recording "reality." By capturing the maximum amount of information you will have the greatest flexibility when it comes to editing the image.

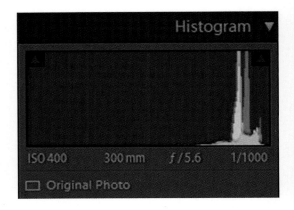

Above, Right Top & Right Bottom: When you expose to the right, the difference between how an image looks on the LCD screen (Right Top) and the edited version (Right Bottom) can be huge. This is why you should always trust the camera's histogram.

Focal length: 300mm

Aperture: f/5.6

Shutter speed: 1/1000 sec.

ISO: 400

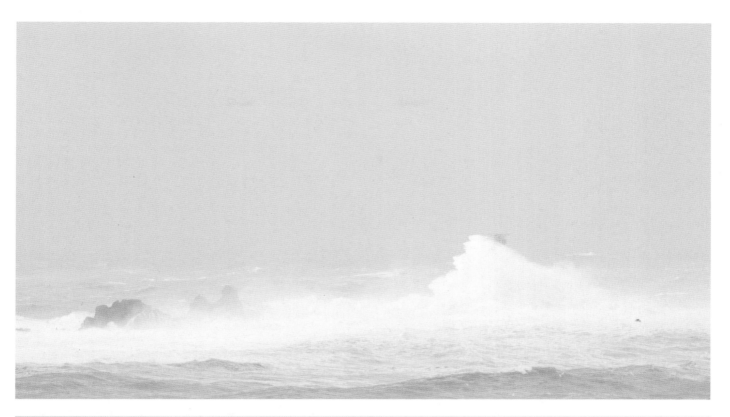

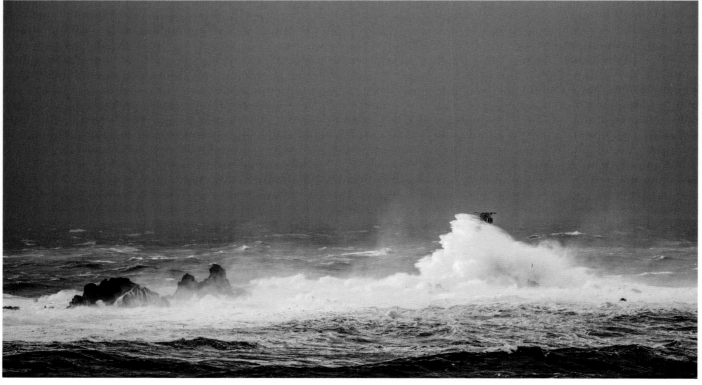

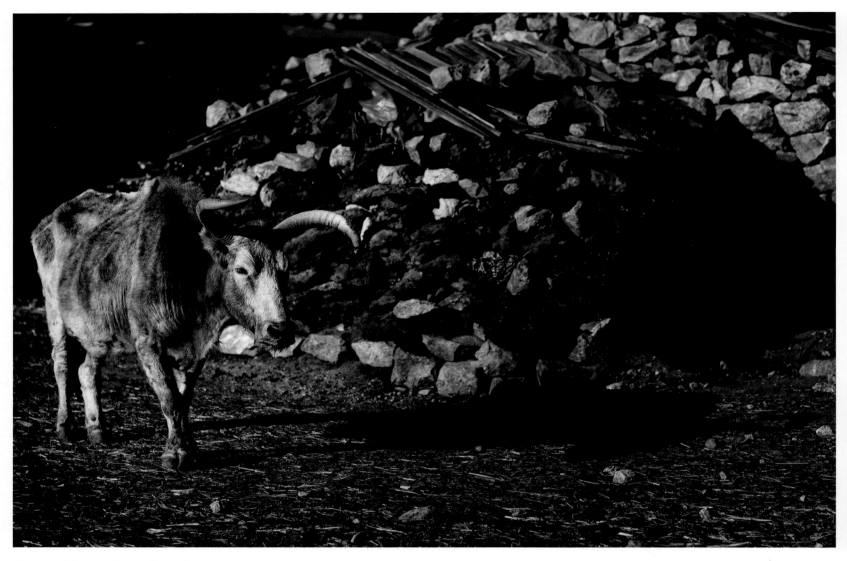

Spot Metering for Accuracy

Most photography books give spot metering a cursory mention, but with black-and-white photography, shooting manually and using your camera's spot meter go hand in hand. Indeed, accurately working out where to place the tones can only be done with a spot meter.

Although this might be daunting initially, it will come as something of a revelation when you realize just how simple it is. The secret is to think both in terms of brightness and how the tones relate to one another.

However, it can be frustrating when you first start using the camera's spot meter, as it takes longer to work out your exposures and you will inevitably make mistakes. Do not be tempted to think "the camera could do better," though, and revert back to multi-area metering and aperture priority or shutter priority. Instead, stick with spot metering and manual mode, and practice—the best way to get good at something is to do it a lot!

In manual mode, the camera's light meter typically shows a range from -2EV to +2EV,

Above: Spot metering forces you to slow down and think about the light. What light is your subject in, and how do you want your image to look? Once you understand how to read the light, you will be able to deal with any situation with difficult lighting.

Focal length: 85mm

Aperture: f/2.8

Shutter speed: 1/1600 sec.

ISO: 100

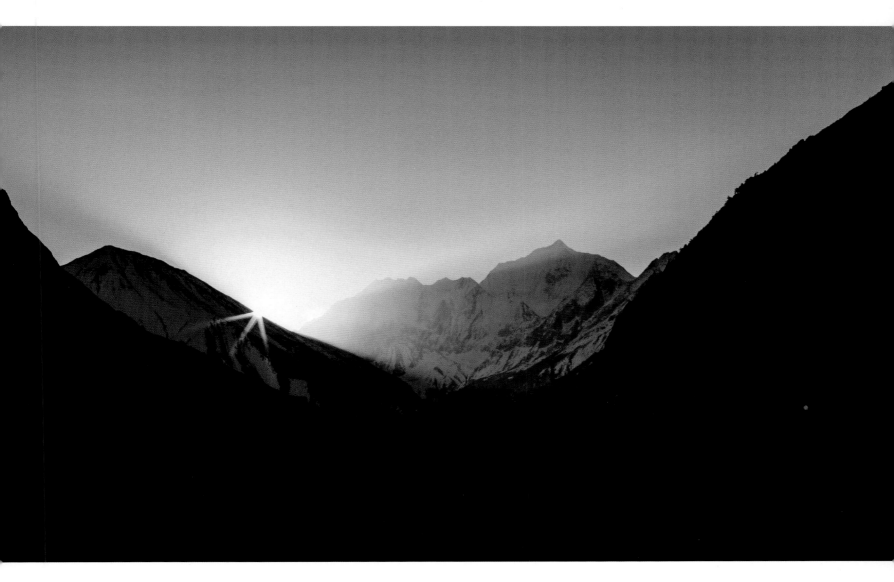

although some cameras can have a range as great as -5EV to +5EV. If you aim the camera's spot meter at something and adjust the aperture and shutter speed until it gives a reading of 0EV, the area you are metering from will be recorded as a midtone. The technical explanation of a midtone is something that has 18% reflectance, but the user-friendly explanation is it is something that is neither bright nor dark.

Now, if you aim the camera's spot meter at the same place and adjust the exposure until the light meter gives a reading of +2EV, this area will be recorded as a bright, near-white tone, although it

will still show some detail. Therefore, you can think of +2EV as "white with detail," or the brightest tone that your camera can record while still showing some detail.

It follows that if you aim the camera's spot meter at something white and set the exposure to +2EV, the camera will record it as it appears—as white. If you adjust the exposure to get a meter reading of 0EV it will be recorded as a midtone, and if the exposure is -2EV it will be very dark.

Above: Your camera would probably do a pretty good job with the exposure in most situations, but when the lighting is challenging it will often get it wrong—and those moments can be some of the most photogenic. It was easy to see where the brightest part of this scene was, so that was where the spot meter reading was taken from. The exposure was then adjusted to get a reading of +2EV, ensuring detail was recorded in the highlight area.

Focal length: 50mm

Aperture: f/11

Shutter speed: 1/400 sec.

ISO: 100

The Zone System

The Zone System was developed and made famous by the legendary landscape photographer, Ansel Adams. The system divides the tones from pure black to pure white into 11 distinct zones, each of which is assigned a Roman numeral (see right). Each zone is twice as bright as the previous zone, and this increase in brightness is the equivalent of letting in one full stop of light.

Although the Zone System was developed for film, it is still relevant in the digital age, as it encourages you to think where you want the tones to be placed and how the image is going to look. Most photography books talk about looking for a midtone to take a meter reading from, because it is what the camera's light meter is calibrated to, but the Zone System shows there are far more choices—just because something is a midtone, that doesn't mean it has to be recorded as one.

THE ZONES	
Zone 0	Absolute black with no detail present. The absence of light.
Zone I	Black with no texture.
Zone II	Very dark, but showing some texture.
Zone III	Heavy shadows showing detail. Camera spot meter reading of -2EV.
Zone IV	Shadows with full detail. Camera spot meter reading of -1EV.
Zone V	Midtone/18% gray. Neither dark nor light. Camera spot meter reading of 0EV.
Zone VI	Pale gray showing full texture. Camera spot meter reading of +1EV.
Zone VII	Brightest tone where detail is still obvious. White with texture. Camera spot meter reading of +2EV.
Zone VIII	Brightest tone where some detail can be recovered if recording Raw files.
Zone IX	Bright white.
Zone X	Specular highlights, pure white.

The Useful Zones

Although it is possible to map out all the tones from black to white and then assign them into distinct zones, there are three zones that are considered the most useful:

Zone VII

As this is the brightest tone where detail is still present, this is where you tell the camera to start recording information; all the darker tones will fall into place. Place the camera's spot meter over the tone you want to place in Zone VII—this should be the brightest part of the scene—and adjust the exposure until you get a reading of +2EV. If you are shooting Raw you can recover brighter tones up to Zone VIII.

Zone VI

This is correctly exposed Caucasian skin, so is a useful reference point when taking portraits of an appropriate subject. Place the camera's spot meter over the subject's face and adjust the shutter speed until you get a reading of +1EV.

Zone V

The perfect midtone; neither bright nor dark. This is always a useful reference point. With the camera's sensor recording more data in the highlights than the shadows, this further reinforces the importance of Zones V, VI, and VII, as this is where the majority of the information is located.

Right: In a high-contrast scene such as this there will be more than 10 stops of light between the brightest and the darkest tones. How the image looks is down to how you decide to interpret the light and where you place the tones.

Focal length: 85mm
Aperture: f/11
Shutter speed: 1/400 sec.
ISO: 100

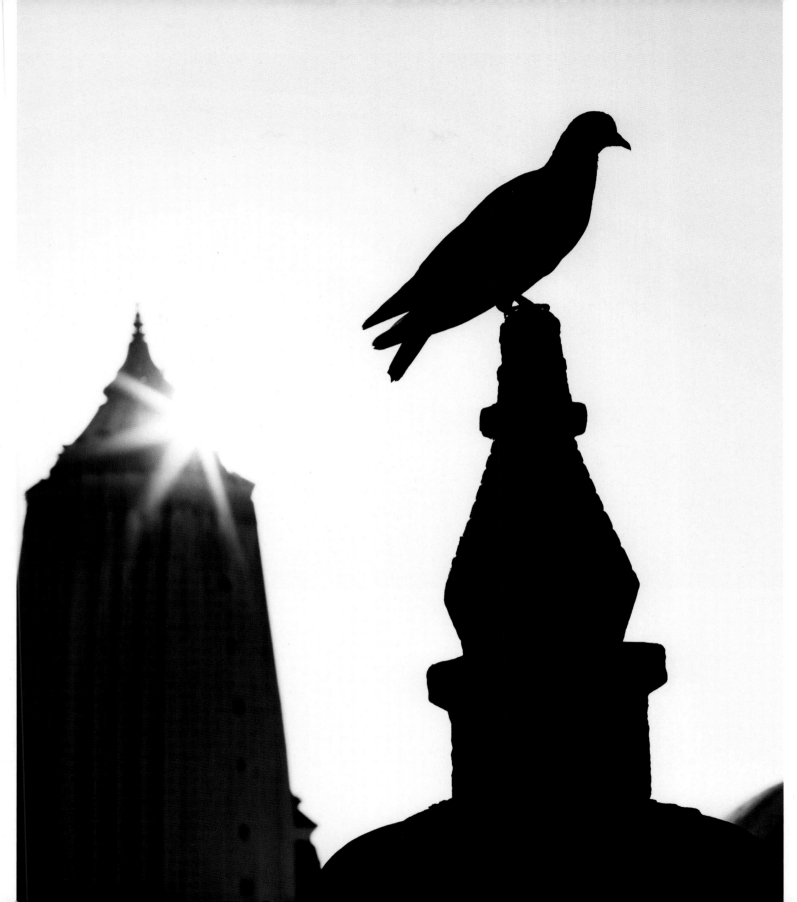

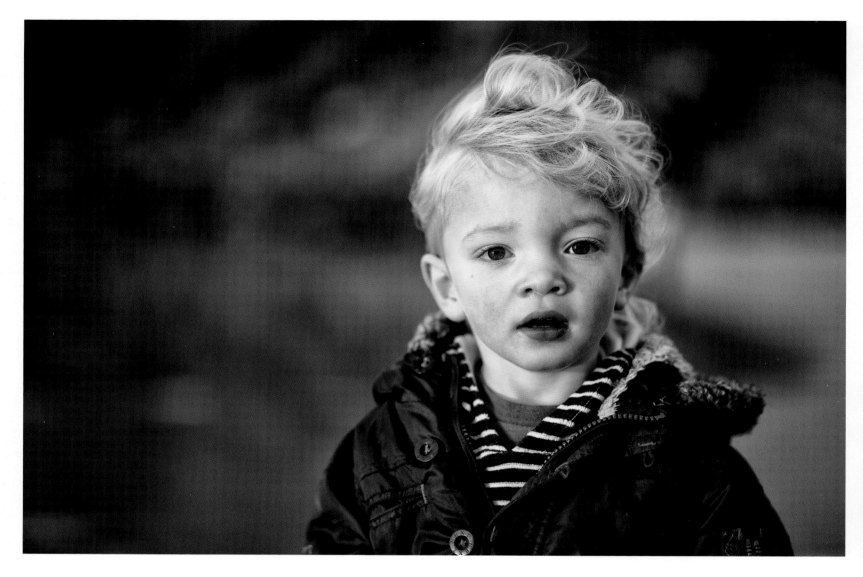

Above: Having a point of reference when it comes to working out the exposure means you can quickly see how the rest of the image will look. This is particularly important with monochrome photography because you can see how the tones will be placed throughout the image. Correctly exposed Caucasian skin gives a reading of +1EV, so for this photograph I simply had to set the exposure so my light meter gave this reading.

Focal length: 85mm

Aperture: f/2

Shutter speed: 1/200 sec.

ISO: 100

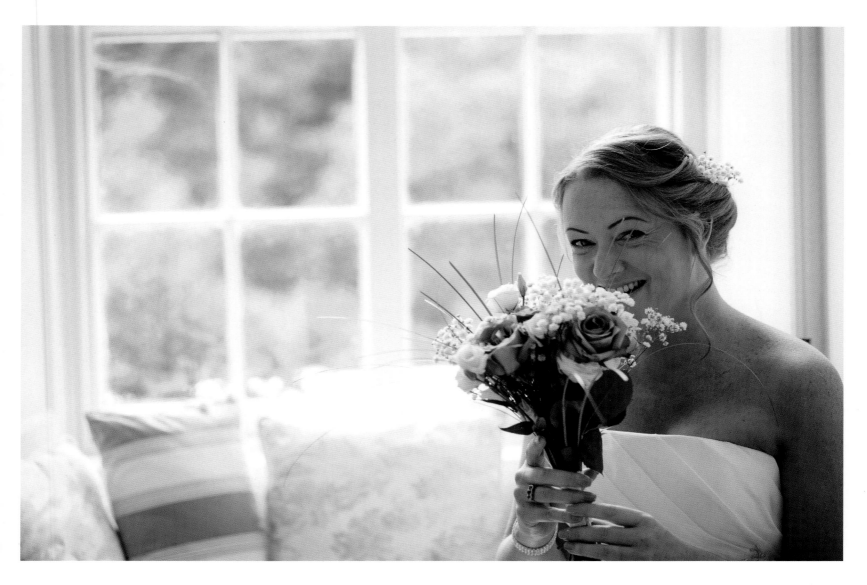

Above: For this image, it was important that the bride was correctly exposed. I metered off the white dress and adjusted the shutter speed to give a reading of approximately +2EV. The much brighter background gives a high-key feel to the shot.

Focal length: 50mm

Aperture: f/2.8

Shutter speed: 1/125 sec.

ISO: 800

High Key

A high-key photograph is one where the majority of the image is made up of bright tones, with very few dark or midtone areas. Because of these white areas, a high-key image naturally suits a black-and-white treatment, although the bright or happy mood it creates is unusual for a monochrome image, where the emphasis is often on creating moody pictures.

Generally, all of the tones in a high-key image are shifted: shadows become midtones, midtones become highlights, and highlights become white and lose all their detail. Although it is perfectly acceptable to have some dark tones in a high-key image, they should be kept to a minimum so as not to become distracting.

The internet is awash with tutorials on how to create high-key images using editing software, but it is preferable to do it in-camera. This relies on having a suitably bright background that is ideally much brighter than your subject. Having chosen your background you then need to decide how you want your subject to look. To do this, set a suitable aperture, place your spot meter over your subject, and adjust the shutter speed to give the appropriate meter reading. With a meter reading of 0EV being a midtone and +2EV being white with detail, you would typically want a reading of +1 to +1.5EV for your subject. You should then check the brightness of the background with the camera's spot meter—hopefully it will give a reading of +3EV or greater, which means no detail will be recorded (it will register as pure white).

The opportunities for creating a good high-key image do not present themselves very often, but when they do, the results can be very effective. As always, using your camera's spot meter will quickly tell you how the image is going to look. When faced with the ideal situation for creating a high key image, you will also have the option of creating a silhouette, as outlined on pages 76–77, allowing you to quickly produce two very different looks.

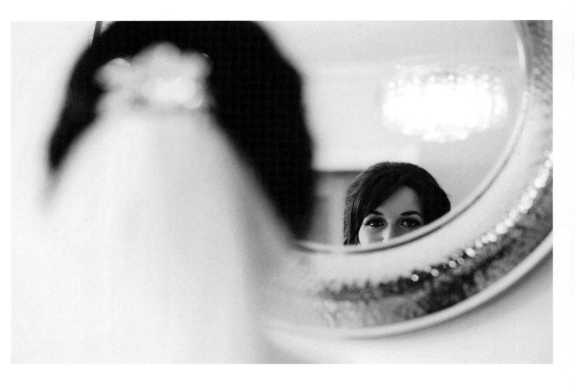

Above: Although there are some shadow areas in this image, it is predominantly made up of whites and midtones. The subject's face was in shadow and the rest of the room was illuminated by strong sunlight, so to expose correctly for her skin I took a meter reading from it and adjusted the exposure to get a reading of +1EV. Because the background was considerably brighter, it was out of the range of the camera's sensor, so very little detail was recorded in it.

Focal length: 85mm

Aperture: f/2.8

Shutter speed: 1/250 sec.

ISO: 400

Low Key

The opposite of a high-key image is a low-key image, which relies on deep, dark shadow areas behind a partially illuminated subject. This is the ideal scenario for a black-and-white photograph, and you could even go as far as saying it should *only* be a monochrome image. With the predominant tones being pure black and only a small section of the image being made up of bright tones, your subject will naturally stand out.

Unlike high-key images, a low-key image will typically be high in contrast. However, it is not simply a case of reducing the exposure to make an ordinary image a lot darker—the contrast between the bright and the dark areas should be significant, ideally exceeding the camera's dynamic range. The most dramatic low-key photographs are those that have no detail in the background at all, which adds drama and mystery to the image.

The secret to creating a successful low-key image is the positioning and lighting of your subject. Side lighting works best, positioned in such a way so that it doesn't illuminate all of your subject and none of the background. Back lighting can also deliver some impressive results and both are easy to create at home in a darkened room with a black backdrop and a separate light source.

As a low-key image relies on lots of dark shadow areas, you need to be careful where you place the tones. Identifying the brightest part of the scene should be easy; you then simply aim the camera's spot meter at it, and having chosen your aperture, adjust the shutter speed to give a meter reading of +2EV. A quick check of the shadow areas with the spot meter should hopefully confirm they will be recorded as dark areas—a meter reading of -2EV or more is ideal. If there is still some detail in the shadows this can be removed during postproduction by making the dark tones darker when you convert the Raw file.

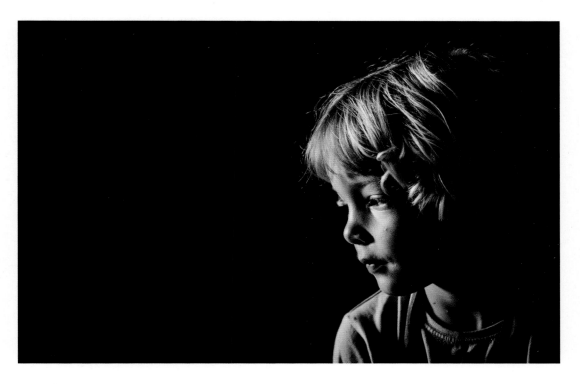

Above: This was taken in a very dark room that had a small area of directional light, so a low-key black-and-white image was the obvious choice. In this instance there was still some detail showing in the shadow areas, but this was removed easily during postproduction to produce a pure black background.

Focal length: 85mm

Aperture: f/2.8

Shutter speed: 1/125 sec.

ISO: 3200

Silhouettes

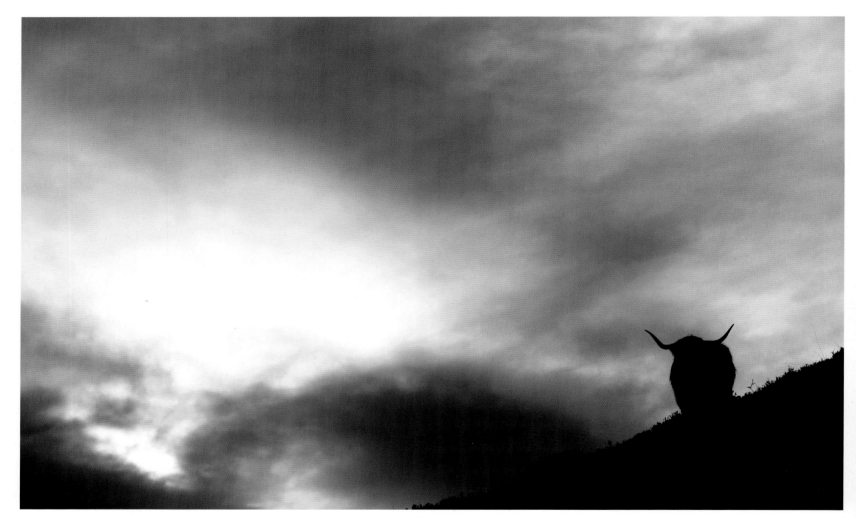

With its pure black focal point, a silhouette makes an excellent monochrome image. Although the area you want the viewer to concentrate on is immediately obvious, the lack of tones, textures, and detail creates a sense of mystery and intrigue. Strong, bold shapes are a good choice for a silhouette, but it doesn't matter if the subject is not immediately obvious. However, it should still be interesting enough to look good, as well as being sharp and well framed, and not interfering with other parts of the image.

As with a high-key image, creating a good silhouette requires a background that is brighter than the subject—the brighter the background, the easier it is to make a silhouette. Because of the high contrast between the bright background and your subject, the dynamic range will be greater than the camera can record, which is why your subject will come out black.

Having chosen your aperture, aim the camera's spot meter at the highlights and adjust the shutter speed to give a meter reading of +1.5EV. In

doing so, you are telling the camera to record the highlights as bright tones with lots of detail present. Take a meter reading from the area you want to be in silhouette—ideally you want a reading of -2EV or less.

If there is still detail present in your subject, the best option is to darken the dark tones during postproduction. This ensures that the highlights remain bright—as a silhouette relies on a bright background, it is better to keep it that way, rather than reducing the exposure.

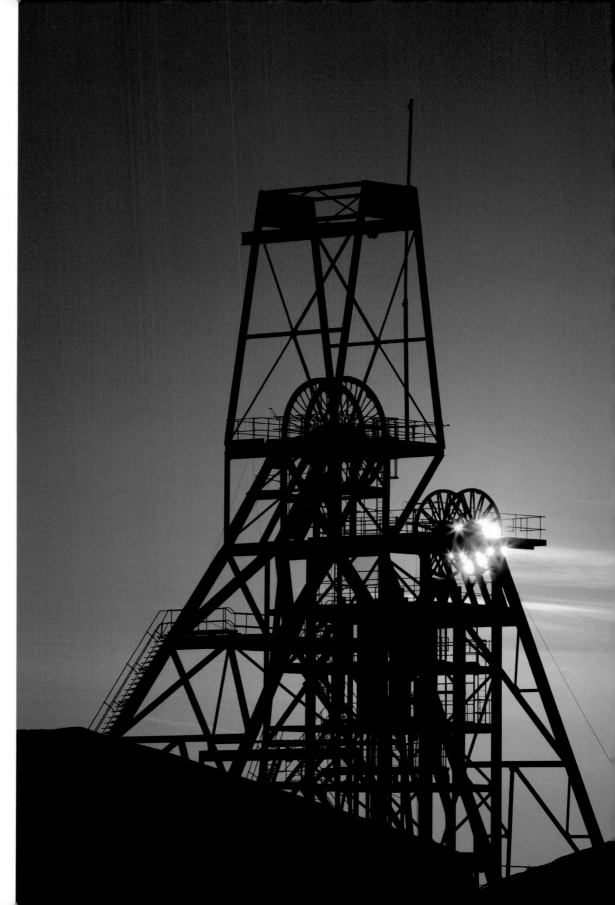

Left: When faced with this scene I had several options: expose the Highland cow and the mountainside correctly (and have a burnt out, featureless sky); expose the sky correctly (and end up with a silhouetted cow); or go for a combination of the two by producing an HDR image. Because of the dramatic sky I opted for a silhouette, positioning my small subject at the bottom corner of the frame to keep featureless areas to a minimum.

Focal length: 90mm

Aperture: f/5.6

Shutter speed: 1/1000 sec.

ISO: 100

Right: A silhouette is an obvious choice at sunset, but if you have the sun in shot you need to be careful to avoid lens flare. For this reason, it can be better to exclude the sun. In this instance, I positioned myself so the sun was partially hidden behind the building—this prevented lens flare and added an extra element to the composition.

Focal length: 235mm

Aperture: f/16

Shutter speed: 1/800 sec.

ISO: 100

Chapter 4
Composition

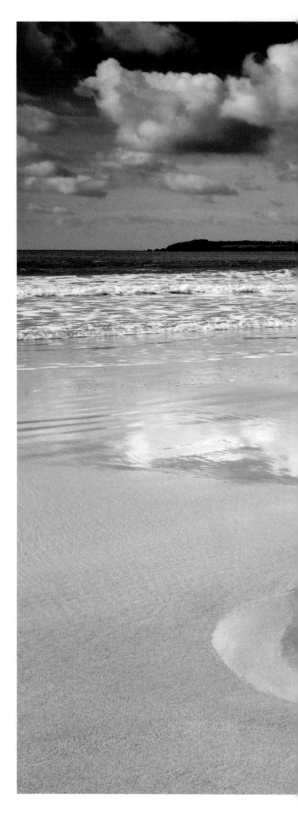

Unlike camera technique, the art of composition cannot be learned by following a series of step-by-step instructions. It is a personal choice, and when faced with the same subject, two people will invariably photograph it differently. How you see the world and choose to interpret it is purely down to your creative vision.

However, learning the established "rules" of composition will enable you to use them as guidelines (when appropriate), to help transform your images. Immerse yourself in the work of good photographers and painters and analyze what makes an image look good. See if it has followed any of the rules of composition and if it hasn't, work out why it still works. With practice you will instinctively start to see strong compositions, your eye will mature, and your photographs will improve.

Right: A well-composed image looks natural. In this coastal scene everything has its place and nothing is dominating the photograph.

Focal length: 32mm
Aperture: f/22
Shutter speed: 1/10 sec.
ISO: 100

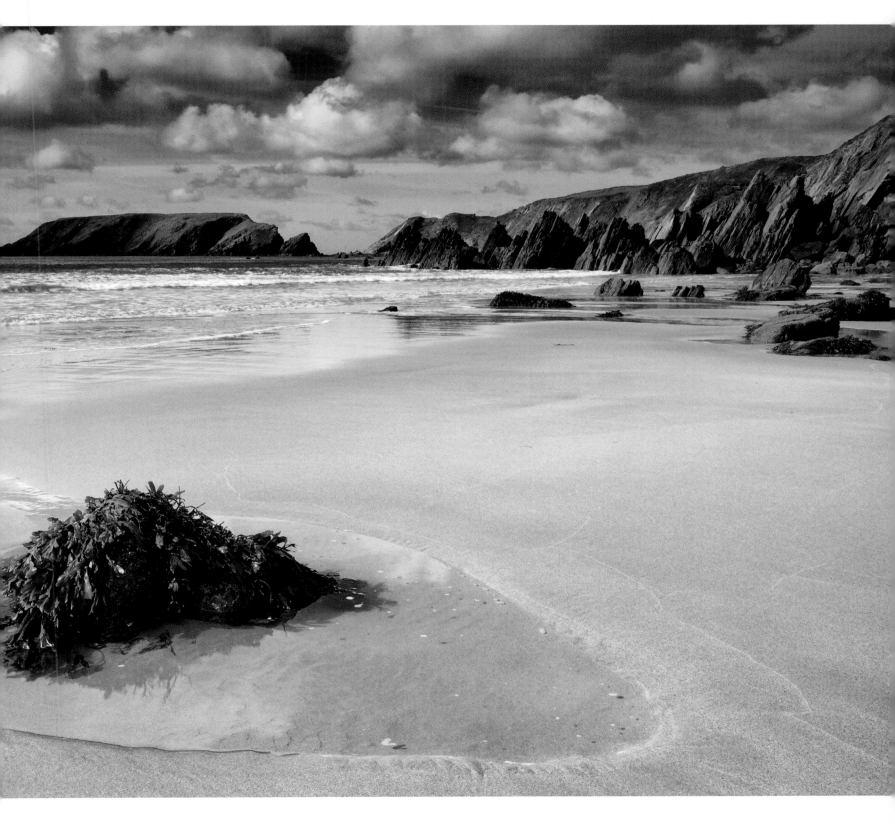

The Rule of Thirds

When it comes to compositional rules, the number three frequently crops up, and the most commonly quoted (and understood) rule is the rule of thirds.

The rule of thirds states that you should place imaginary lines on an image to divide it into thirds, both vertically and horizontally (see right). Placing key parts of the scene along these lines and/or positioning your main subject or a point of interest where the thirds-lines intersect will naturally create

Above & Right: Placing your subject at one side of the frame helps create flow in an image. If the subject is at the center of the frame there is nowhere for the eye to travel to and the image won't hold the viewer's attention for as long.

Focal length: 90mm

Aperture: f/16

Shutter speed: 1 sec.

ISO: 100

a more "dynamic" image than placing those elements at the center of the frame.

Many cameras have a grid based on the rule of thirds that can be superimposed over the image when you look through the viewfinder. However, although this is a useful aid, if you always place your subject on an intersection of thirds there's a danger that all of your photographs will start to look compositionally similar. A better approach to framing your subject would be to place the point of interest off center. It doesn't have to be on a third—just avoid the "bull's eye" shot with your subject placed centrally in the frame.

It is widely thought that because we read from left to right in western culture, placing your subject on the bottom left intersection point is compositionally stronger than placing it on the bottom right third. This is because of the way in which we naturally want to "read" an image (from left to right, as we read text). While this has an element of truth to it, it also depends on the subject and how it is interacting with the rest of the content of the frame. If you position your subject so it is entering the frame, it really doesn't matter which side you position it, as long as it has space to move into.

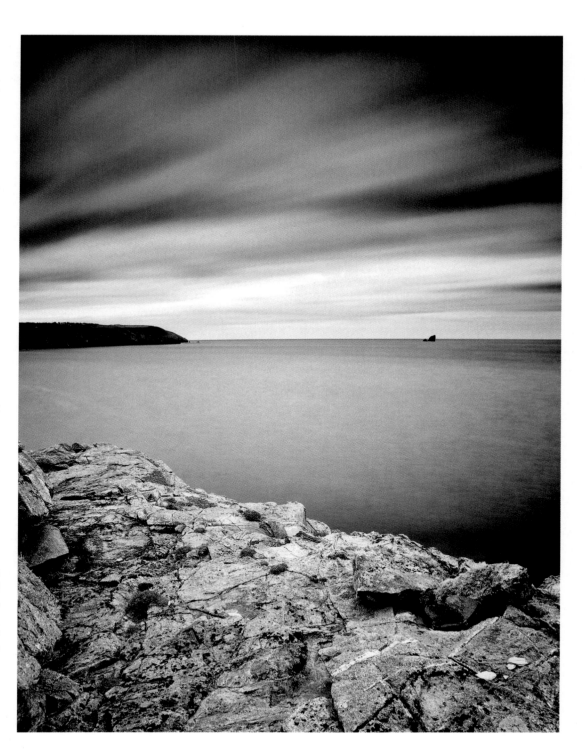

Right: There will be occasions when breaking the rules works, so follow your instincts. If something looks good (even though the rules might suggest otherwise), then go with it. I tried several times to frame this image differently, convinced that a 50/50 split between the sea and sky should be avoided, but in the end it was the best choice for this scene.

Focal length: 19mm

Aperture: f/11

Shutter speed: 150 sec.

ISO: 100

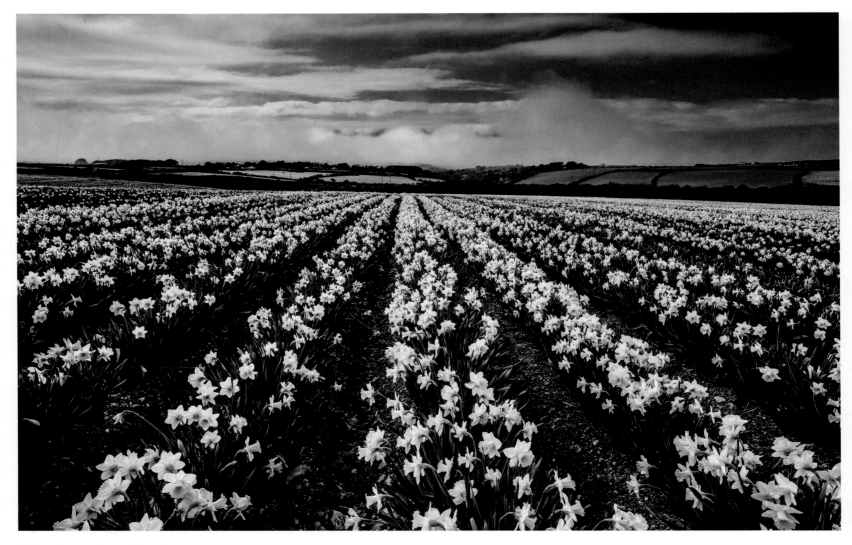

Placing the Horizon

A classic use of the rule of thirds is placing the horizon in a landscape (or seascape) photograph. Placing the horizon on one of the horizontal thirds lines makes for a far more pleasing composition than placing it at the middle of the frame; it creates a natural balance that just looks good.

If the photograph is all about what's in the foreground, you can devote two thirds of the image to that area, leaving the remaining third for the sky. The viewer is left in no doubt as to what you want them to concentrate on. Conversely, if the sky is more interesting than the foreground, you can switch the bias to make that part of the scene more prominent.

However, don't feel that you have to stick to composing images with the horizon placed exactly on one of the thirds lines—there will always be exceptions to the rule. If you are faced with a dramatic sky, for example, you might want to devote nearly all of the image to it, leaving just a thin sliver of land to provide a reference point. A 50/50 split between the land and the sky should usually be avoided, though, as the eye cannot "read" which part of the frame is more important.

Above: Always consider what drew you to a scene in the first place, and if appropriate, give it greater dominance in the frame. In this image it was the deep yellows, greens, and blues that made a monochrome conversion seem appropriate. The colors were enhanced by using a polarizing filter and then manipulated during the black-and-white conversion. Being able to adjust a specific color so easily is one of the wonders of black-and-white digital photography.

Focal length: 24mm

Aperture: f/16

Shutter speed: 1/20 sec.

ISO: 100

The Rule of Odds

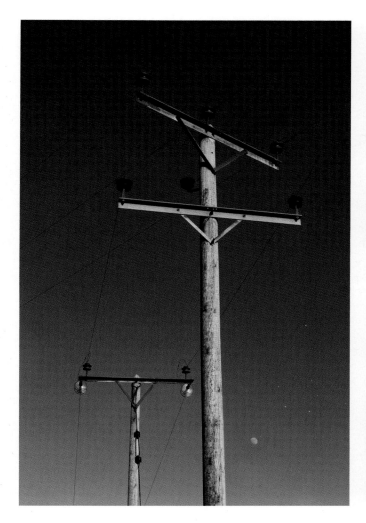

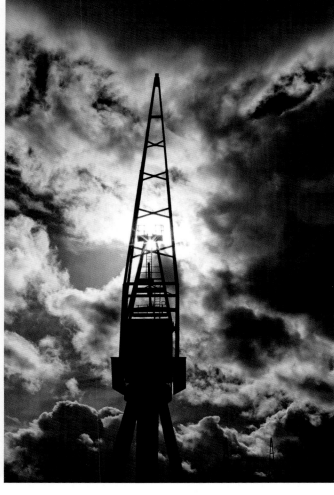

It is widely considered that odd numbers of objects in the frame are more visually satisfying than even numbers—three points of interest in a picture will, more often than not, look better than two, for example. The randomness associated with odd numbers can create mystery and hold the viewer's attention for longer, while having even numbers in an image creates an organized, symmetrical feel that can appear staged. Think of two people choosing between three objects—the variables are far greater than having two people choosing between two objects.

Above Left: Cover up the moon in the picture and see the difference it makes to the image. It is this third point of interest that finalizes the composition. Although a tiny part of the scene, it makes the photograph a lot stronger and the image would be incomplete without it.

Focal length: 43mm

Aperture: f/14

Shutter speed: 1/160 sec.

ISO: 200

Above: Without the tops of the two small cranes at the bottom right of the image, the main crane with its starburst could arguably only be positioned centrally. The additional cranes suggest more is going on outside of the frame—at first glance you don't see them, but once you do they become an important part of the composition.

Focal length: 50mm

Aperture: f/16

Shutter speed: 1/000 sec.

ISO: 100

The Golden Ratio

The golden ratio is a very old compositional rule. Although similar to the rule of thirds, its complexity (and often long-winded and overly complicated explanation) means that it is not something you will come across as frequently.

The basis of the rule is a mathematical formula that can be written as follows:

$a/b = a + (a/b) = 1.618$

What this means is that a line divided into two parts will adhere to the golden ratio if the ratio of the small part to the big part is the same as the ratio of the big part to both parts combined.

In real terms, this means that instead of dividing the frame into equal thirds (as you would if you were to apply the rule of thirds), you would divide the frame using an approximate 60/40 split. As with the rule of thirds, the point where the lines intersect is where you place either your subject or a point of interest.

Using the golden ratio is generally considered to be preferable to the rule of thirds because it is not as predictable, but the important thing to remember is that both are just guidelines—sometimes an image works precisely because it has broken the rules.

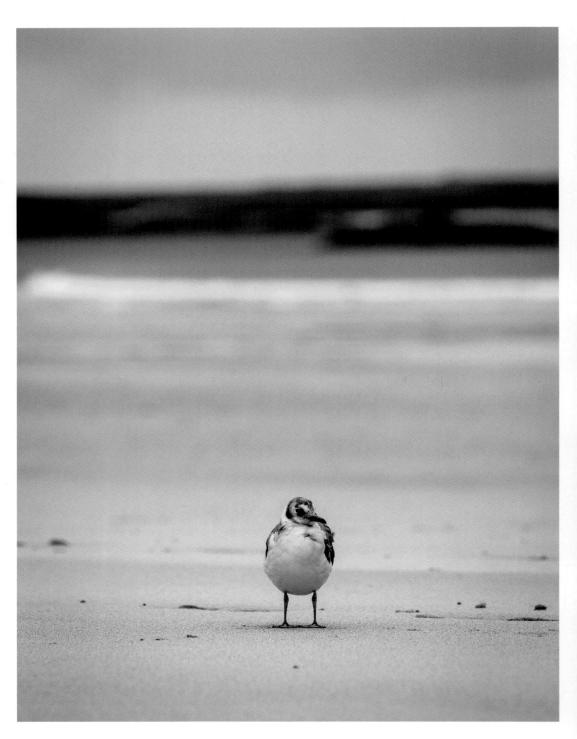

Right: Having a subject that's small in the frame often forces you to think more about how it should be positioned in the frame.

Focal length: 200mm

Aperture: f/5.6

Shutter speed: 1/320 sec.

ISO: 200

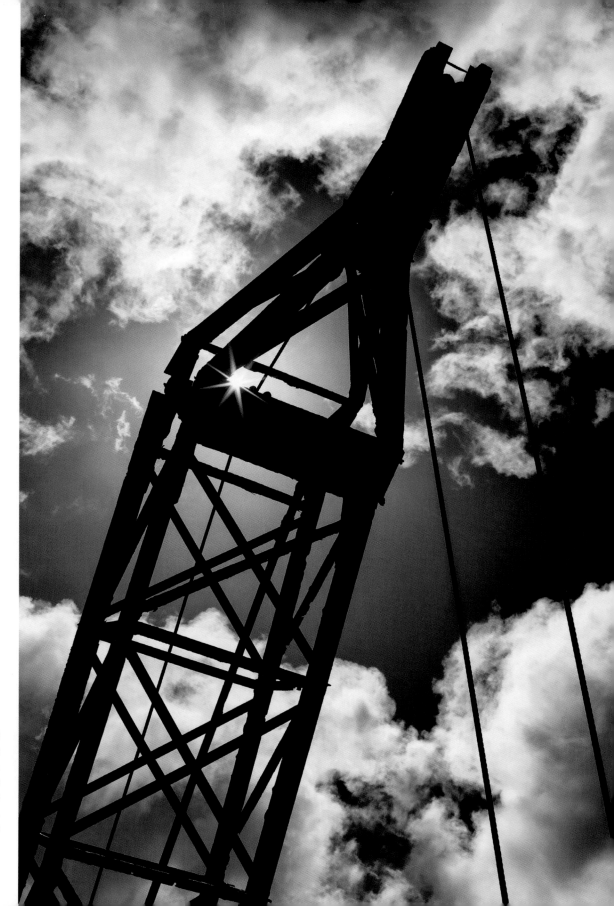

Right: Do not feel compelled to compose all of your images according to set rules—sometimes it is better to just go with what feels right at the time.

Focal length: 50mm

Aperture: f/16

Shutter speed: 1/500 sec.

ISO: 100

The Golden Triangle

If you run a line diagonally from one corner of the frame to the other you will create two equally sized triangles. If you divide one of these into two smaller triangles that are the same shape (but different sizes), you will have what is known as the "golden triangle." This is a rule that benefits an image with strong diagonals running through the frame, and by placing a point of interest where the triangles meet, you can further strengthen the composition. The main division of the image from one corner to the other doesn't have to be an obvious division—it is often better when the division is subtle.

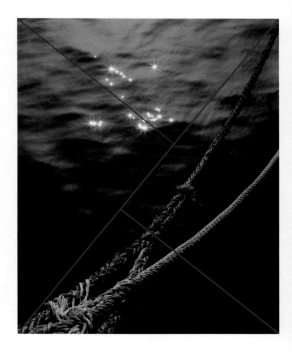

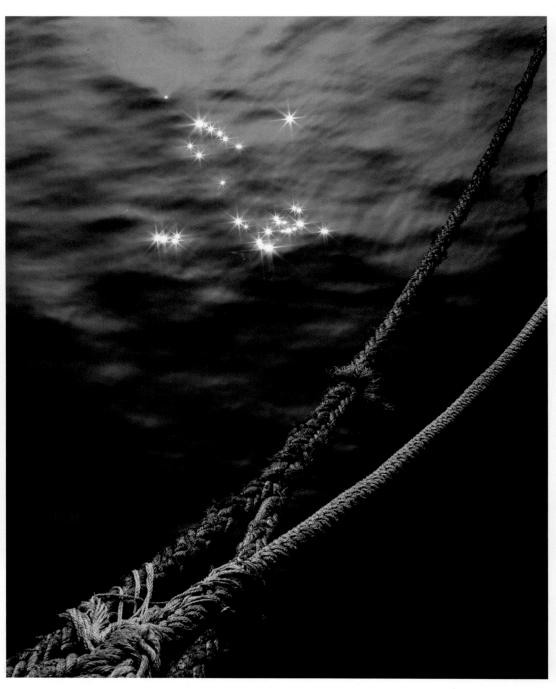

Above & Right: The ropes lead the eye through the frame, with the starbursts holding the viewer's attention. This type of high-contrast scene is well suited to black-and-white photography and something that I always look out for.

Focal length: 50mm

Aperture: f/16

Shutter speed: 1/100 sec.

ISO: 100

Leading Lines

Using a line to lead the eye from one part of the image to another is one of the most commonly used compositional tools in photography. The viewer is taken on a visual journey through the frame and this will typically culminate at a point of interest. This natural flow in an image is a very strong compositional tool, so care must be taken not to lead the eye straight out of the image—it is important the journey ends somewhere.

Using two lines that converge toward the horizon is compositional dynamite. The depth that this technique can deliver to an image really helps to give a three-dimensional feel to a photograph.

Note that lead-in lines don't have to be straight—they can also be curved or even wind their way through the frame (a meandering river or road, for example). As long as your line leads the eye somewhere interesting it will help strengthen the composition.

Having led the eye to a point in the image, there then needs to be something to latch onto. This will hold the viewer's attention for as long as possible, and also help to resolve the composition.

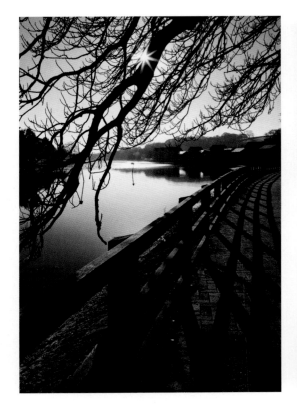

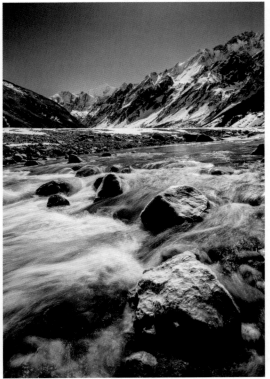

Above: A lead-in line can be used to lead the eye into an image, and also to lead it back out again. Here, the railings draw the eye toward the back of the picture and then the branches on the tree lead it back down to the foreground where the journey starts all over again. This circular journey holds the viewer's attention for longer.

Focal length: 32mm

Aperture: f/16

Shutter speed: 1/150 sec.

ISO: 100

Above: Anything can be used to lead the eye toward a focal point—it doesn't just have to be a continuous line. In this photograph, the boulders lead the eye toward the mountains in the background. It could be argued that this subtle approach works better, as you don't always need to have something pointing directly at the main focal point.

Focal length: 24mm

Aperture: f/16

Shutter speed: 1/3 sec.

ISO: 100

Aspect Ratio

The aspect ratio of an image is the ratio of its width to its height. By far the most common aspect ratio is the 3:2 ratio, which is used by both full-frame and ASP-C-sized sensors (the Micro Four Thirds system and some compact cameras use a 4:3 aspect ratio, which is not quite as elongated).

However, perhaps the most famous aspect ratio among black-and-white photographers (particularly in the fine art world) is the 1:1 square format, which is reminiscent of the iconic medium-format film cameras from manufacturers such as Hasselblad and Rolleiflex.

Just because your camera takes photographs in a particular aspect ratio, that doesn't mean you have to stick to it. There are no rights or wrongs when choosing an aspect ratio, but if your camera enables you to change the aspect ratio before you take the photograph, don't! It is far better to capture the fullest possible image and then crop it during postproduction. This is because you will have more information, and therefore more options available if you change your mind later. Another advantage of postproduction cropping is that you are not limited to a specific aspect ratio.

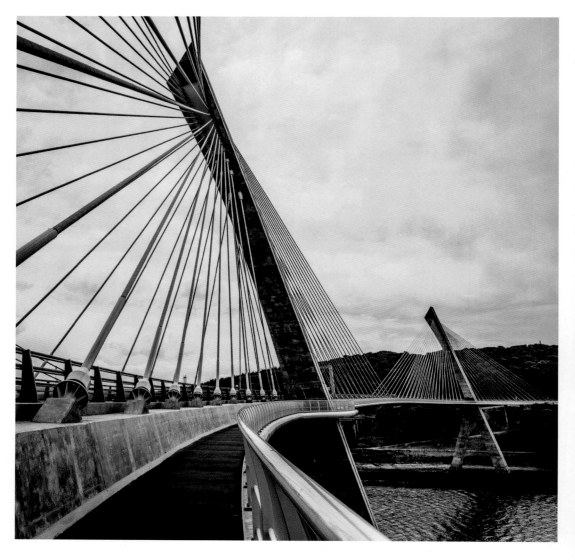

Right: The square, 1:1 aspect ratio was made famous by medium-format Hasselblad and Rolleiflex cameras (among others). It has regained popularity thanks to Instagram.

Focal length: 23mm

Aperture: f/16

Shutter speed: 1/125 sec.

ISO: 100

Right Top: A 3:1 ratio is a panoramic or "letterbox" format that can produce some excellent results. However, it is usually preferable to create a stitched panorama out of several images, rather than cropping a single frame, as this enables you to record much more information.

Focal length: 90mm

Aperture: f/11

Shutter speed: 1/500 sec.

ISO: 100

Right Bottom: Although sometimes called a panoramic ratio, the 16:9 ratio is the standard format for "widescreen" televisions and is nowhere near as long and thin as a true panoramic format.

Focal length: 85mm

Aperture: f/16

Shutter speed: 1/60 sec.

ISO: 100

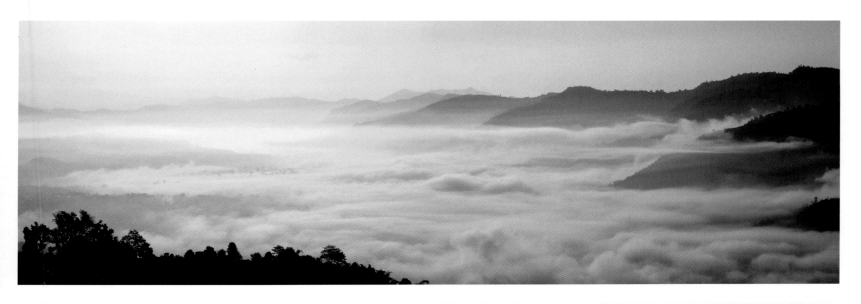

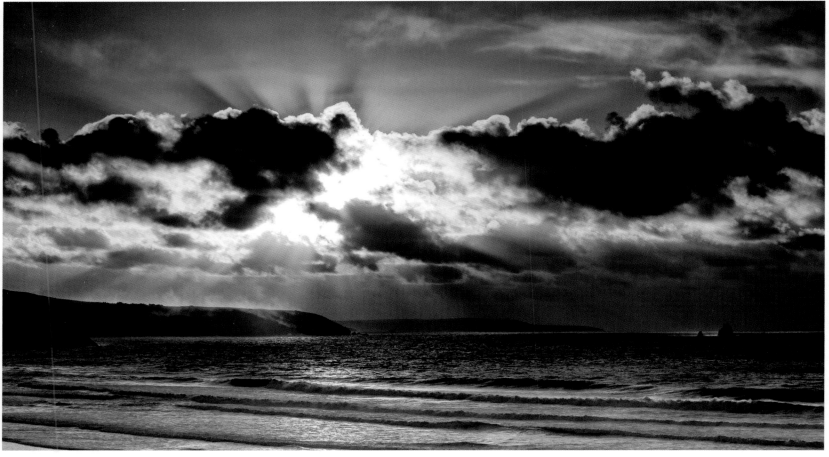

Spatial Awareness

Everyone needs their own space, and this analogy can be extended to thinking about how you frame your subjects. Sometimes, the tendency to crop tightly in on your subject can have a detrimental effect on the image, so give the focal point of your photograph space to rest in the frame. Your image not only needs to appear balanced, but your subject needs breathing room.

By keeping the edges of the frame free from distracting elements, less can become more, and what you choose to leave out of the image can be as important as what you decide to include. Even when a composition is stripped down to its basic components, simplicity can still be hard to achieve.

If an element of the composition enters or leaves the frame (a road or river in a landscape, for example), careful positioning is essential. If I am using something to lead the eye toward a focal point I will often try to position the lead-in line so that it enters the frame at the bottom left or bottom right corner. This is because it can be too dominant if it enters the frame at the bottom center; although it leads the eye into the image, it also holds it for too long.

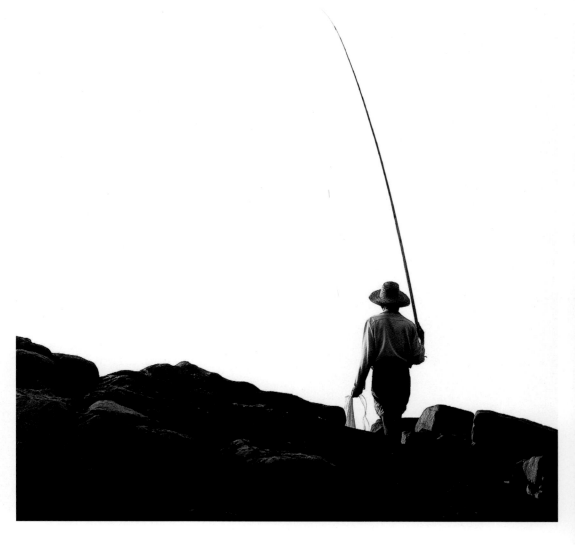

Right: I had no option other than to give my subject space, as my lens was at its maximum focal length and I was unable to get any closer. Don't feel you always need a frame-filling shot.

Focal length: 200mm

Aperture: f/5.6

Shutter speed: 1/500 sec.

ISO: 200

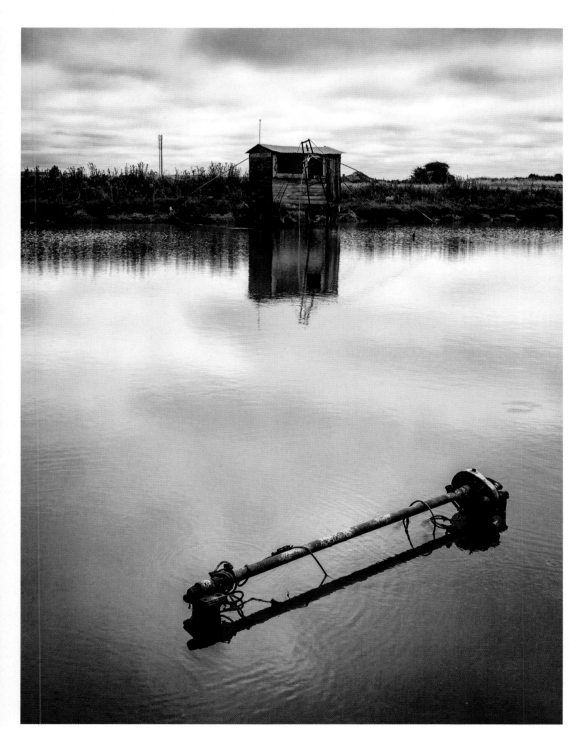

Left: Leaving space around the pole in the water has helped balance it with the hut in the background.

Focal length: 38mm

Aperture: f/16

Shutter speed: 1/80 sec.

ISO: 200

Photographic Discord

Creating the musical equivalent of "discord" in an image is an effective way of creating tension, giving a photograph an unresolved feel, even though the composition is complete. It is this unresolved tension that keeps drawing the eye back into the image. This is a compositional technique that is more likely to present itself to you, rather than something you would go out looking for.

Divide the image into two halves; where normally it is the foreground that leads the eye toward the background, photographic discord also leads the eye out of the foreground back toward the viewer. In this way the image can take you on two separate journeys, although there is usually one section that is more dominant than the other.

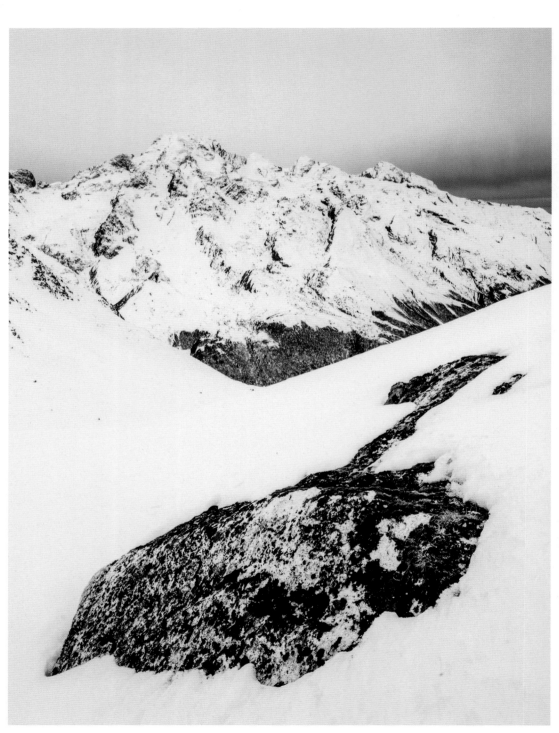

Right: When I saw this rock I was immediately drawn to this composition. The rock seemed to point toward the mountain, helping to give the image depth, but when I came to edit the photograph I found my eye started at the rock's "tail" and was then drawn back out of the image. Although the mountain in the background was still an important part of the image, it had somehow become separated from it. There had become an underlying tension; I wanted to look at the mountain, but the rock wouldn't let me. In a musical context this reminded me of a discord, waiting to be resolved into a more harmonious chord.

Focal length: 24mm

Aperture: f/16

Shutter speed: 1/60 sec.

ISO: 100

Right: The road leads the viewer's eye into the background, but the arrow implies there is something else of importance. By using a very narrow depth of field and keeping just the arrow in sharp focus it becomes even more dominant in the frame. However, the road in the background, leading out of the frame, keeps the viewer in a constant state of tension.

Focal length: 50mm

Aperture: f/2.8

Shutter speed: 1/2500 sec.

ISO: 100

Bipolar Pictorial Composition

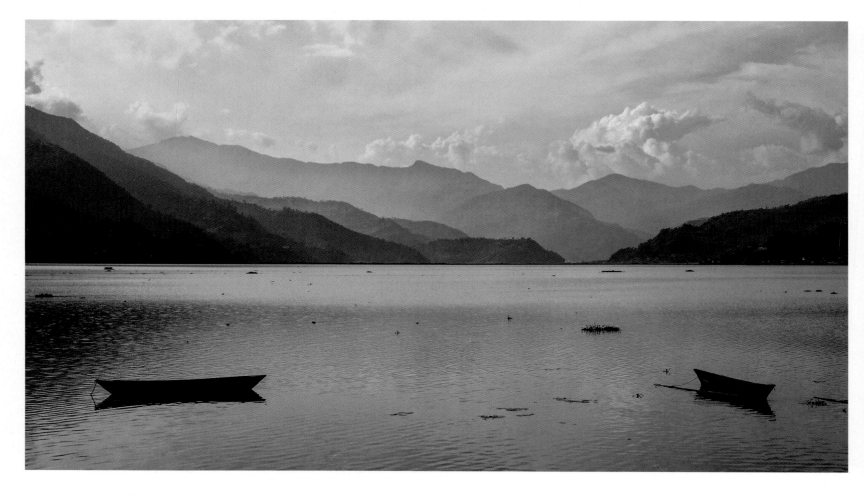

Having two points of interest and placing them at opposite ends of the frame creates what is known as a "bipolar pictorial composition." Here, the eye moves between the two equally relevant points of interest, with neither one dominating the frame. This creates a harmonious balance that holds the viewer within the frame. It is a compositional technique that can be easier to find with a zoom lens than a lens with a fixed focal length.

Above: The position of the boats in the frame draws the eye from one side of the image to the other, and back again. This image contradicts the rule of odds, as there are only two boats, but the composition still works because they are not symmetrical.

Focal length: 50mm

Aperture: f/8

Shutter speed: 1/320 sec.

ISO: 100

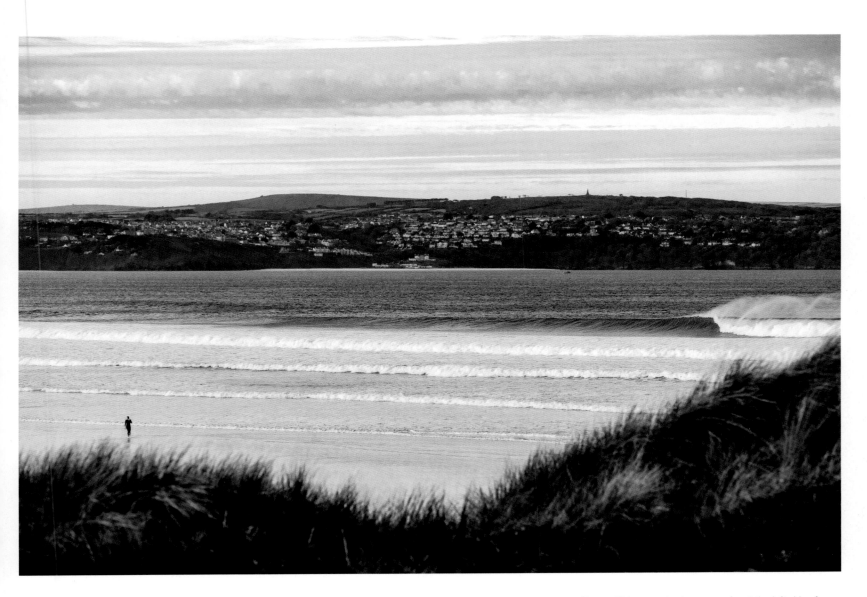

Above: This example shows a surfer at the left side of the image and a wave breaking at the right side. They are obviously related to one another and each is as important to the composition as the other. If you cover up the surfer, the wave is too far to the right of the frame and the photograph appears unbalanced. As soon as the surfer is uncovered, balance is restored. Being able to place two points of interest at opposite ends of the frame is not something that happens often, but when it does, it immediately finalizes an image. In this case it was the "decisive moment."

Focal length: 148mm

Aperture: f/5.6

Shutter speed: 1/200 sec.

ISO: 200

Shapes & Patterns

Composing using strong shapes and patterns is one of the cornerstones of black-and-white photography. With everything within a photograph being made up of shapes, how you choose to arrange them is what makes a good composition.

When you first approach a composition, try not to concentrate on the smaller details within the frame first. Instead, look for the bigger shapes—it is the arrangement of these bigger shapes that will be the backbone of the image.

A trick I use is to squint my eyes slightly or pull the lens slightly out of focus, causing everything to lose its detail and become a collection of shapes (although not so much that everything becomes unrecognizable). Once you get your "eye in" you start to see shapes in everything; arranging these shapes is the first piece of the puzzle and this becomes the foundation of the image.

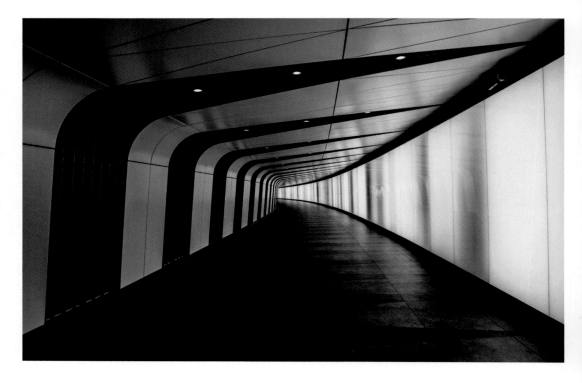

Above: The repeating shapes draw the eye into the picture as they converge into the distance. With such strong shapes, and the repeating bright and dark areas, this could be nothing other than a monochrome image.

Focal length: 24mm

Aperture: f/8

Shutter speed: 1/125 sec.

ISO: 1600

Right: The arrangement of shapes is central to both color and black-and-white photography, but the abstraction of a black-and-white photograph takes things one stage further. Ideally you want the viewer to see the pattern as an image before they work out what it is. Although we normally try to do everything we can to create depth in an image, on this occasion it becomes almost advantageous not to: once the viewer knows what it is, the photograph will never look the same again. A true abstract may never reveal its secrets.

Focal length: 50mm

Aperture: f/11

Shutter speed: 1/13 sec.

ISO: 100

Using a Narrow Depth of Field

How much of the image you choose to have in sharp focus is, of course, partly governed by your choice of camera and lens. A lens with a short focal length will deliver a greater depth of field at any given aperture than a lens with a long focal length. In other words, when composing your image and deciding how much of it you want to be in sharp focus you will need to work within the parameters of your equipment.

Using a narrow depth of field is an excellent compositional aid; even the mundane can be made to look interesting when isolated from its background. By using a narrow depth of field and isolating your subject, distracting elements in the frame can be thrown out of focus, concentrating the viewer's eye on the subject.

However, using a narrow depth of field is no substitute for a poorly composed image. The background is still important to the balance and symmetry of the image, even if it is out of focus.

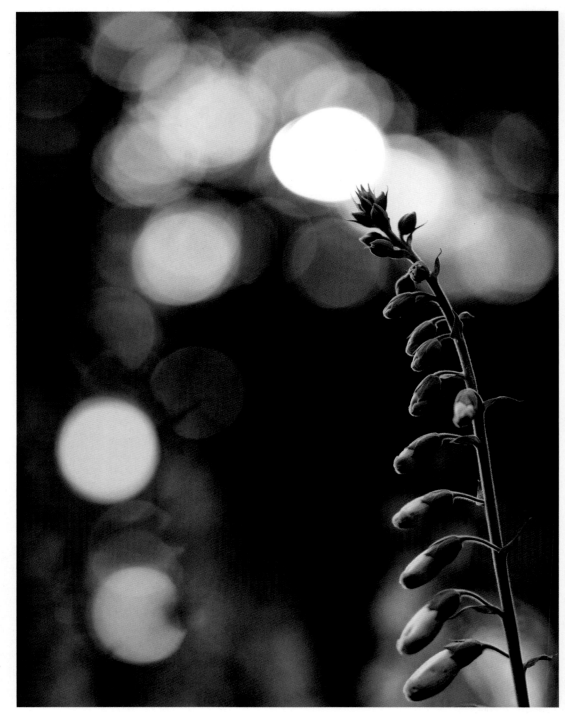

Right: How the lens records the out-of-focus areas of an image is known as "bokeh." The bokeh that a lens produces differs between manufacturers, so a 50mm f/1.4 lens from Canon will have a different look to a 50mm f/1.4 Nikon lens. Typically, the more expensive the lens, the more pleasing the bokeh will be.

Focal length: 90mm

Aperture: f/2.8

Shutter speed: 1/160 sec.

ISO: 100

Right: If the background is distracting, as it was here, a narrow depth of field can be used to clean up the composition. I don't remember if it was the building or the shrine that wasn't straight, but in the end I opted to keep the shrine level.

Focal length: 50mm

Aperture: f/2

Shutter speed: 1/80 sec.

ISO: 200

Negative Space

If you think of your subject as occupying "positive space," the area around it is "negative space." If there are no distracting elements within the negative space, your subject is naturally going to stand out more and the eye will be drawn instinctively to the focal point. By using negative space effectively, the emphasis will always be on what you want the viewer to concentrate on—they won't be searching around the frame looking for a point of interest.

A silhouette makes good use of negative space, as the focal point will be obvious and naturally stand out. With a silhouette being about as two dimensional as is possible in a photograph, it shows just how well this technique works.

Something that is always worth looking out for is a dark subject against a light background, or a light subject against a dark background—in both instances the subject will naturally "pop out" from the negative space behind and around it.

Above: This image highlights negative space well. Although a large part of the photograph is essentially made up of "nothing," it doesn't look out of place. I based my exposure on the brightest section of the white wall.

Focal length: 85mm

Aperture: f/4

Shutter speed: 1/640 sec.

ISO: 100

Simplicity

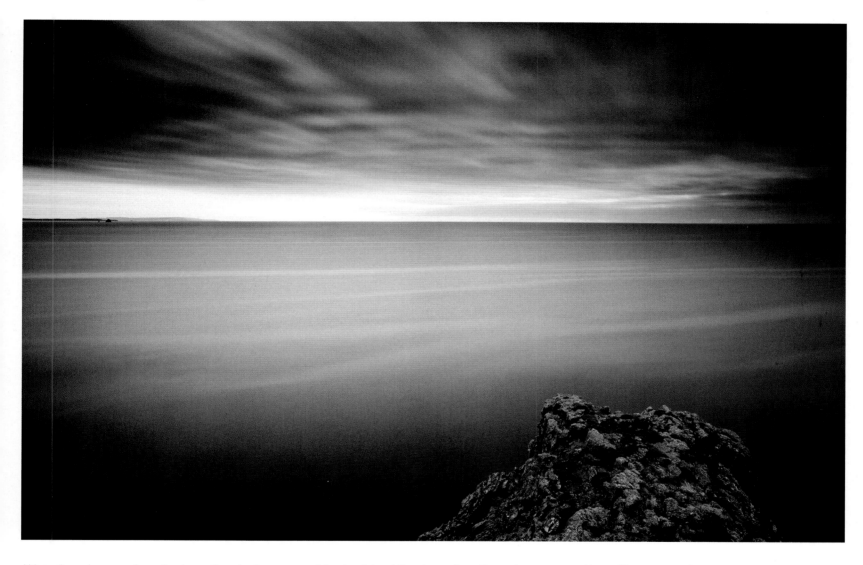

Although we have spoken about creating depth in an image and using more than one focal point to hold the viewer's attention for longer, some of the finest black-and-white photographs are very simple. For some excellent examples of these, you might want to look at the work of Michael Kenna.

Typically, a simple photograph will have its subject placed against a monotonal background, or there will be very distinct areas in the frame, each made up of a different tone. There will be

nothing to distract the viewer from the main subject or, more rarely, subjects.

With the focal point of the image usually being small, you must choose a subject that will stand up to being the center of attention, as the eye will always be drawn back to it. A narrow depth of field will help isolate the subject, and is an excellent way of achieving simplicity within a complex scene, although as your subject will be the only thing both in focus, its position in the frame is critical.

Above: The more complex the scene is, the harder it will be to create a simple image. Long exposures can make very simple images, but it can be surprisingly hard to achieve a "clean" image that is free from distractions.

Focal length: 24mm

Aperture: f/11

Shutter speed: 260 sec.

ISO: 100

Balance & Symmetry

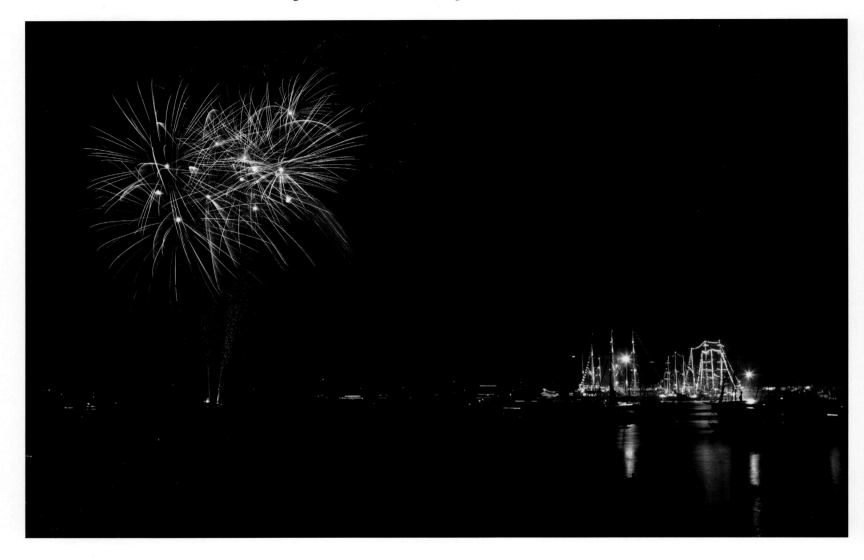

When we talk of balance in a photograph there will be at least two elements in the frame whose positioning will need to be considered. To create a balanced image, the position of one object needs to be counterbalanced by another. When you try to arrange them in the frame, you will reach a tipping point where the balance has been lost and one element becomes more dominant.

You can balance a bright area with a dark area easily (just think of a typical photograph that includes both land and sky); you just need to be careful as to how you frame it and where you place the horizon. A well-balanced image should look complete, with everything not only having its place in the image, but also deserving to be there.

Above: Here the fireworks are balanced with the lights on the boats and help to give meaning to the image.

Focal length: 45mm

Aperture: f/8

Shutter speed: 20 sec.

ISO: 50

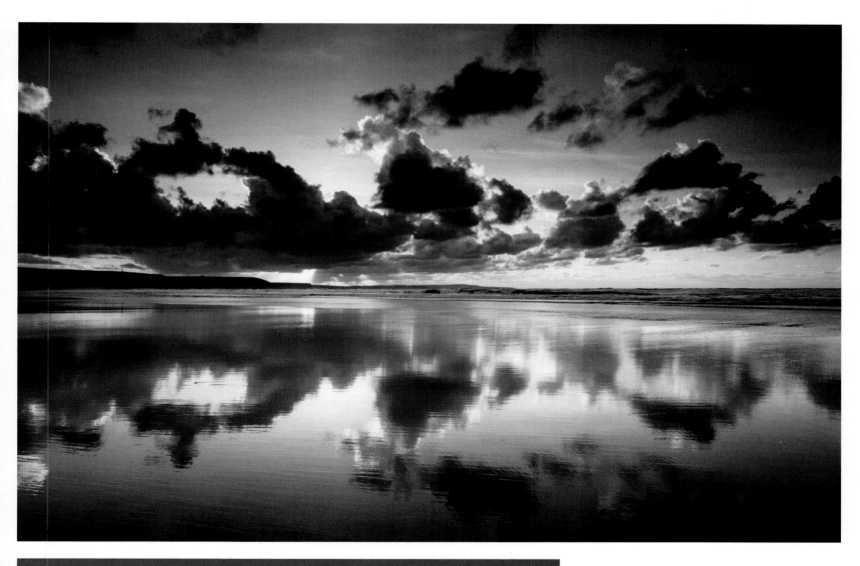

Above: Although not a perfect reflection, this image still displays near-perfect symmetry.

Focal length: 24mm

Aperture: f/8

Shutter speed: 1/40 sec.

ISO: 100

NOTES

- It is not just objects that need to be balanced—a sloping horizon can ruin the balance in a photograph, for example.

- A symmetrical image is pleasing to the eye, but when faced with a subject that exhibits symmetry you should try and make sure that it is exactly symmetrical—an "almost symmetrical" image creates tension.

- One instance when having the horizon running across the center of the frame works well is with a perfect reflection—a gentle reminder that all rules are meant as guidelines and are not fixed.

Framing the Subject

If you want to emphasize a particular element of your composition, framing it within something else will draw the viewer's eye into the photograph and make your subject stand out more. Think of a framed picture hung on your wall, where the frame is used as a boundary that stops the eye from wandering outside it—the same principle applies within an image.

A frame will also help you to add a sense of depth to your photograph. It becomes the first "layer" in the image, as what it frames will typically be behind it and further away. If you were to photograph your subject without the frame, you would lose that extra depth.

Using a frame that is darker than the subject will make it immediately obvious where you want the viewer to look. As it is darker than the subject, the frame will also become less dominant—the brightness of your subject is what will catch the viewer's eye. What you choose to frame the subject with can be tenuous, although if the frame is worthy of being a photograph in its own right, the composition will be stronger.

A narrow depth of field can also be used to frame your subject. This gives a far subtler result than using something more obvious and is an excellent way of drawing attention to the subject when there is nothing else at your disposal. Portraiture benefits from this approach, but you need to ensure your subject's eyes are sharp.

Left: Although out of focus, the plants in the foreground frame the image and are a vital part of the composition. Taken with an 85mm prime lens, I couldn't get the depth of field I needed to have both the foreground and the background sharp, so I decided to make sure the foreground was completely out of focus instead.

Focal length: 85mm

Aperture: f/4

Shutter speed: 1/500 sec.

ISO: 100

Breaking the Rules

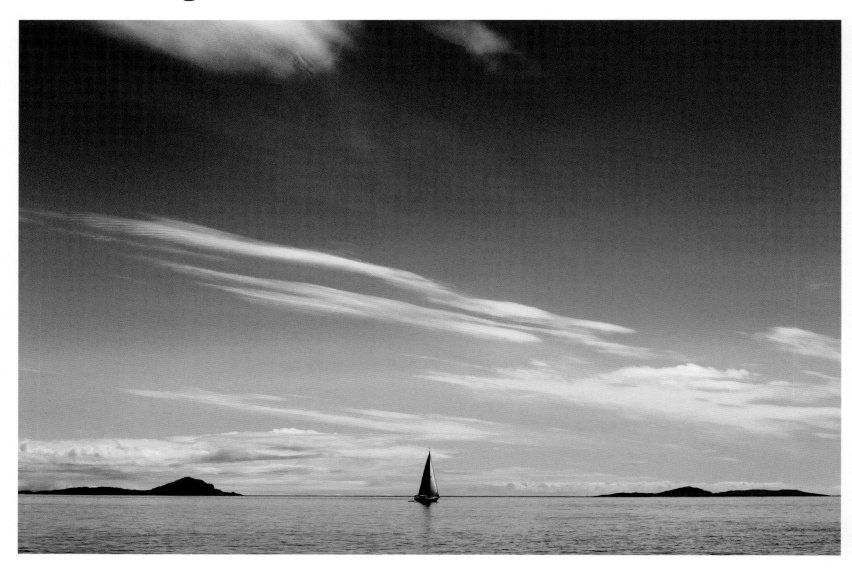

When you analyze the composition of a successful image it will often combine several rules, but it will likely break others. If something looks good, don't get hung up on the fact that it has broken one of the main rules of composition—just go with it. After all, if every photographer stuck firmly to the rules of composition everything would look similar and boring. However, it is still important to first learn the rules before you go out breaking them.

Above: A number of rules have been broken here, but I still ended up with a successful image. This demonstrates that the established rules should always be thought of as "guidelines," not something to adhere to slavishly.

Focal length: 70mm

Aperture: f/8

Shutter speed: 1/640 sec.

ISO: 100

Above: No classical rules of composition have been followed here, but the image has benefited from this. It has turned a very common subject in boring light into something worthy of a photograph.

Focal length: 70mm

Aperture: f/8

Shutter speed: 1/125 sec.

ISO: 200

Chapter 5
Subjects

I think it is reasonable to assume that most subjects lend themselves to being photographed in black and white, with some genres—portraiture, for example—arguably looking better in monochrome than in color. This is probably why black-and-white photography has never lost its popularity as a medium. Indeed, as photography has evolved from film to digital, not only has black and white stood the test of time, it has gained popularity.

Black-and-white photography is special because of the opportunities it can offer. The harsh light of the midday sun would result in a washed-out color picture, for example, but shooting for black and white will allow you to embrace the high-contrast lighting, play with the strong, dark shadows, and produce some stunning results. There are simply more creative opportunities when it comes to creating a black-and-white photograph.

Right: The strong contrast between the figure and the water made it a good candidate for a monochrome image. The human figure also helps give a sense of scale to the breaking wave and gives the image depth. Whenever I see a scene with areas of strong contrast I immediately think of a black-and-white photograph.

Focal length: 400mm

Aperture: f/6.3

Shutter speed: 1/1000 sec.

ISO: 500

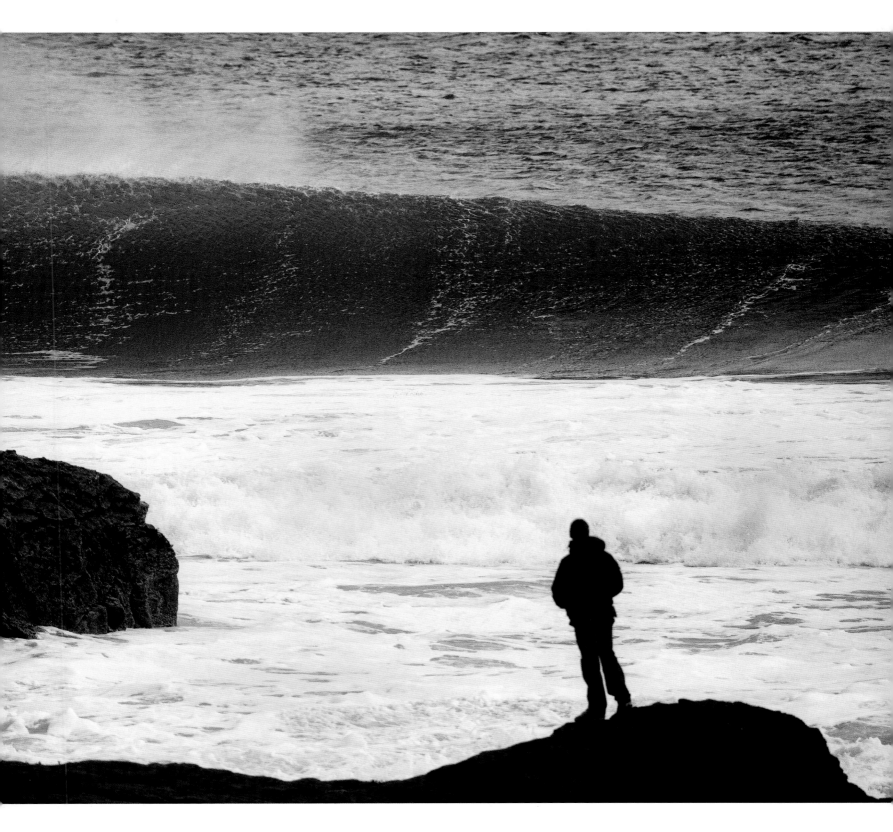

Landscape Photography

The very foundations of landscape photography were built around black-and-white photography. It was the work of Ansel Adams that showed just what was possible, and his collection of black-and-white photographs taken in the Yosemite National Park, USA, have not lost any of their impact.

There is what I call "the three Ls" of landscape photography: location, lighting, and luck. First and foremost, the location should do most of the hard work for you—even a poorly composed photograph of a stunning landscape should elicit a positive response.

Next, there's the lighting, with the best light found around the popular (and predictable) golden hour. Compose your photograph with the sun to the side of you and the landscape will be modeled by soft directional lighting, with long shadows that help give depth to the image.

All that remains is luck. Although you cannot plan for it, there is no doubt that the more time you spend out in the landscape taking photographs, the luckier you will become.

The one thing black-and-white photography cannot show is color in the sky, so you cannot hide behind a colorful sunset (photographically speaking). Instead, you need to work hard to make sure your compositions are strong and that you are making the most of the interaction of the light with the landscape.

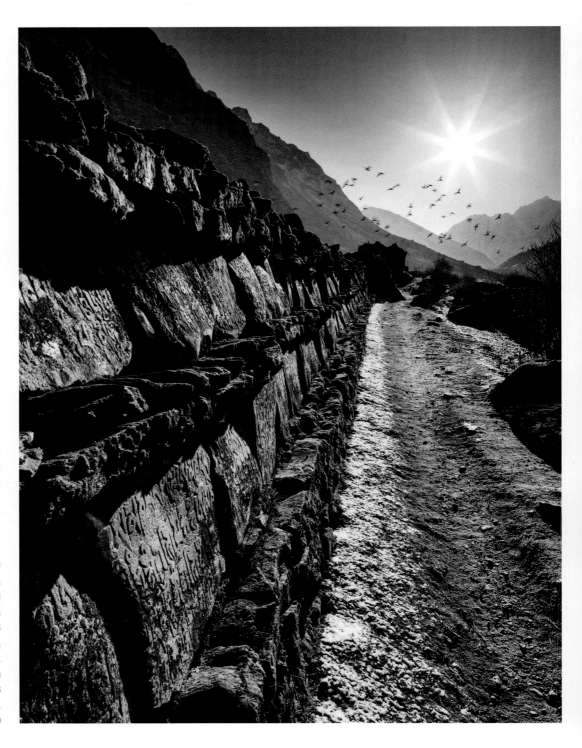

Right: Although slow moving, there can still be a "decisive moment" in landscape photography. Here, the lighting, contrast, and dominant lead-in lines make for a strong monochrome image, but it is the birds that add that extra something. The location was stunning, the lighting was good, but having the birds fly by was lucky: location, lighting, and luck.

Focal length: 24mm

Aperture: f/16

Shutter speed: 1/30 sec.

ISO: 100

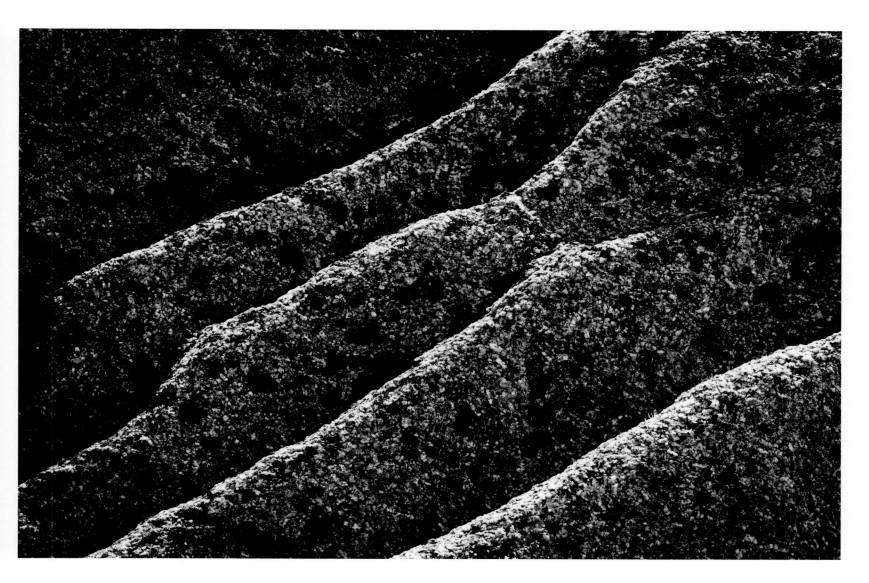

Above: Don't forget the details. There is more to landscape photography than a wide-angle view. In this case, the light was just catching the tops of the rock, emphasizing the abstract pattern.

Focal length: 85mm

Aperture: f/22

Shutter speed: 1/10 sec.

ISO: 100

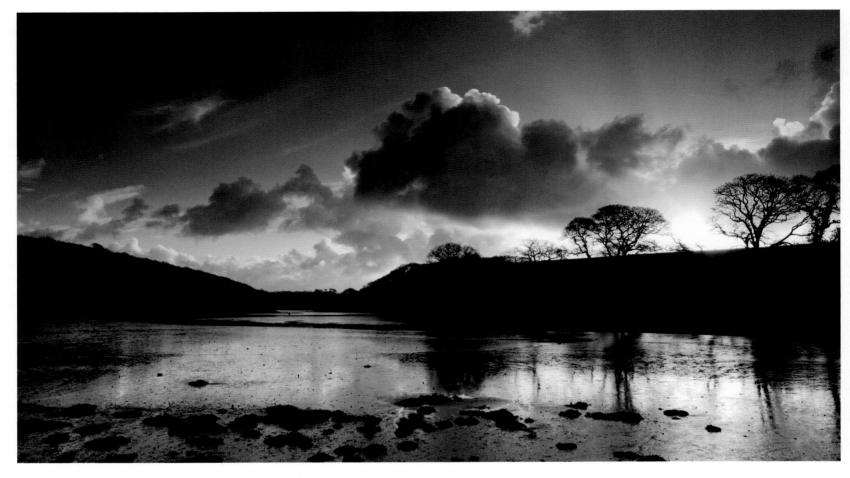

Spot Metering & Landscape Photography

Ideally, you need to be able to identify two different tones in the scene you want to photograph: the brightest part of the scene, and a midtone. In doing so you will be able to check your exposure readings are correct by comparing light readings for the two areas. The process is as follows:

1 Set your ISO to its lowest value to ensure the best-quality image. This is typically ISO 100.

2 Decide on the aperture setting you need to use, based on how much of the scene you want in focus. Although you may want to maximize depth of field, note that an aperture setting smaller than f/16 will likely result in diffraction, which causes a slight softening of the image. However, this is not something to get hung up about.

3 Locate the brightest tone in your composition (but not the sun). Aim the camera's spot meter at the brightest tone and adjust the shutter speed until you get a reading of +2EV.

4 Identify a midtone, and without adjusting the shutter speed, aim the camera's spot meter at it to see what EV value your light meter reads. It should ideally be 0EV. If it isn't, see *Exposure Correction,* opposite.

5 Having taken your photograph, check the camera's histogram: the graph should be just touching the right side. Do not rely on how the image looks on the screen, but learn to trust the histogram. You should be more interested in capturing as much data as possible, rather than how it looks on the back of the screen. A moody looking image on the camera's preview screen is invariably underexposed, which means it will have a reduced tonal range.

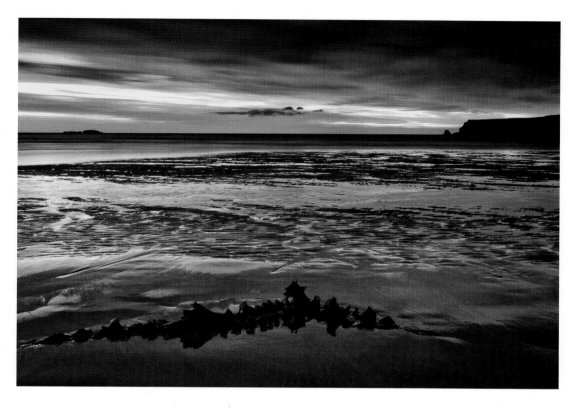

Left: Successful landscape photography requires planning and perseverance; you may have to return to a location several times before the conditions are in your favor.

Focal length: 27mm

Aperture: f/11

Shutter speed: 1/20 sec.

ISO: 100

Exposure Correction

If the light meter gives a reading of less than 0EV when you aim the camera's spot meter at a midtone, this indicates that the camera will be able to record detail in the brightest tones with your current settings, but what should be a midtone will be underexposed (if the reading is -1EV, the midtones will be 1-stop underexposed, for example). To counter this you could increase the exposure to ensure the midtone is correctly exposed, but in doing so, your brightest tone will be overexposed by a corresponding amount. Instead, there are five options for correcting this, which—in order of difficulty—are:

1 Do nothing. As it's a black-and-white image it won't be as noticeable as if it were color, so the photograph might not even look like it needs adjusting.

2 Allow the midtones to be underexposed by 1 stop and then lighten the shadows during postproduction. This is quick and easy to do, but noise may become more noticeable in the shadow areas.

3 If the exposure between the sky and ground needs balancing, use a graduated ND filter. Getting it right in camera will reduce the amount of editing you need to do on your computer, although an ND grad might also darken areas that would otherwise be OK.

4 Shoot a series of images at different exposure settings and blend them together to create an HDR (high dynamic range) image. Done well, it can be impossible to tell that you have blended multiple exposures, but this process involves specialist software and both images need to be identical (nothing can be moving between the frames).

5 Use a combination of a graduated ND filter and exposure blending.

Above: For this shot, a 2-stop graduated ND filter was used to control the contrast between the sky and the foreground. Without the filter, the foreground could have been correctly exposed, with the sky burnt out, or the sky could have been correctly exposed, leaving a very dark foreground.

Focal length: 31mm

Aperture: f/16

Shutter speed: 82 sec.

ISO: 100

Overleaf: I metered from the brightest area, set the exposure to +2EV, and just let the other tones fall into place, knowing the dark areas would add to the drama. This was one occasion that benefited from not using a graduated ND filter.

Focal length: 170mm

Aperture: f/11

Shutter speed: 1/120 sec.

ISO: 100

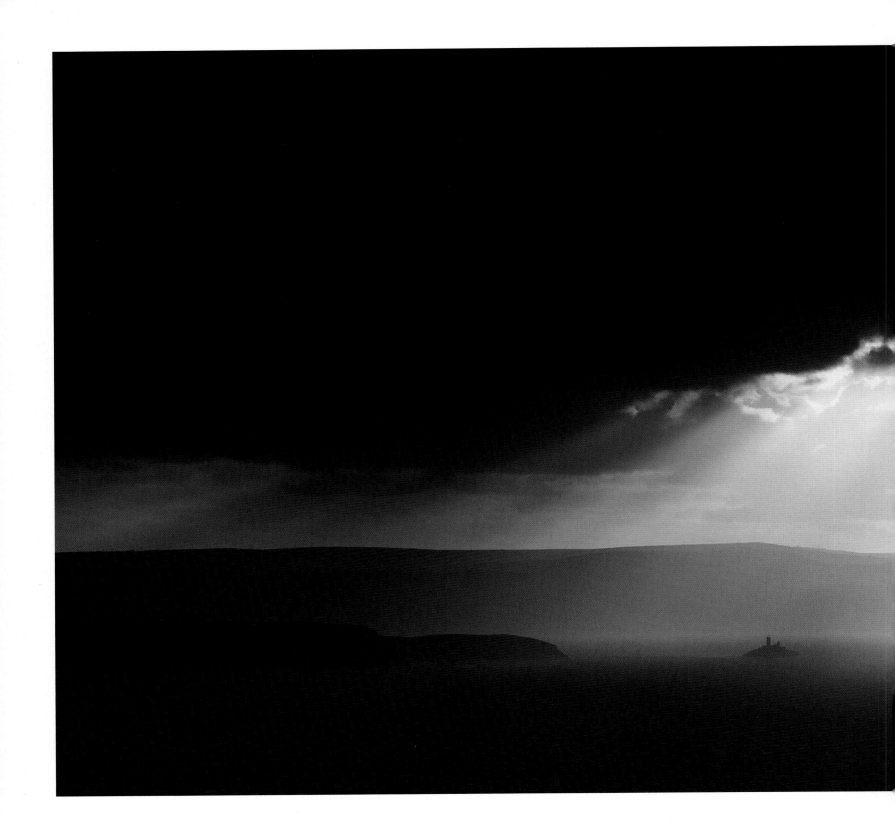

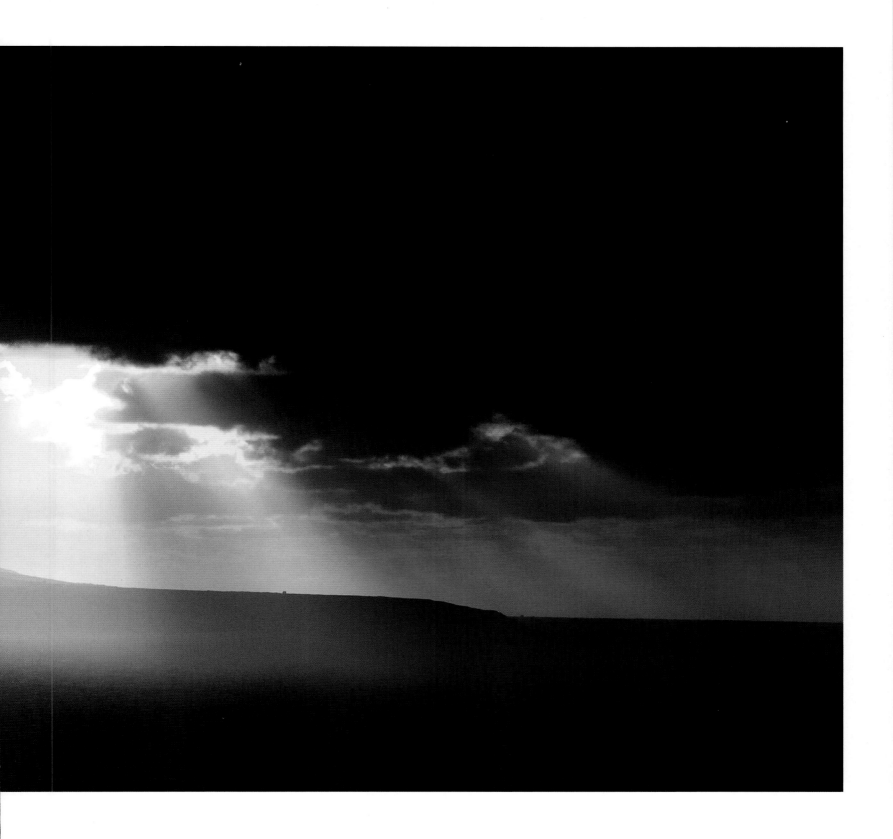

Wide-Angle Landscape Photography

One of the biggest problems facing inexperienced photographers is being able to see a composition, rather than an extra-wide view. The most obvious solution is to try and fit everything in, but in doing so, the more photogenic sections of the landscape invariably become lost in the extreme wide-angle view: what the eye sees and how it is portrayed by the camera are two entirely different things. Trying to fit too much of the landscape into the frame also means the image can become confusing and lack the apparent depth of a tighter and more considered composition.

Therefore, it is better to break the wider view down into smaller sections, treating each one as a separate photograph. Out of all the sections there will be one that stands out from the rest and this should be your starting point. You then need to find a suitable foreground that not only balances the image, but also leads the eye into the picture. The foreground should ideally be an image in its own right. By combining it with the background (which is why you chose the location in the first place), the whole image will then fit together and become visually stronger.

Above: By breaking the elements of the landscape into foreground and background, you can find one part that works and then look to complement it with the other. In this example, I found the cluster of rocks first; the way the outline of the dark clouds almost mirrored the outline of the rocks became the second half of the image.

Focal length: 24mm

Aperture: f/16

Shutter speed: 5 sec.

ISO: 100

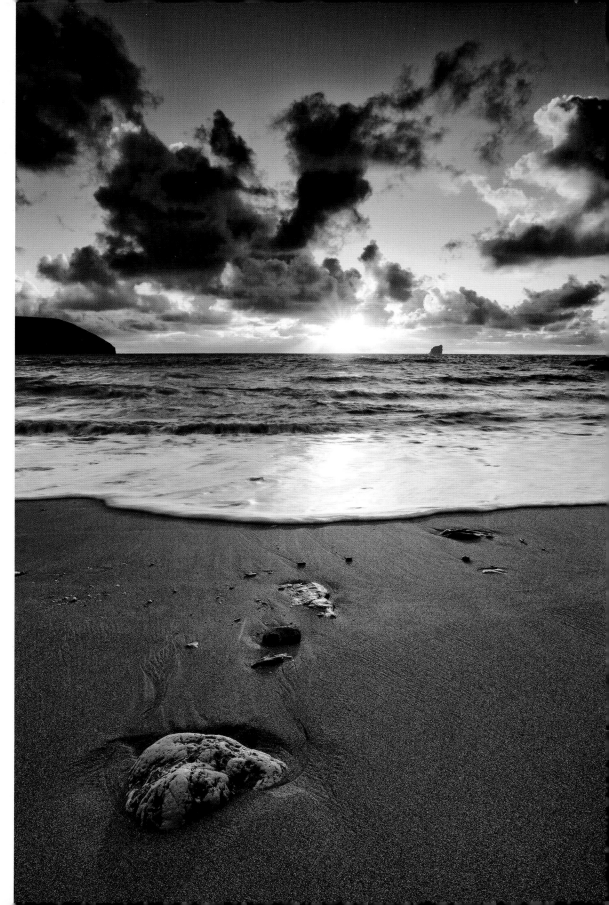

Right: This image takes the concept of combining two separate areas a stage further, with the addition of an interesting middle ground. This adds extra depth to the photograph and holds the viewer's eye for longer. A shutter speed of 1/5 sec. has recorded movement in the water, while still retaining texture, and the rocks all line up and point toward the island. It was one of those occasions when everything just came together.

Focal length: 24mm

Aperture: f/16

Shutter speed: 1/5 sec.

ISO: 100

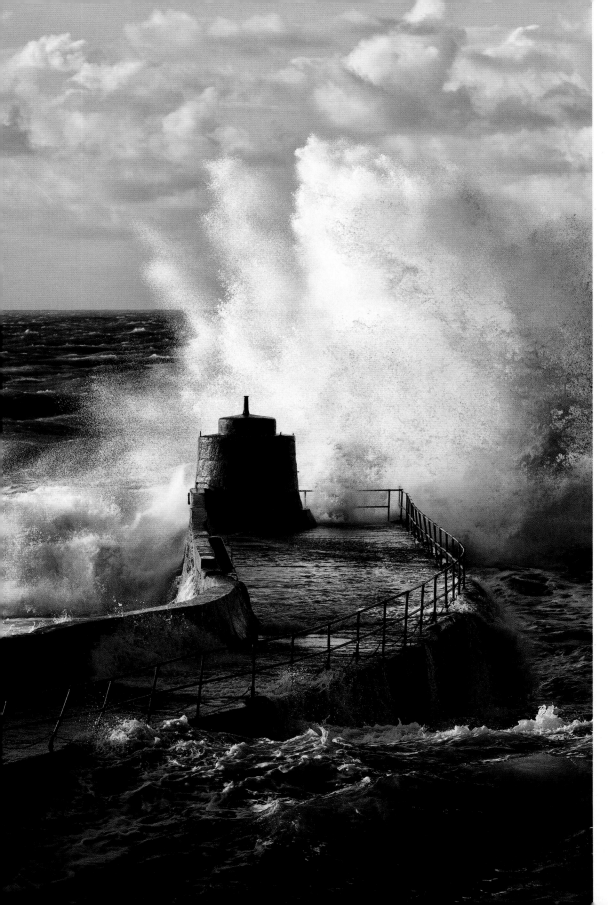

Bad Weather

There's no escaping the fact that clear blue skies are boring. They might be what you want when you go on holiday, but when it comes to landscape photography—especially in black and white—the more dramatic the sky, the better!

If you are willing to go out when the weather is bad, you will be rewarded with good landscape photographs. However, you can maximize your chances of getting some good light if you are on the edge of a weather system, just before it hits or just after it leaves. The biggest problem in these conditions is keeping your equipment dry, as you will invariably be pointing your camera toward the oncoming wind and rain. Protect the camera as best you can, and have lots of lens cleaning tissues handy.

Left: Even when you are using a long focal length, you can still include a strong foreground to help give an image depth. It isn't the railings that make the foreground strong in this shot (although they do help), it's the crest of the wave illuminated by the sunlight. To achieve this, the timing was critical, as was keeping dry!

Focal length: 125mm

Aperture: f/5.6

Shutter speed: 1/1000 sec.

ISO: 200

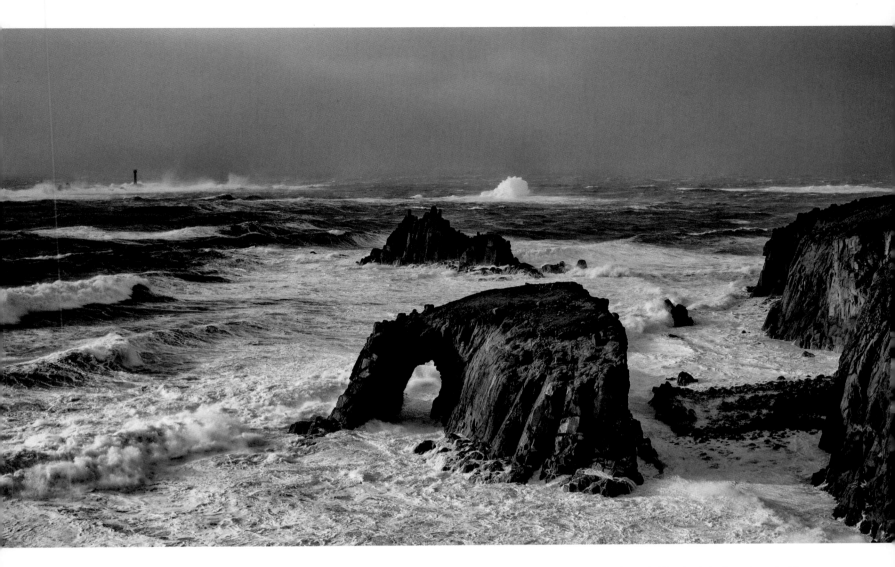

Above: Taken in 70mph winds, it was important to use a shutter speed that was fast enough to allow me to both handhold the camera and freeze the breaking waves. Depth of field was not an issue, because everything in the frame was—as far as my lens was concerned—at infinity. However, as dramatic as the stormy conditions were, it is the areas of sunlight that lift the image and transform it into something worthy of hanging on the wall.

Focal length: 50mm

Aperture: f/5.6

Shutter speed: 1/1000 sec.

ISO: 200

Long Exposures

Water and clouds can both look stunning as a monochrome long exposure. Recording the passing of time leads you into a whole new world of photography, where clouds can become streaks and water can look like mercury. Although often overdone, if you find the right subject you can easily enter the realm of fine-art photography.

To create a long exposure, most photographers will use a plain ND filter that reduces the exposure by 10–12 stops. When calculating the exposure time with this type of filter, you also need to take account of any changes in the light levels. This is particularly important around sunrise and sunset when the light levels can change quickly.

For example, if you were photographing at sunset with a 10-stop ND filter and you had an exposure time of 1 sec. without the filter, you would be able to work out that with the filter attached, the exposure would need to be 16 minutes. However, because you're shooting at sunset it is likely that the landscape would be darker at the end of a 16-minute exposure, so your image would then be underexposed.

If you have a separate light meter you will be able to measure how much the light has changed by and extend your exposure accordingly. If not, you will just have to guess, and although this is a bit hit and miss, with practice you can soon get good results.

Right: Taken long after the sun had set, there was barely any light left in the sky. I didn't expect to have much detail in the cliffs, but I knew the dark shape leading toward the light would make an excellent monochrome subject.

Focal length: 35mm

Aperture: f/16

Shutter speed: 822 sec.

ISO: 100

NOTES:

- Increasing the ISO to compensate for an underexposed image can be preferable to increasing the exposure time: extending a 16-minute exposure by 1 stop would mean your next shot would need to be exposed for 32 minutes.

- If you end up with an exposure time longer than 30 seconds you will need to use your camera's Bulb mode. A remote release (ideally in conjunction with a mirror lockup function) is essential, as is a tripod.

- Noise can be a problem with long exposures and is caused by the sensor heating up.

SHUTTER SPEED WITHOUT FILTER	SHUTTER SPEED WITH 10-STOP ND FILTER
1/8000 sec.	1/8 sec.
1/4000 sec.	1/4 sec.
1/2000 sec.	1/2 sec.
1/1000 sec.	1 sec.
1/500 sec.	2 sec.
1/250 sec.	4 sec.
1/125 sec.	8 sec.
1/60 sec.	15 sec.
1/30 sec.	30 sec.
1/15 sec.	60 sec. (1 min.)
1/8 sec.	120 sec. (2 min.)
1/4 sec.	240 sec. (4 min.)
1/2 sec.	480 sec. (8 min.)
1 sec.	960 sec. (16 min.)
2 sec.	1920 sec. (32 min.)
4 sec.	3840 sec. (60 min.)

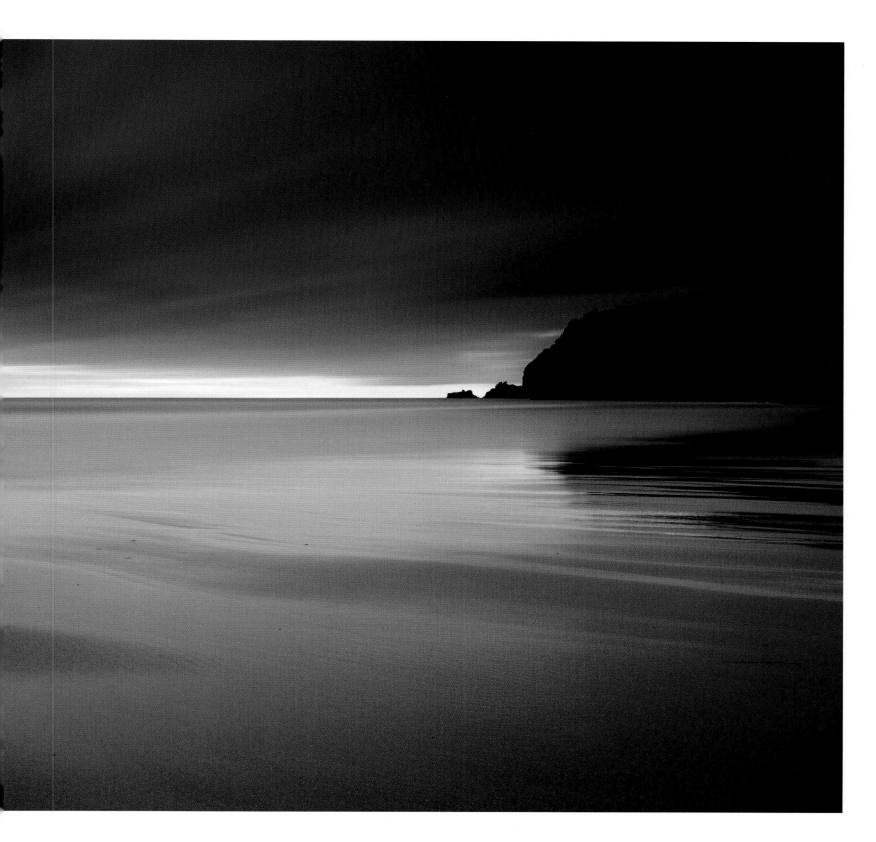

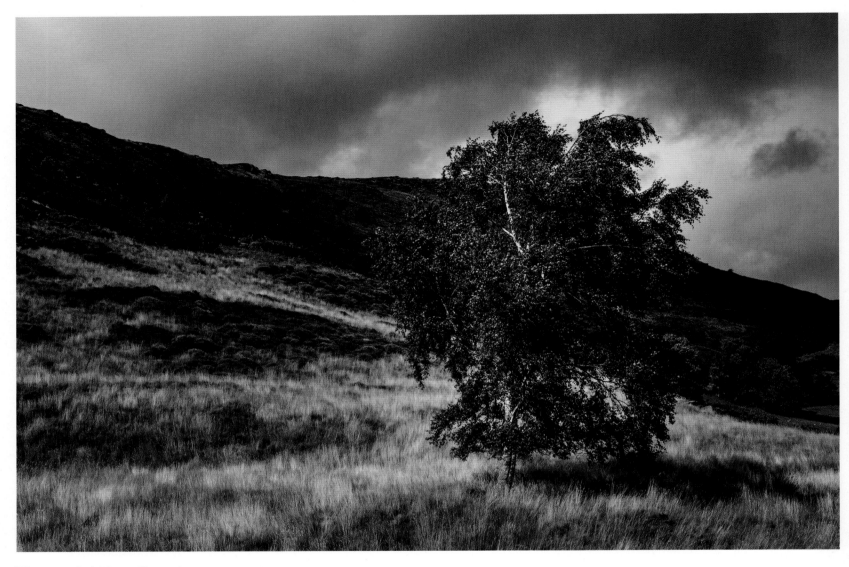

Trees & Woodland

The strong, graphic shapes of trees make them excellent subjects to photograph in black and white. Photogenic trees are normally fairly easy to spot; a lone tree in the landscape is a common subject. Throw in a dramatic sky and a well-placed sunburst and you have the makings of an excellent black-and-white photograph.

Having found a photogenic tree, the tones should be different to the background. If there is no tonal separation everything will just merge together. Look out for natural clearings where the light will be brighter and anything in there will naturally stand out from the darker background.

Photographing in woodland can be very challenging, as it is a lot harder than you might think to find order among the chaos. Contrast levels can also be extreme, making cloudy days ideal for shooting woodland interiors (and misty days even better).

Above: Although something of a cliché, it can be hard to walk by a solitary tree because they do make an excellent subject to photograph. With frequent pockets of sunlight moving quickly across the landscape I waited for the tree to be illuminated, not the background. This helped to give a degree of tonal separation, which was essential to the image working in black and white.

Focal length: 50mm

Aperture: f/8

Shutter speed: 1/250 sec.

ISO: 100

Above: A large branch had been ripped off this beech tree in a storm, opening up the canopy and bringing in extra light. I opted for more of an abstract shot, concentrating on the shapes and patterns.

Focal length: 90mm

Aperture: f/16

Shutter speed: 20 sec.

ISO: 100

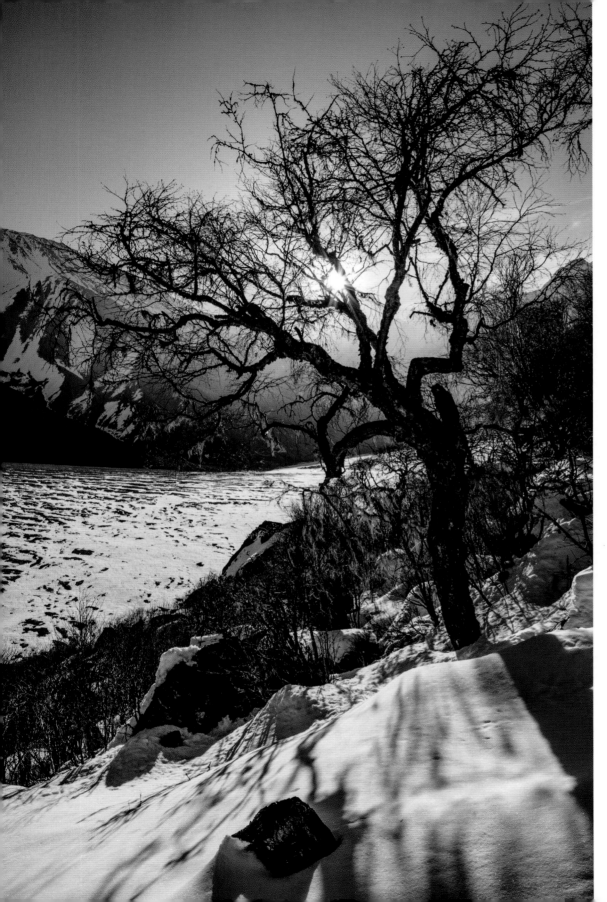

Left: Although backlit, the snow has reflected light back onto the tree trunk. This was important, as it helped provide tonal separation between the tree and the background.

Focal length: 24mm

Aperture: f/11

Shutter speed: 1/250 sec.

ISO: 100

Right: Shot with a very wide aperture, the depth of field in this image is so shallow that only the closest branches are in focus. With the tonal separation not being great across the image, isolating the foreground from the background has helped rescue the image. There is plenty of scope for creativity when photographing trees, although it can also be very challenging in black and white.

Focal length: 35mm

Aperture: f/1.4

Shutter speed: 1/3200 sec.

ISO: 100

Portraiture

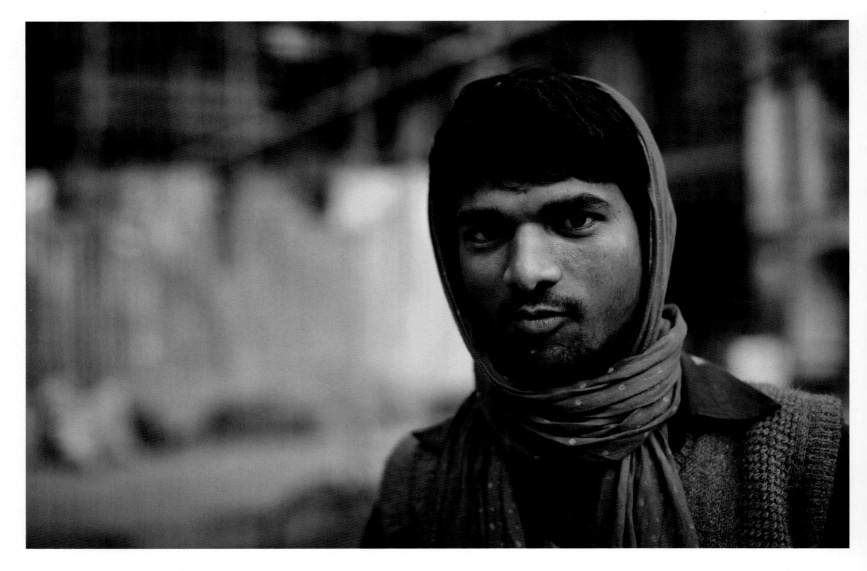

If there was ever a subject that cries out to be photographed in black and white it has to be the humble portrait. With the right light you can produce something that will be both stunning and timeless.

Portraiture is all about the eyes. Your subject doesn't have to be looking directly at the camera, but their eyes should be in sharp focus. This means focusing precisely is your priority, either by selecting an appropriate focus point, using your camera's focus lock, or switching to manual focus.

Many cameras allow you to assign autofocus to a button other than the shutter-release button. You will find this allows you to work a lot faster, as having focused on the subject's eyes you can quickly take three photographs without the camera refocusing. Typically, in one photograph the eyes will be shut, in another your subject will have a

Above: Taken using a wide aperture setting, the background has been thrown out of focus. The depth of field is so shallow that only the subject's eyes are sharp, so he naturally pops out of the frame. I was also careful to place him in front of a bright background to ensure some tonal separation.

Focal length: 50mm

Aperture: f/2

Shutter speed: 1/200 sec.

ISO: 200

funny expression, and the third—hopefully—will be a keeper.

If you are using a classic portrait lens with a focal length of 85mm or greater (see page 30), this will naturally blur the background, regardless of your choice of aperture. However, if you have more than one person in your photograph (and you are using a wide aperture), you need to be careful they are all in sharp focus. With the depth of field being so narrow, make sure they are all stood roughly the same distance from the camera, or use a slightly smaller aperture to extend the depth of field.

NOTE
Always pay close attention to the background in your portraits. Even if it is out of focus, a tree sticking out of the top of someone's head is not a good look!

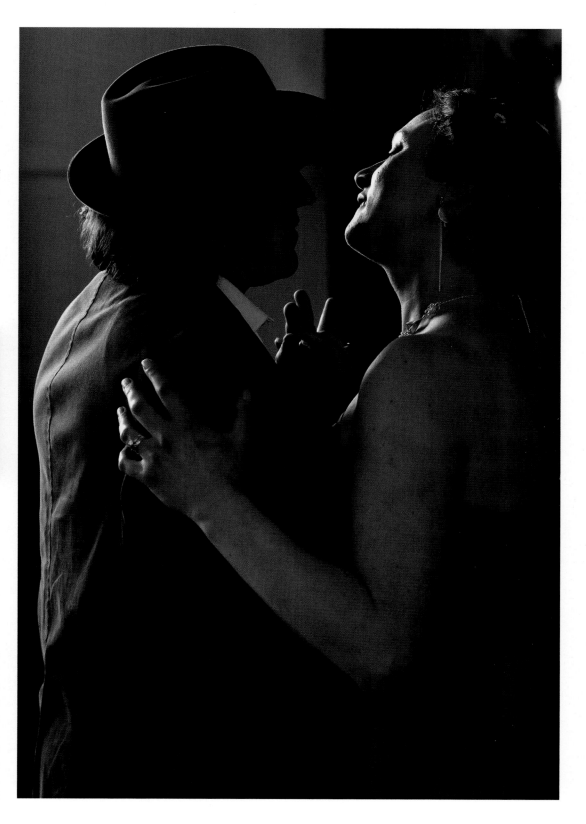

Right: The light source for this scene was a high window at the left of the frame. I based my exposure on the sunlight on the floor, knowing that the couple would be dancing slowly through it. The way in which the highlights have caught the side of her face and the back of his hat is what makes the image.

Focal length: 50mm
Aperture: f/2.8
Shutter speed: 1/250 sec.
ISO: 1600

Direction of Light

The direction from which the light falls on your subject can make or break a portrait.

Front Light
Unless the sun is very low in the sky, front lighting should always be avoided, as looking toward the sun will cause your subject to squint badly.

Side Light
Side lighting is preferable to front lighting, and can deliver particularly impressive results in black and white. To soften the shadows, use a reflector on the opposite side of the light source to bounce some light back onto your subject.

Backlight
Backlighting is always a good choice—your subject will not be squinting and he or she will have a lovely rim light around their head. You will need to be careful with your metering, though. Your subject needs to be properly exposed, so you should base your exposure on them, rather than the background.

Rembrandt Lighting
This is a classic studio lighting setup, although it can also be replicated using sunlight. The light source should be above and to the side of your subject, so the shadow of their nose creates a triangle of light just below the eye. The eye that is in shadow should also catch the light, otherwise it can look dull and lifeless.

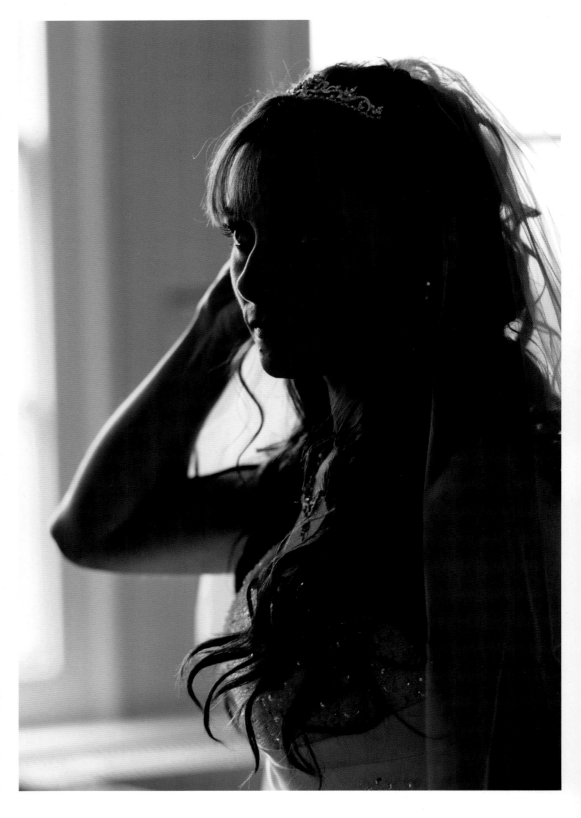

Right: This is almost a silhouette, but because the subject's head is turned slightly, her nose has just caught the light. This has added depth to the image and created a low-key look.

Focal length: 85mm

Aperture: f/2.8

Shutter speed: 1/125 sec.

ISO: 400

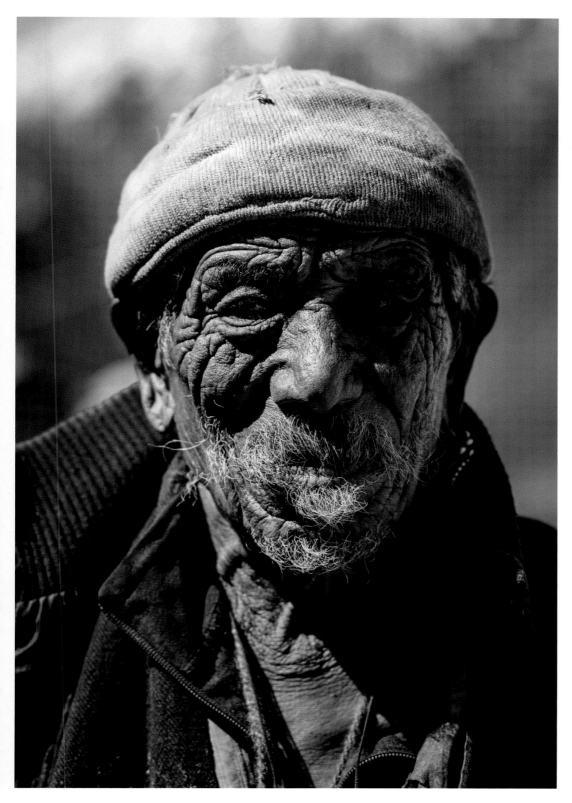

Left: Side lighting with strong natural light and no fill-in flash gives a very distinctive look. Because of the high contrast, exposing for the highlights means the shadows will be very pronounced. In this case, I took a meter reading from the subject's hat and adjusted the shutter speed to give an exposure of +1.5EV. I chose +1.5EV instead of my usual +2EV to make sure that the highlights on his face were not overexposed.

Focal length: 85mm

Aperture: f/2.8

Shutter speed: 1/1250 sec.

ISO: 100

Using Flash

There are two main types of portable flash: the camera's built-in (or "pop-up") flash, or a hotshoe mounted flash. A hotshoe mounted flash gives you the greatest control because you can usually tilt and swivel the flash head (depending on the specification of the flash). This enables you to change the direction of the light, so you can bounce it onto your subject from a ceiling or wall, creating a larger, softer light source that gives a more flattering look.

Often, flash is not used to illuminate the subject, but to "fill in" any shadows (hence the term "fill flash"). The simplest way to apply fill flash is to set the camera to its TTL (Through The Lens) flash metering option. TTL flash works by firing a pre-flash to gauge the exposure needed, before firing the main flash and taking your shot. It also takes into account where the lens was focused, so the background isn't illuminated, just the subject.

You can then use flash exposure compensation to make the flash stronger or weaker. The power adjustment you make will largely depend on the look you are after, but for direct fill-in flash I set the flash exposure compensation to about -1.5EV. This is enough to lift the shadow areas, but without the flash becoming dominant.

If you are bouncing the light from the flash then the power may need to be increased—a quick check of the preview screen will show you if you have got it right.

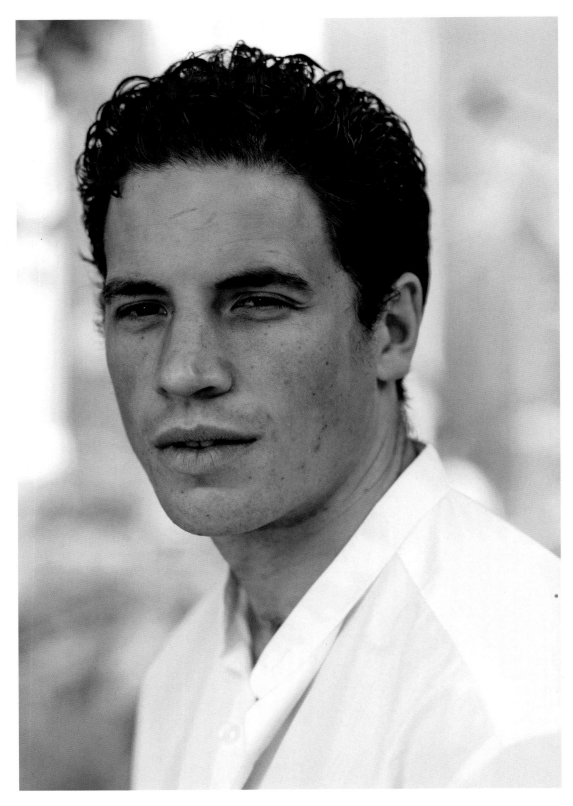

Left: Fill-in flash helped lift the shadows here and you can see catchlights in both eyes. However, there is no other obvious sign that flash was used.

Focal length: 85mm

Aperture: f/2.8

Shutter speed: 1/200 sec.

ISO: 200

Off-Camera Flash

Operating the flash away from the camera gives you the maximum control over how you want your images to look. You can also determine how the background appears, and then illuminate your subject with flash that is controlled remotely by the camera, either wirelessly or via a dedicated TTL flash cable.

The beauty of this type of setup is that a digital camera allows you to see the results instantly, so you can make adjustments and reshoot immediately if you are unhappy with the result. Of course, this is still a technique that needs to be practiced, so you know instinctively where to position the flash and roughly how powerful the output needs to be.

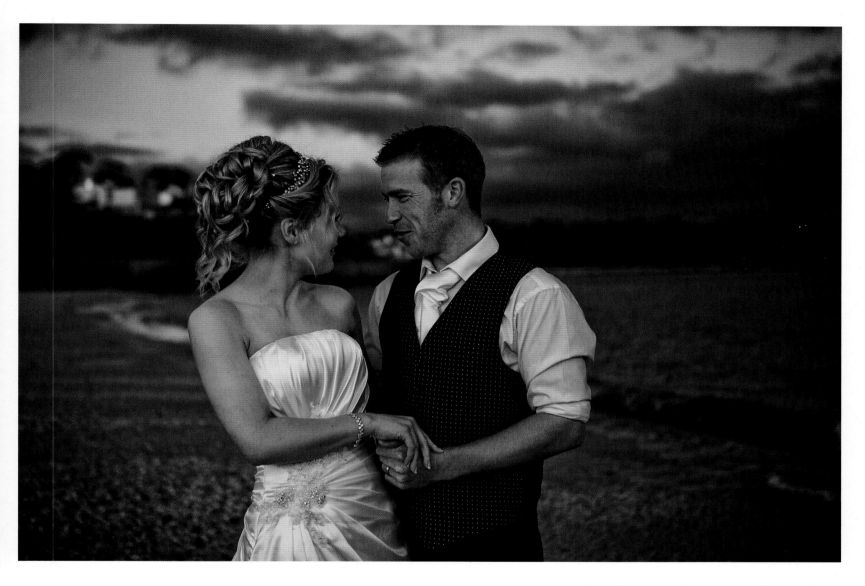

Above: The sun had set, but there was still some color in the sky when I took this shot. I took a meter reading from the brightest part of the sky and adjusted my exposure to give a reading of +1EV, which underexposed the sky slightly, making it appear more dramatic. However, this also meant that the couple would be underexposed, so I used flash to make sure they were exposed correctly, helping them stand out in the picture.

Focal length: 52mm

Aperture: f/2.8

Shutter speed: 1/125 sec.

ISO: 200

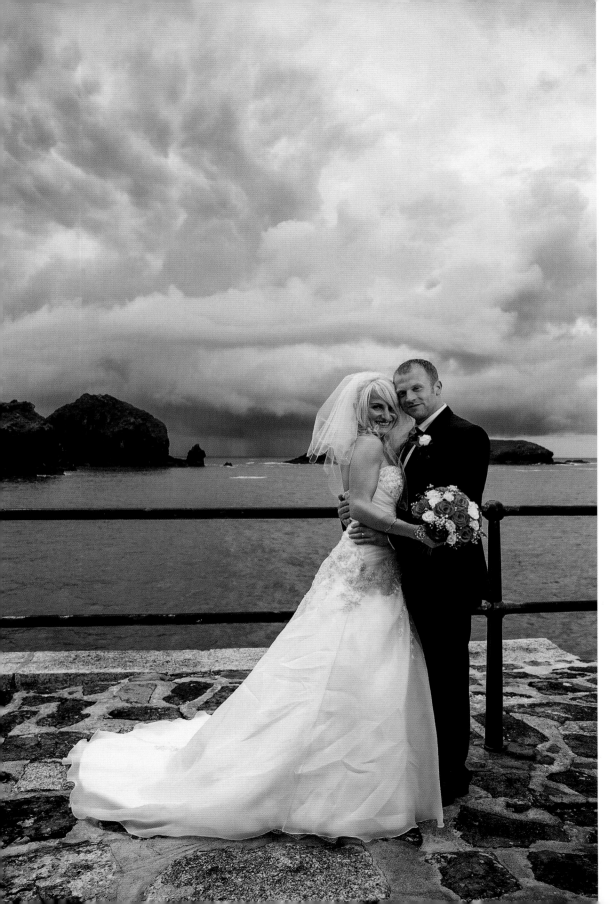

Left: Having chosen an aperture of f/5.6, I metered off the brightest part of the sky and adjusted my shutter speed to give a reading of +1EV. This meant that an already dramatic sky was made even more so by slight underexposure. An off-camera flash was then held at the right of the couple.

Focal length: 24mm

Aperture: f/5.6

Shutter speed: 1/640 sec.

ISO: 100

Documentary Photography

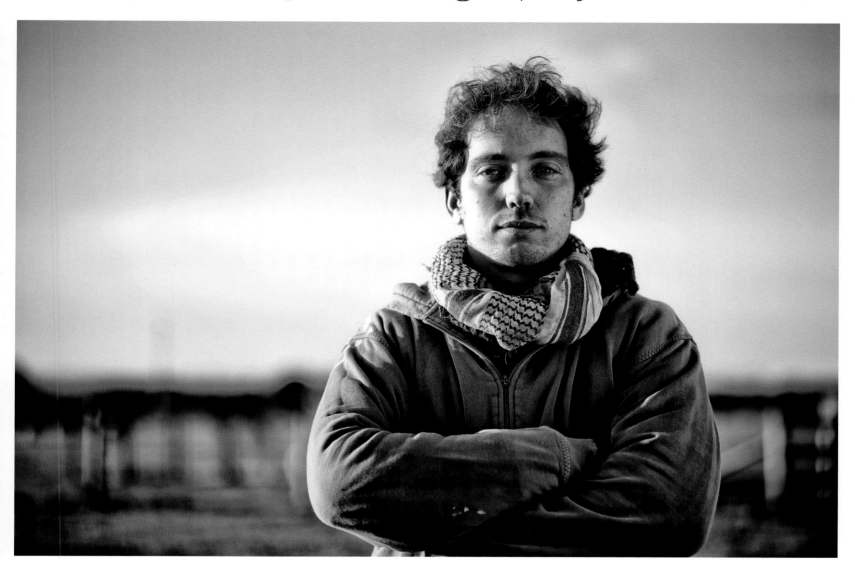

Documentary photography is arguably the genre most associated with black-and-white photography, where the medium is used as if to further reinforce the authenticity of the situation depicted: there is no questioning the honesty of black and white. This is at least partly a result of traditional newspapers, which saw "real-life stories" sitting alongside monochrome photographs— the black-and-white image becoming a literal illustration of "the truth." Although modern newspapers are mainly printed in color, black-and-white photographs are still used to document stories, and even today have the effect of adding credibility to the event being depicted.

Documentary photography covers a broad range of approaches, although it normally involves a body of work with a common theme photographed over a period of time. Collectively,

Above: This portrait is part of an on-going project documenting a wooden surfboard maker.

Focal length: 85mm

Aperture: f/2

Shutter speed: 1/640 sec.

ISO: 100

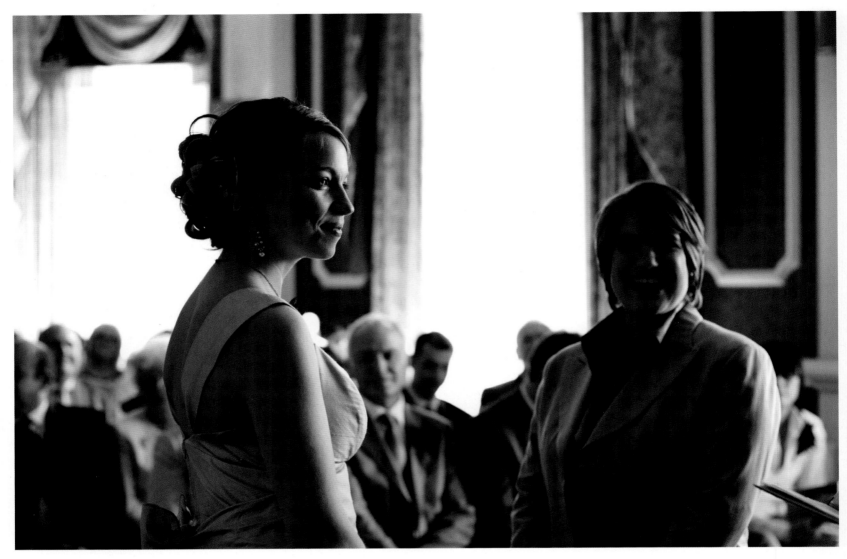

the images are stronger and tell more of a story than a single image could. The exception to this is photojournalism, which could easily be a single, exceptional image—being in the right place at the right time to capture a newsworthy event.

A documentary photography project is an excellent way of injecting some spark and enthusiasm into your photography, particularly if you are stuck in a creative rut. It doesn't have to be something exceptionally involved—just find a subject that interests you and see how you can create a series of images around it that tell a story and help hone your skills.

Photojournalism

Some of the most dramatic and thought-provoking monochrome images fall under the genre of photojournalism. With its strict ethics of truthfulness and impartiality, photojournalism has created some truly great monochrome images, taken in some of the world's most hostile and dangerous environments. Not all photojournalism involves war zones, deprivation, and poverty, though—there will be photojournalistic opportunities wherever you live.

Above: Wedding photography is often approached in a "reportage" fashion, but how you choose to interpret the light will still make or break a black-and-white photograph. Having a tonal range that exceeds the camera's capabilities forces you to make a choice as to how you would like the image to look.

Focal length: 50mm
Aperture: f/2.8
Shutter speed: 1/100 sec.
ISO: 100

Reportage

Digital photography has created a huge interest in black-and-white reportage photography, particularly with event photographers. Wedding photography has evolved from posed portraits of family members lined up in a row, to a "fly-on-the-wall" reportage approach that reveals the natural emotions of the day. Good reportage photography is about more than just recording an event, it is about interpreting it in an artistic way.

Being able to capture spontaneous moments requires not only an impeccable sense of timing, but also a good understanding of light and how you want the camera to record it. Shooting manually in mixed lighting requires a lot of skill as a photographer, and there will always be that fear of missing something. However, quality is better than quantity, and if you are always thinking about the light, then you are thinking like a photographer.

Above: It was the curved paving that first caught my eye and I photographed it without anyone in the frame. Although this resulted in an interesting abstract, it missed that extra something. It was when two people walked through the shot that I knew I had the missing piece of the puzzle. The human element completed the picture.

Focal length: 66mm

Aperture: f/16

Shutter speed: 1/125 sec.

ISO: 800

Street Photography

There are two main tactics when approaching the difficult and often frustrating genre of street photography: you either roam the streets looking for something to happen, or you find something of interest that will be dramatically improved by the addition of a well-placed human figure. I prefer the latter approach as it relies on good judgment more than luck. Whatever your approach, you need to be familiar with your equipment and try and blend in with your surroundings.

Remaining unobserved is one of the biggest challenges facing a street photographer. The easiest option is to stand back and use a long focal length, but then all of your images will have a distinctive "long lens" look, which creates distance not only between you and your subject, but also between the viewer and the subject.

Some of the best street photography has been taken using a 35mm or 50mm lens. This means getting close to your subject while still being able to take photographs. One technique is to shoot from the waist without looking through the camera's viewfinder. With a little practice you can soon get usable images and it doesn't look like you are taking photographs. Wear dull clothing and try and blend in with the other people around you. A small camera will not draw the same attention that a DSLR will, and for that reason it is often the best choice for street photography.

Shooting manually can present something of a problem with street photography—if you are trying to work discreetly, looking through the viewfinder while you decide what exposure settings to use will give the game away. Instead, it is far better to have the camera already set up. Start by choosing an aperture of around f/8, which will give you a good depth of field, as well as being where your lens is optically at its best.

Then, manually focus the lens at the hyperfocal distance for your chosen aperture. This is the point at which everything from half that distance to infinity will be acceptably sharp. For a 35mm lens set at f/8, the hyperfocal distance is about 16 feet (5m), so everything from 8 feet (2.5m) to infinity will be sharp.

Finally, switch to multi-area metering (spot metering is not a practical option in this scenario), and set the ISO to Auto. If you can assign a minimum shutter speed that the camera cannot go below then make this the slowest speed at which you can comfortably handhold the camera.

> **NOTE**
> There will always be the moral dilemma of whether or not to ask permission before you take someone's photograph. Generally speaking, if you ask permission, it will probably result in a better portrait, but you will lose the "candid" look that typifies street photographs.

Right: Street photography doesn't necessarily have to be about people—it is about capturing the interesting and the unusual.
Focal length: 50mm
Aperture: f/2.8
Shutter speed: 1/1000 sec.
ISO: 100

Still Life Photography

Put simply, still life photography is the arrangement of an object or objects in an artistic way, which is then photographed. Owing to its absence of color, back-and-white still life images have to rely solely on shapes and textures, but even the most mundane of subjects can look good if presented in an artistic way. Look at the work of Edward Weston—particularly his study of a shell—to see how the ordinary can be made extraordinary.

There are three main considerations with still life photography: your choice of subject, how you present it, and how you light it. It is important to get all three elements right if you want to have an image that stands out.

The Subject

This can be broken down into two distinct genres: natural and manmade. In either case, the simple question you have to ask yourself is, "is it photogenic?" The natural world is full of photogenic objects, and a quick look in your refrigerator or fruit bowl will reveal myriad shapes and textures.

You may like to look at the monochrome botanical photographs of Karl Blossfeldt for inspiration—they are somewhat clinical in their presentation, but demonstrate some of the diversity and beauty of the natural world.

Although slightly macabre, I have also seen some excellent still life photographs of dead seabirds, typically presented in an old wooden

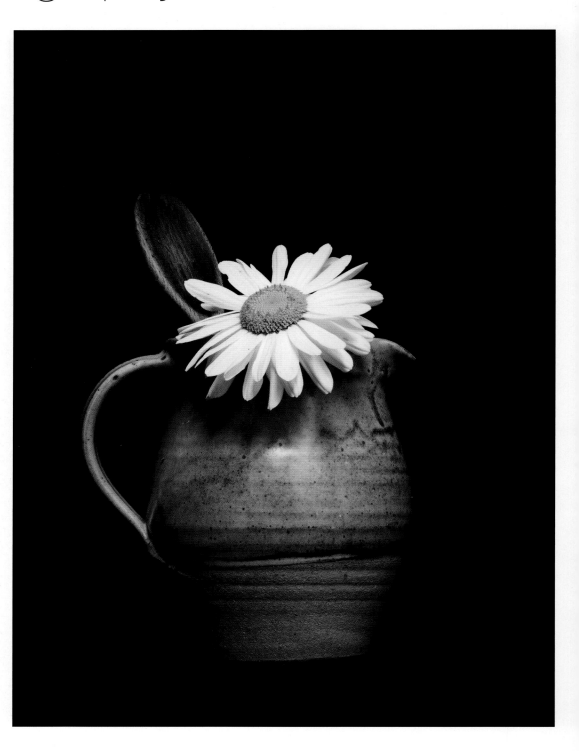

Right: The subject was illuminated by a skylight above. I used a polarizing filter to try and cut down some of the reflections on the jug's glaze, and based my exposure on the flower, as it was the brightest part of the scene.

Focal length: 90mm

Aperture: f/22

Shutter speed: 10 sec.

ISO: 100

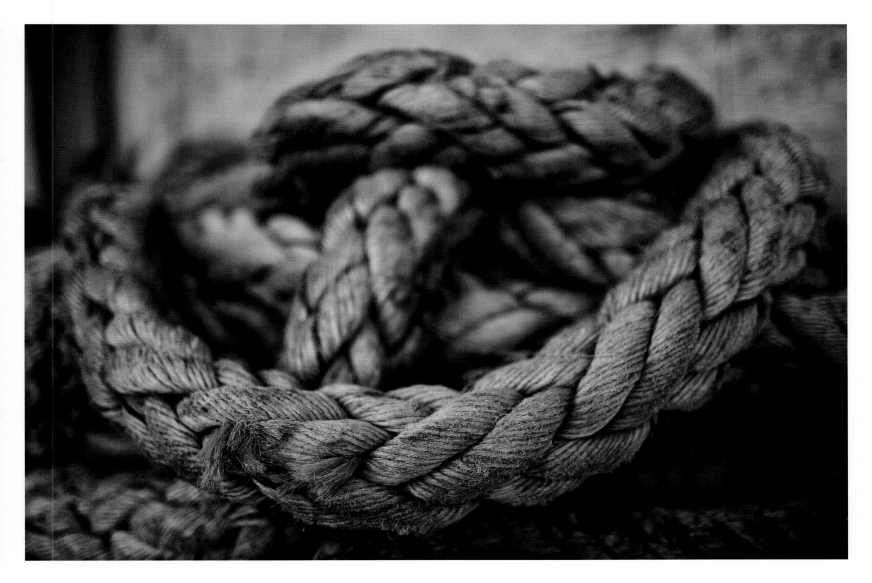

box. There is a beauty in death as well as in life—how you present it is the key to its success. Manmade objects that look interesting tend to be those that are unusual, rustic, or old.

Presentation

How you present your subject is as important as your subject choice and there are two main considerations: where are you going to place it, and what is going to be behind it? When deciding on a backdrop, nothing should draw the viewer's

eye from the subject and it is for this reason that a typical backdrop for a still life is monotonal, featureless, or at the very least out of focus. If the eye is drawn to the background, some of the impact of the subject will be lost—remember that you are trying to show the beauty in an arrangement and nothing should detract from this.

Lighting

How the light interacts with the subject is the key to success with a still life photograph. Natural light

Above: Although I didn't set up this composition, it can still be classified as a still life. I didn't have a tripod with me, so I set a wide aperture to give me a shutter speed I could comfortably handhold. I took several shots to make sure that one of them was sharp in the right place—this is something I always do when working with such a shallow depth of field.

Focal length: 35mm

Aperture: f/1.4

Shutter speed: 1/640 sec.

ISO: 100

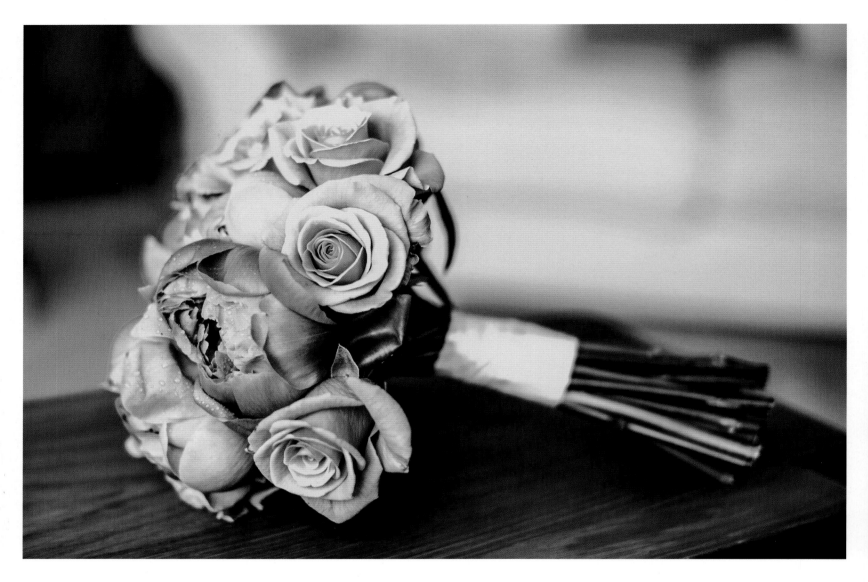

is always my preference, with the aid of a reflector to help fill in the shadows. This gives a softer, more natural look than studio lights, and is of course considerably cheaper!

The only problem with using natural light to illuminate a still life is that you are limited to working in daylight hours. If you don't have any natural light, then try using a lamp reflected off white card. Use this in conjunction with a reflector or a second lamp placed opposite as a fill-in light.

Whenever possible, you should use a tripod for still life work, as you need to be able to make changes to your arrangement so you can see the

difference it makes to the composition without moving the camera. You may also be using a small aperture to maximize the depth of field, and this could result in a slow shutter speed that makes handholding the camera impossible.

Another trick for maximizing the depth of field is to focus one third of the way into the frame. Use Live View and the camera's depth of field preview button to check everything is sharp, or take a photograph, play it back, and zoom in to check sharpness across the frame. Another effect that works well is using a shallow depth of field and having a sharp point of interest as the focal point.

Above: When I photographed weddings for a living, I frequently had to quickly set up still life arrangements. I never had the time to use a tripod, so they were invariably shot with a wide aperture/shallow depth of field to give me a fast shutter speed.

Focal length: 50mm

Aperture: f/2

Shutter speed: 1/250 sec.

ISO: 800

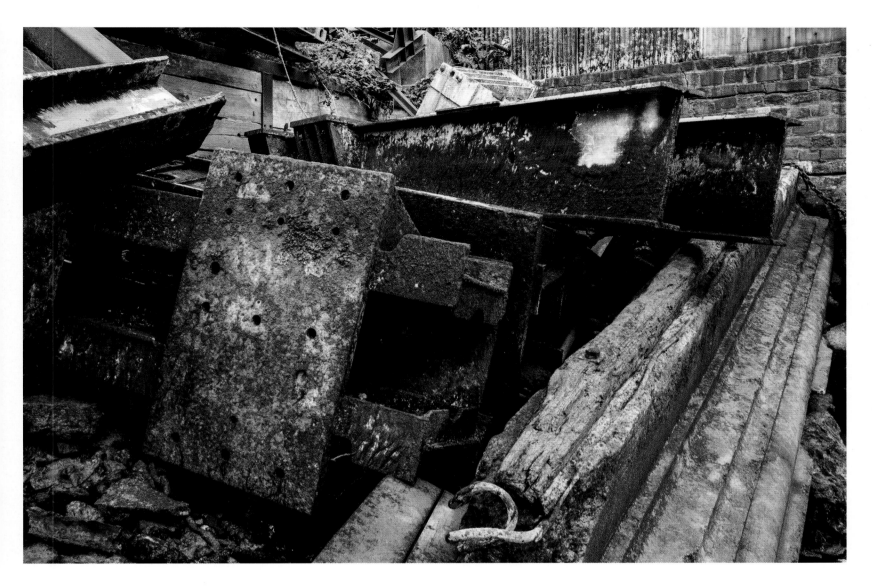

Above: When shooting still life images there will be occasions when you cannot manipulate your subject. Instead, you will have to move around it until you find the best angle. Having found your shooting position, use a tripod so that you are able to fine tune your composition easily.

Focal length: 35mm

Aperture: f/16

Shutter speed: 1/4 sec.

ISO: 100

Architectural Photography

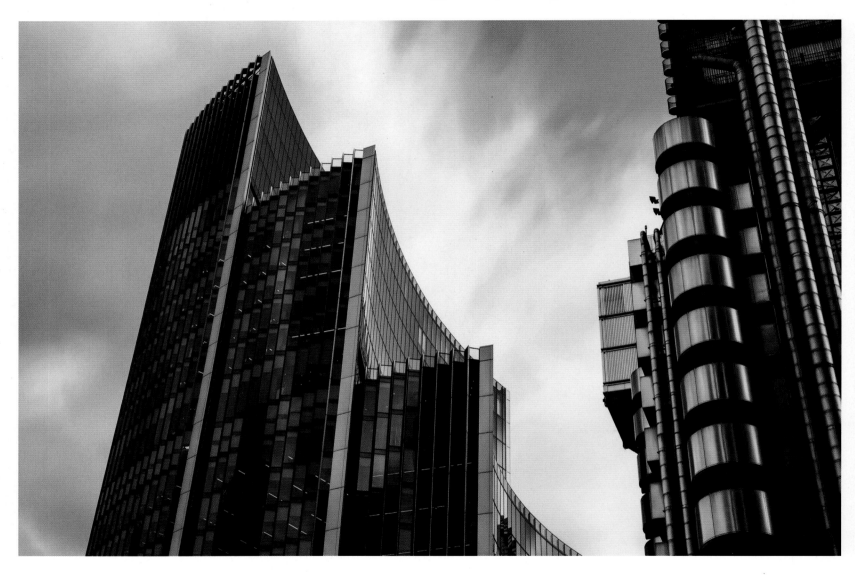

Traditionally, architectural photography was the preserve of large-format cameras with built-in movements that could correct converging verticals and reveal the subject in amazing detail. However, you don't have to use a large-format camera to take good architectural photographs; it can be a rewarding subject whatever camera you use, and it's also easily accessible. Modern architecture typically has big areas of glass and shiny steel, all of which are highly reflective and well suited to a black-and-white treatment.

Above: A long exposure was used here, to show some movement in the clouds. As that was the brightest part of the scene, this was where I based my exposure, knowing that the buildings would have areas of dark black to complement it.

Focal length: 50mm

Aperture: f/11

Shutter speed: 5 min.

ISO: 100

Lighting

It is a fair assumption that you cannot light a building, so you have to work with what is available, or come back at a different time of day when the light is more favorable.

Side Lighting

Side lighting is generally considered to be the best light for architectural photography, as the shadows model the building, drawing attention to details and giving the image depth.

Front Lighting

Light falling on the front of a building is ideal if you simply want to create a record of a building, but it is not considered interesting. Shadows will be minimal, so textures and details will not stand out, making the building appear "flat."

Backlighting

This is the worst kind of lighting for architectural photographs, unless you want to record a silhouette. A strongly backlit building that is correctly exposed will result in a burnt-out sky.

Crossover Light

The "crossover light" between day and night is generally thought to deliver the best results for architecture. Balancing twilight with the artificial lighting inside a building gives an even and interesting luminance throughout the frame. However, the striking color contrast between the cool blue sky and warm orange interior lighting is lost in monochrome.

Right: Backlighting is not usually ideal for architectural photography, but on this occasion it worked well. The light helps draw the eye toward the buildings and accentuates their reflections.

Focal length: 24mm
Aperture: f/16
Shutter speed: 20 min.
ISO: 100

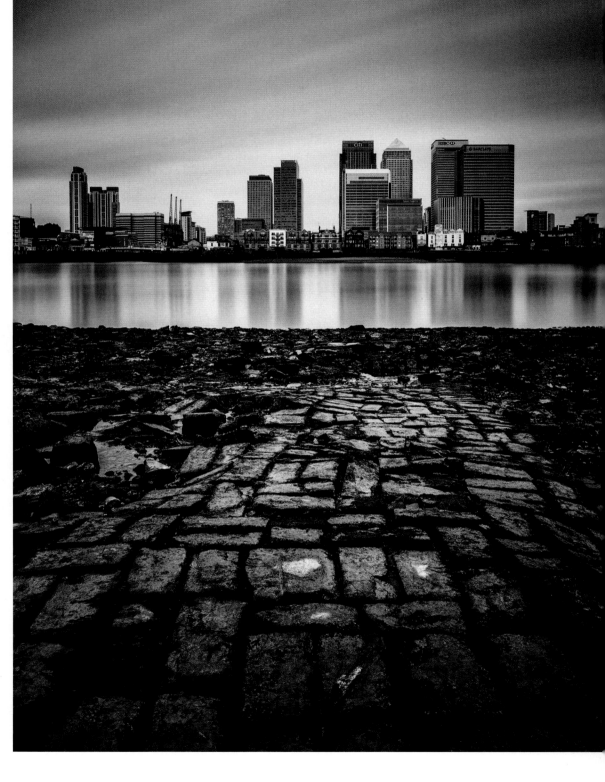

Cloudy Days

When it's cloudy, contrast is reduced, giving much softer results that can lack the drama and impact that often benefits a monochrome image. Although a lack of contrast can help bring out the detail in a building, the image runs the risk of looking flat and boring if it includes a large expanse of featureless gray sky.

Midday Sun

One of the joys of monochrome architectural photography is that the harsh midday sun can deliver some excellent results. However, as the contrast between the brightest and the darkest tones may be beyond the range of the camera's sensor, it is a good idea to expose for the highlights and allow dark shadows to add drama.

Above: It was the juxtaposition between the old and the new that inspired me to take this photograph. The harsh shadows benefit a black-and-white photograph, with the statue taking prominence at the center of the frame.

Focal length: 70mm

Aperture: f/8

Shutter speed: 1/125 sec.

ISO: 200

Converging Verticals

When you aim your camera upward to include the top of a building, it will cause the building's edges to converge toward the center of the frame, hence "converging verticals." How you choose to deal with converging verticals is down to what tools you have at your disposal and personal taste. There are several options available to you:

1 Do nothing and just go with it. Alternatively, use a wide-angle lens and get in close to exaggerate the effect. Although this is not how we naturally see buildings, the effect is not unpleasant, and because you know the building is straight, the eye will accept it.

2 Use image-editing software to correct it. This works very well, but is achieved by cropping the image and stretching the pixels. This needs to be taken into account when you're taking the photograph—if the edges of the building are too close to the edges of the frame you could end up losing an important part of the image when you crop it. To avoid this, ensure there is room around the building to allow for straightening and cropping later.

3 Stand far enough away so that the camera is parallel to the building, while getting the entire building in the frame. As you have not had to tilt the camera upward, you will not create converging verticals. However, it may not be possible to stand far enough away from the building to do this.

4 Use a tilt-and-shift lens (see page 146).

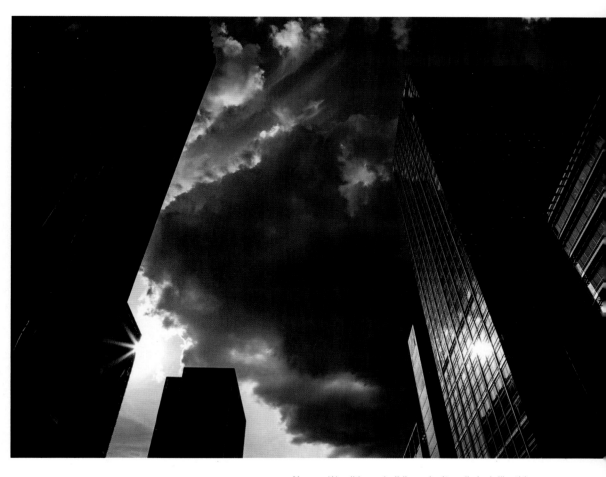

Above: We all know buildings don't really look like this, but the creative use of converging verticals can add to an image. I metered close to the sun and partially hid it behind the building to try and control lens flare.

Focal length: 24mm

Aperture: f/16

Shutter speed: 1/160 sec.

ISO: 100

Tilt & Shift Lenses

A tilt-and-shift lens is designed to mimic the movements available on a large-format camera, enabling you to keep the back of your camera parallel to your subject, while shifting the lens upward to include it in its entirety. This is the ideal solution for converging verticals, although these lenses are expensive and tricky (and slow) to use.

However, not only are they the lens of choice for the serious architectural photographer, they are also excellent for landscape photography, where the "tilt" function can be used to extend the depth of field at any given aperture. This means you might be able to achieve the same depth of field at f/8 as you can at f/16, for example, which avoids any issues with diffraction.

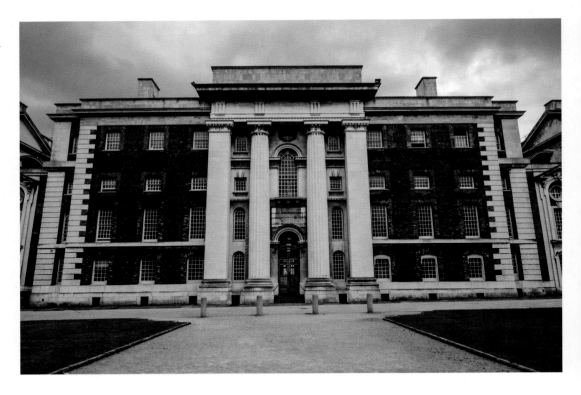

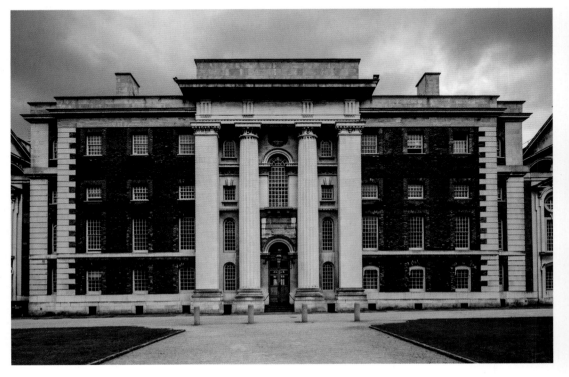

Right Top & Right Bottom: When I took this photograph I was stood with my back up against a fountain, unable to go any further backward. It is in situations like these that a tilt-and-shift lens really comes into its own; here it enabled me to get a frame-filling shot of the building, without introducing converging verticals.

Focal length: 24mm

Aperture: f/11

Shutter speed: 1/50 sec.

ISO: 100

Details & Abstraction

Unless a building is positioned on its own, the chance of photographing it as a standalone subject can be remote. This often proves the case in cities, where space is at a premium and buildings are crammed tightly together. In this situation it can be impossible to stand far enough back to include the whole building in the frame.

This is the ideal time to look out for details and abstract patterns. Modern architecture often cries out for an abstract approach, where the more unrecognizable the subject, the better. Try and move away from showing everything in three dimensions and concentrate instead on the arrangement of shapes, patterns, and strong dynamic lines.

The juxtaposition of old against new, straight against angular, or light against dark can also create interesting images—try photographing the reflection of an old building in a modern building, for example. If you can capture the contrast between two different variables it adds an extra element to your composition.

Right: The inside of buildings—especially old ones—can offer some excellent opportunities for detail shots. Pay attention to the background and look out for the interesting and the unusual.

Focal length: 70mm

Aperture: f/2.8

Shutter speed: 1/125 sec.

ISO: 100

Left: When I first saw this reflection I was disappointed that the water wasn't still, as I had wanted to photograph the building with its perfect reflection. In hindsight, what I ended up taking was better suited to a monochrome image and also far more original.

Focal length: 38mm

Aperture: f/8

Shutter speed: 1/125 sec.

ISO: 400

Chapter 6
Postproduction

The days of darkened rooms, noxious chemicals, and wasted paper in the pursuit of a decent black-and-white print have now become the preserve of a few dedicated black-and-white film users. For everyone else, the monochrome magic takes place in the digital darkroom. This new way of working has revolutionized black-and-white photography, making it accessible to anyone with a computer and some image-editing software.

This ease of accessibility, combined with black and white's timeless appeal, has resulted in its popularity increasing. There is a wide choice of programs to convert a color photograph into black and white, as well as plugins designed to emulate old film types (many with a simple click of the mouse). One of the great things about black-and-white photography is that anything goes—you are only limited by your imagination and (to some extent) your choice of editing software. Consequently it is easier than ever to achieve stunning results and get the pictures you want.

Right: With a good digital negative as a starting point you can make substantial adjustments to the image. However, some of the best monochrome images require very little work.

Focal length: 400mm

Aperture: f/5.6

Shutter speed: 1/1000 sec.

ISO: 400

Software

Most digital cameras come with a basic Raw file converter that will allow you to make a monochrome conversion. However, there are also many third-party options available, and these will typically offer a far greater level of control when it comes to converting an image to black and white. Using a third-party program also means it doesn't matter what make of camera you use—you only need to learn how to use one program.

Whatever image-editing software you choose, the main consideration should be the level of control you have over the colors during the black-and-white conversion—the greater the control you have, the more options there are when it comes to determining the final look of your image.

Having good contrast control is also important, both in terms of adjusting the contrast across the image as a whole and for performing localized, targeted adjustments.

Your image-editing software should also be relatively easy to understand and enjoyable to use—with such an important part of the creation of a black-and-white print involving software, the less fraught it is to use, the better.

There is a wide range of software available, but the most widely used programs are all made by Adobe: these are Photoshop, Photoshop Elements, and Lightroom, which we shall explore here. There are, of course, other options—Corel's PaintShop Pro is similarly priced to Elements and offers a comparable level of control, for example, while GIMP is an open-source program that provides sophisticated image editing at zero cost (the downside is its less refined interface).

Right: Having a high level of control over how colors translate into tones is where good conversion software comes into its own.

Focal length: 24mm

Aperture: f/16

Shutter speed: 0.4 sec.

ISO: 100

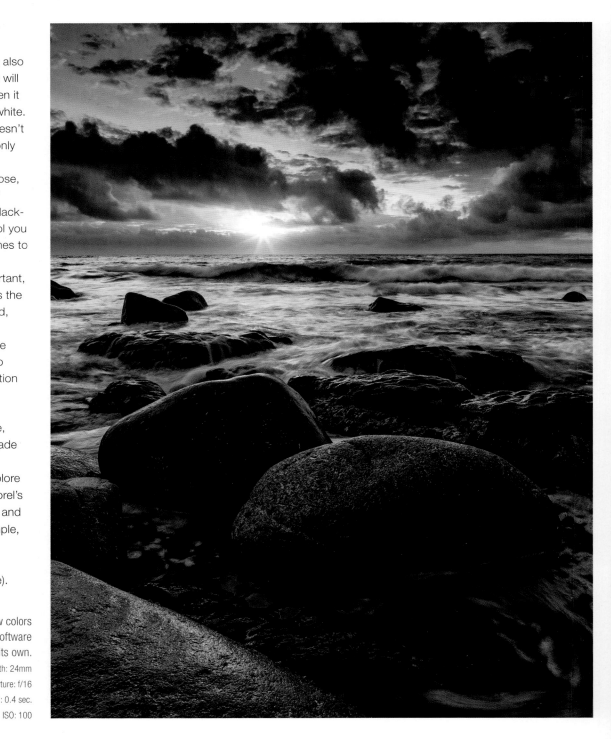

Adobe Photoshop Elements

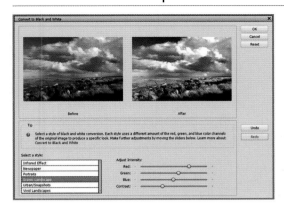

Elements' Monochrome Tools

The cheapest of the three Adobe offerings, Elements is a stripped down ("elementary") version of Photoshop for the consumer market. Consequently, there is more of an emphasis on "Auto" settings, but you still get control over how a monochrome conversion takes place.

If you are shooting Raw files, Elements uses the Adobe Camera Raw (ACR) engine to process and convert Raw files. However, while this is essentially the same Raw conversion technology used by Lightroom and Photoshop, the Elements version is not as sophisticated, with more limited control.

For converting color JPEGs to black and white, Elements' main conversion method is found in the Enhance menu. This enables you to adjust the ratio of the red, green, and blue channels (in a similar fashion to Photoshop's Channel Mixer—see page 156), and it also has a dedicated contrast slider.

The downside is that the monochrome conversion is applied directly to the image, rather than to a separate layer. This means you cannot change the settings once they have been made. Elements also lacks a dedicated Curves function for controlling contrast, which again limits you when it comes to producing black-and-white photographs. However, Elements is still capable of delivering excellent results—you simply have to accept it is not with the same degree of finesse that you would get from Photoshop or Lightroom.

Dodge and Burn: Similar to Photoshop's tools of the same name, but with less control over the softness of the brush.

Levels: Accessed by choosing *Layer > New Adjustment Layer > Levels...* from the main menu. Levels is excellent for brightening or darkening either the whole image or selective areas. You can reduce its effect on specific parts of an image by selecting the Levels adjustment layer and using the Eraser tool, applied with a soft brush.

Brightness and Contrast: Click on *Layer > New Adjustment Layer > Brightness and Contrast* to create a layer that enables you to adjust the brightness and/or contrast of underlying layers. The tools are relatively simplistic, so care is needed to avoid clipping the highlights or shadows.

Vignette: Darkens (or lightens) corners of your image, to give it a more "vintage" look. The Vignette tool is found in the Filter menu under the Correct Camera Distortion tab.

Toning: In Elements, you can add a tone to a black-and-white image using a Hue/Saturation adjustment layer (*Layer > New Adjustment Layer > Hue/Saturation*). Make sure the Colorize box at the bottom of the dialog window is checked, then use Hue to choose your color and Saturation to control its intensity.

Adding grain: Faux film grain can be added using *Filter > Noise > Add Noise*. You must apply this directly to the image layer (not an adjustment layer), so it should be one of the very last steps in your editing. Better still, save it until the very end and keep two versions of your image—one with grain, and another without.

Adobe Lightroom

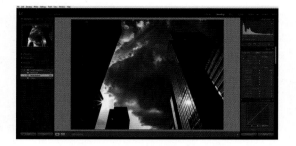

Lightroom is the most recent offering from Adobe and unlike Photoshop (and, to a lesser extent, Elements), it is aimed solely at photographers. As such, it offers an extremely high level of control over your monochrome conversions, with the addition of a wide range of user presets to choose from. The overall feel of Lightroom and the way everything is set out is (relatively) easy to understand, so you feel in control of what you are doing. Lightroom also works with a wide range of plugins and is only marginally more expensive than Elements, making it a good option.

Lightroom's Monochrome Tools

Black & White adjustment: This panel gives far greater control over a monochrome conversion than Elements, allowing you to adjust the ratio of eight different colors (effectively emulating the use of colored filters over the lens). There is also a target adjustment tool that can be placed over a specific tone in the image—dragging the mouse up will make that tone brighter; dragging down will make it darker.

Tone Curve: This panel is used to adjust the contrast across the whole image. It offers a high level of control, plus several preset options (the Strong Contrast preset is well suited to monochrome images).

Clarity: Found in the Basic panel, the Clarity slider can be thought of as "micro contrast." It is superb at giving an image extra punch and definition by bringing out detail in the midtones.

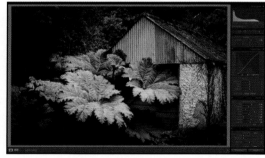

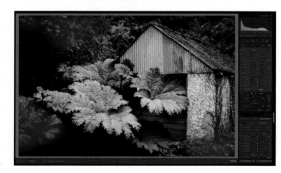

Targeted adjustment brush: Located in the tool panel below the Histogram, the adjustment brush can be used to change a wide range of settings on

any part of the image. Simply brush the area you want to adjust and then use the relevant slider to make your adjustment. I favor a Feather of 100, as this creates a very soft brush that gives subtle results.

Split Toning: This panel allows you to add a tint of any color to the highlights and the shadows. The balance between them can be adjusted using the Balance slider.

Vignette: Vignettes are best applied using the Post-Crop Vignetting tool in the Effects panel. It allows a high degree of customization and will automatically re-apply the same vignette should you later decide to crop the image.

Grain: Also found in the Effects panel, and an easy way to replicate the look of an old film type or disguise a noisy image.

Radial filter: Found next to the Adjustment brush, the Radial filter can be used to quickly draw attention to your subject. Simply drag and adjust the area of the filter to cover your subject; changes made in the adjustment panel will only affect the areas outside the selection.

Although not aimed specifically at the monochrome photographer, Lightroom also has an excellent Print module, which includes options for creating an online photo gallery or even a book that you can upload directly to Blurb, or save as a PDF file. Lightroom is also compatible with a range of plugins, making it an excellent choice for the black-and-white photographer.

Adobe Photoshop

Photoshop is the industry standard when it comes to image-editing software, but it is also the most expensive option (currently you have to subscribe on a monthly basis to access the program).

As its sophistication might suggest, it offers many ways of converting an image to black and white and provides you with a great level of control over the individual colors. It also provides the most control over any further adjustments, be it contrast, dodging and burning, toning, and so on. Consequently, any monochrome "look" can be replicated in Photoshop—it might not necessarily be easy, but it can be done.

The Adobe Camera Raw engine used by Photoshop is essentially the same as that used by Lightroom (and, to a lesser extent, Elements), with the notable exception of the targeted adjustment tool in Lightroom's HSL/Color/Grayscale panel, and its Radial Filter. The main drawback is the level of complexity and the time it takes to learn how to use the program—with so many tools at your disposal it can be hard to know where to start.

Which is Best?

Determining which of the three Adobe products is "best" for black-and-white photographers is hard to say. For ease and pleasure of use I would say it has to be Lightroom, but if the decision were based on cost it would be Elements.

While Photoshop offers the most control, a monthly subscription is not something that everyone wants to sign up to, and some of the tools it offers will never be used. These non-photographic tools add unnecessary complexity to an already complicated program, making it a bewildering proposition for newcomers.

However, the good news is that whichever program you choose, there is no reason why you cannot produce a good quality monochrome print—you just need to become proficient with your chosen software and recognize its strengths and weaknesses. That said, as Photoshop is the industry standard when it comes to monochrome digital photography, the rest of this chapter will concentrate on that program.

Plugins

Although Photoshop may be the best program in terms of the level of control it offers, it is far from the easiest to use. That accolade is reserved for the specialist black-and-white plugins that are dedicated to converting images to monochrome. The list is extensive, but some of the better known ones are Topaz B&W, Silver Efex Pro, Perfect B&W, VSCO Film, and DxO FilmPack.

But, having already bought a program that converts images to black and white, why bother investing even more money in a dedicated mono conversion plugin? The reason is simple. While you may be able to achieve similar results in Photoshop, the chances are you would need to be a Photoshop expert to do so. What a dedicated black-and-white plugin brings to the table is ease of use, speed, and a more focused user experience. All the controls are dedicated to creating black-and-white images, and there will likely be an excellent array of presets to choose from, meaning you are totally immersed in the world of monochrome.

I regularly use two plugins in both Lightroom and Photoshop. For black-and-white landscape photography I will normally use Silver Efex Pro, and work on one image at a time. However, if I have a collection of images that I would like to appear as though they were taken on the same film type, I will use a tweaked VSCO Film preset.

Above: The different layouts of three of the more popular black-and-white plugins: DxO FilmPack, Silver Efex Pro, and Topaz B&W.

Black & White Conversions

There are numerous ways to convert an image to black and white using Photoshop; some of the better-known methods are covered here, along with their Elements and Lightroom equivalents (or alternatives).

As previously stated, starting with a color image—so the color information is available to manipulate both before and after the monochrome conversion—will give you the greatest level of control over how the final image looks.

Grayscale

This is the simplest method of converting a color image into black and white. It simply converts the colors into luminance values (their corresponding levels of brightness) and then discards the color information, giving you a black-and-white image.

However, you have no control over the monochrome conversion, so images converted this way will typically look rather flat. Also, as the color information is discarded, your options for fine tuning the image become somewhat limited—you cannot adjust specific colors or emulate colored filters to make the green leaves on a tree brighter, or a blue sky darker, for example.

1 Open the image (TIFF or JPEG) in Photoshop.

2 Select *Image > Mode > Grayscale* from the top menu.

3 When asked if you want to "Discard color information?" click Discard.

Elements: Use *Image > Mode > Grayscale.*
Lightroom: Use *Settings > Convert to Grayscale.*

Channel Mixer

Photoshop's Channel Mixer provides you with a slider for the red, green, and blue channels in your image, allowing you to adjust the brightness of the corresponding color even when the image is in black and white.

The best way to implement the Channel Mixer is as an adjustment layer, so you can reselect the layer and make further changes later on. Keeping the black-and-white information on a separate layer is known as "non-destructive editing," as it does not affect the underlying image; by deleting or turning the adjustment layer off you can revert back to the original color image at any time.

1 Open the image (TIFF or JPEG) in Photoshop.

2 Select *Layer > New Adjustment Layer > Channel Mixer.*

3 In the Channel Mixer dialog box check the Monochrome option to convert your image to black and white.

4 Adjust the Red, Green, and Blue sliders to alter the image and get the effect you are after. The numerical values for each slider are shown as a percentage and although it is said that the total ratio between the three should be around 100%, in practice this needn't be the case.

5 There is a number of presets you can choose from to mimic using a colored filter. It is always worth trying these presets because they can potentially save you a lot of time.

Elements: Use *Enhance > Convert to black and white* instead.
Lightroom: Use HSL/Color/Grayscale panel.

NOTE
In early versions of Photoshop, the Channel Mixer was the standard method for converting images to black and white. However, it has now been superseded by Black & White adjustment layers, which are far more sophisticated.

Black & White Adjustment Layers

Having a dedicated black-and-white adjustment layer is similar to using the Channel Mixer, but you have far greater control. In addition to sliders for adjusting the Red, Green, and Blue channels there are sliders for Cyan, Magenta, and Yellow as well. There is also a targeted adjustment tool that you can place on any tone on the image to adjust it directly. This allows you a greater degree of control over how the colors are represented during the black-and-white conversion process.

1 Open the image (TIFF or JPEG) in Photoshop.

2 Select *Layer > New Adjustment Layer > Black & White* from the main menu.

3 Adjust the color sliders to get the effect you are after. If you want to make a targeted adjustment, click on the hand icon in the Black & White dialog box, and place the eyedropper tool on the point you want to adjust. Hold the mouse button down and move the mouse to the right to lighten the tone, or to the left to darken it.

4 As with the Channel Mixer, there is a number of different colored filter presets available to use, although Black & White adjustment layers offer considerably more choice.

Elements: Use *Enhance > Convert to black and white*.
Lightroom: Use HSL/Color/Grayscale panel.

NOTE
It is also possible to tint an image using a Black & White adjustment layer. In the Properties dialog box, simply check the Tint box and select the color you want to use from the colored box. Should you change your mind, you can uncheck the Tint box to revert to black and white, or change the color of your tint.

Adobe Camera Raw

Adobe Camera Raw (ACR) is where you should do all the basic adjustments before opening a Raw image in Photoshop. It is mentioned here because ACR's HSL/Color/Grayscale panel allows you to convert your image to monochrome. However, if you do this, all the color information will be discarded once you open the image in Photoshop. Again, this severely limits how much control you have over the final image. For this reason, I don't recommend converting the image to monochrome at the Raw conversion stage (the exception to this is if you are using Lightroom, as this is the only way of converting an image to monochrome unless you are using a plugin).

Elements: Uses a limited version of ACR.
Lightroom: Uses the same ACR engine as Photoshop.

Silver Efex Pro

One of the benefits of using Photoshop (and Lightroom) is that you can use a plugin to convert your image to monochrome. Silver Efex Pro is one of the better-known black-and-white programs, with all the tools dedicated to black-and-white photography in the same place. Most of the time it seems to create a better "look" than Photoshop.

You should perform your basic Raw adjustments in Photoshop before opening your image in Silver Efex Pro. You should then apply Silver Efex Pro to a Smart Layer, as this will allow you to reopen the plugin and make any further adjustments. If you don't apply it to a Smart Layer you will not be able to reopen the plugin and refine your image once it has been closed.

1 Open the converted Raw image in Photoshop.

2 Select *Layer > Duplicate Layer*.

3 Click on *Layer > Smart Objects > Convert to Smart Object*.

4 Choose *Filter > Nik Software > Silver Efex Pro*.

When Silver Efex Pro opens, your image will be in monochrome, ready for further adjustment. At the left side of the screen is a wide range of presets to choose from. These can be surprisingly effective—some of my favorites are High Structure, Wet Rocks, Dark Sepia, and Film Noir 1.

At the right side of the screen are all the tools for adjusting the image; they are all dedicated to

black-and-white photography and most are self-explanatory. There are, however, some that are worthy of further explanation:

Structure: Found in the Global Adjustments panel, Structure is a micro contrast control that is excellent for enhancing texture. It is similar to the Clarity slider in ACR and Photoshop, but with dedicated sliders for highlight, midtone, and shadow areas. The Fine Structure slider concentrates on areas with high levels of detail.

Film Types: In the Film Types panel there is a dropdown menu giving you a choice of different films. Holding the cursor over each film type will show you a preview of what it will look like on the screen. Before committing to a specific look, I like to zoom in to 50% to gauge the effect in the shadow areas.

Sensitivity: Sensitivity sliders for different colors are also found in the Film Types panel. These allow you to adjust the individual colors in the image, just as you would with a Black & White adjustment

layer in Photoshop. Effectively it's like using colored filters over the camera lens.

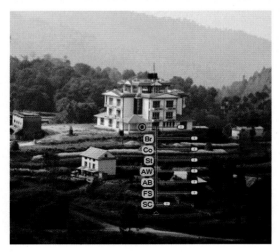

Control Points: In the Selective Adjustments panel you will find Control Points. You can add a control point anywhere in the image to make a targeted adjustment. Simply click on the Add Control Point button and then on the image where you want to make an adjustment.

Each control point offers an array of sliders that are used to make your adjustments: the top

slider controls the size of the adjustment, followed by sliders for Brightness, Contrast, Structure, Amplify Whites, Amplify Blacks, Fine Structure, and Selective Colorization.

In the control panel you can turn a Control Point on and off, and by checking the small box after the percentage value you can show just where the adjustment is being targeted. You can have as many Control Points as you like, allowing a high degree of customization.

Contrast Control

With contrast being such an important part of a monochrome image, being able to perform both general and localized adjustments is essential. In Photoshop, the two most important tools for controlling contrast are Levels and Curves.

Levels

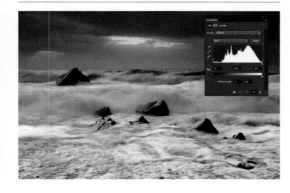

A Levels adjustment layer is normally used when the tonal range of an image needs correcting; changes will affect all the tones across the image.

Start by creating a Levels adjustment layer (*Layer > New Adjustment Layer > Levels...*)

The Levels panel contains a histogram showing how the tones (from black to white) are distributed throughout the image. As with the histogram on your camera, the left side ("0") is pure black and the right side ("255") is pure white, as indicated by the arrows under each end of the graph.

Sliding the black arrow toward the center of the histogram will make the dark tones darker, while moving the white arrow toward the center will make the bright tones brighter. If the histogram falls short of either end of the graph when you open the Levels dialog, moving the relevant arrow to the start of the histogram can make a massive improvement to an image.

NOTE
The gray slider below the center of the Levels histogram controls "gamma," which is effectively the overall brightness of the image. Sliding it to the left or right will darken or lighten the image.

Curves

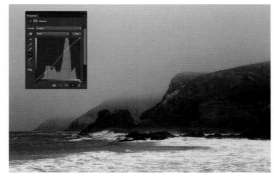

While Levels is typically used for repairing the contrast of an image and preventing it from looking flat, Curves is used to add drama. This is because a curve allows you to adjust specific tones in the image, without affecting the others. For example, you can make the highlights brighter without affecting the midtones and shadows; darken the shadow areas without altering the highlights; or intensify both the shadow and highlight areas without "clipping" (losing detail) in either of the tonal extremities.

To access Curves, choose *Layer > New Adjustment Layer > Curves...* from the main menu. This will apply the curve as a non-destructive adjustment layer, rather than it affecting the underlying image directly. Consequently, you can go back and edit the curve at any point.

To add contrast to an entire image, you apply what is known as an "S-shaped curve" (or "S curve"). When you open the Curves dialog, you will see a line running from the top right to bottom left of the Curves window. Although straight, this is your "curve," and like Levels it extends from black (the left end of the line) to white (the right end).

If you click on the curve toward the lower left side and pull the line downward, you will see the dark tones in your image get darker still. Click on the curve toward the upper right side and push the line upward and the lighter areas will become brighter. You will also notice that this changes your curve from a straight line to an elongated "S" shape—the classic, contrast-boosting "S curve."

Something I frequently do is to slightly exaggerate the S curve to give too harsh an effect, and then reduce the Opacity of the Curves adjustment layer.

NOTE
Curves is not available in Elements, only in Lightroom and Photoshop.

Selective Contrast Control

Levels and Curves can also be used to adjust contrast to a smaller, localized area of your images. To do this, you first need to make a selection of the area you want to adjust using one of Photoshop's (many) selection tools, such as the freehand Polygonal Lasso tool.

Having made your selection, it is a good idea to feather the edge so the subsequent adjustment isn't too clear-cut. If you're using the Polygonal Lasso panel select Refine Edge, and use the controls in the Adjust Edge panel to control the transition between the selected and unselected areas. The most useful sliders are Feather, which softens the edge by feathering the transition, and Shift Edge which allows you to move the edge. I typically set Feather to at least 100 pixels—any

lower and the contrast adjustment becomes far less obvious.

Once you have made your selection, the next step is to add a Curves adjustment layer using *Layer > New Adjustment Layer > Curves* (or a Levels adjustment layer if you prefer). However, this time round, any adjustments made with the Curves panel will only affect the area you have selected.

BEFORE CURVES ADJUSTMENT

REFINE EDGE DIALOG

CURVES PANEL

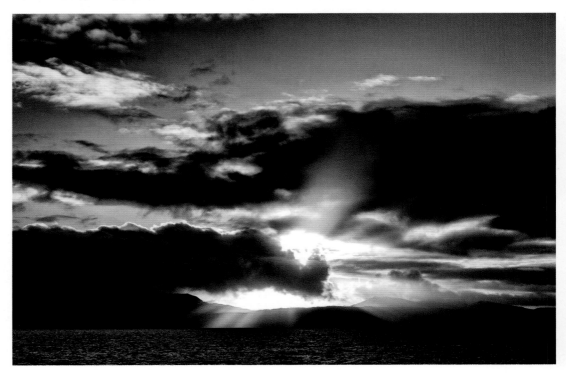

Right: A selective Curves adjustment makes this already dramatic image really come to life.

Focal length: 90mm

Aperture: f/5.6

Shutter speed: 1/250sec.

ISO: 100.

Dodging & Burning

Dodging and burning are traditional black-and-white printing techniques that have really come of age in the digital era. Burning is a darkening process, which is useful for hiding distracting elements, while dodging lightens areas of the photograph, allowing you to brighten part of the image to make it stand out more.

Just like using a Curves layer, you can make dark tones darker and highlights brighter, without affecting the midtones, which makes dodging and burning an excellent way of adding contrast to an image and emphasizing textures. However, unlike Curves, dodging and burning is done using digital "brushes," so you can control precisely where it is applied, and with what intensity.

1 Select either the Dodge or Burn tool from the tool palette.

2 In the Dodge (or Burn) tool panel at the top of the screen, choose between Shadows, Midtones, and Highlights. This determines which tones the tool will affect.

3 Set the Brush size and hardness. I favor a very soft brush so the dodging or burning doesn't appear obvious.

4 Set the Exposure. Note that even very low values have a visible effect—I often set the Exposure as low as 3%.

5 Make sure the layer that is highlighted in the Layers palette is the image.

6 "Paint" over the area you want to adjust.

It pays to be careful when you brush the area you are working on, as this is a technique that can look dreadful if overdone. If you start to see haloing around the edges of an area you are working on, this is normally an indication that you have pushed things too far.

Dodging & Burning with Lightroom

Lightroom doesn't have dedicated dodge and burn tools, but the same effect can be achieved by using the Adjustment Brush. Once you get the hang of it, this can be a very precise way of selectively adjusting tones.

1 Select the Adjustment Brush from the tool panel.

2 Check Show Selected Mask Overlay at the bottom left corner of the screen. This will show a red mask where you brush—the darker the red, the stronger the effect will be when it is applied.

3 With a soft brush, brush over the area you want to adjust.

4 Uncheck Show Selected Mask Overlay, and either reduce the Shadows slider to burn the selected adjustment area and make it darker, or increase the highlights slider to dodge that area and make it brighter.

5 If the effect isn't strong enough, click on the pin that marks the adjustment area and brush the area further.

6 To dodge or burn a different part of the image select New from the Adjustment Brush menu. You can then create a new adjustment area, without affecting the previous one.

Right Top & Bottom: The top image is a basic black-and-white conversion, before any dodging or burning has been applied. The bottom image shows the ability these tools have for adding contrast to specific areas of the image.

Focal length: 17mm

Aperture: f/22

Shutter speed: 1/6sec.

ISO: 100

BEFORE

AFTER

Adding Grain

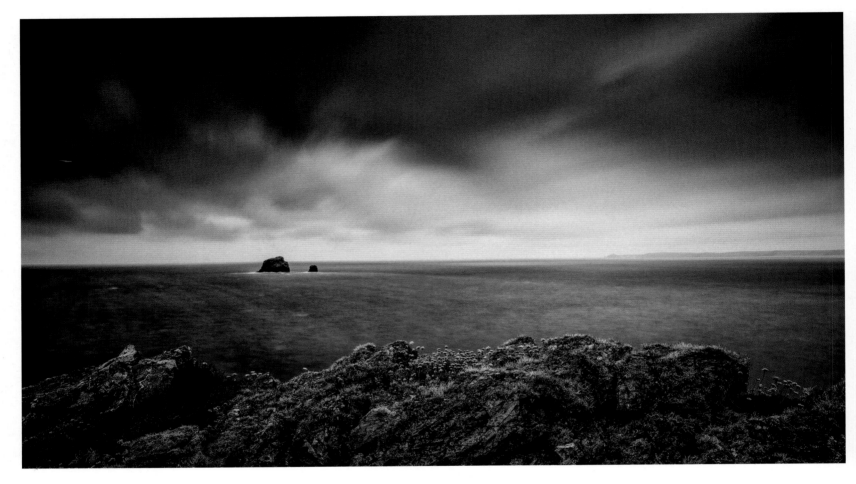

Although adding grain to an image may seem counterintuitive in terms of getting the best possible quality from your Raw file, it does have its place in black-and-white photography. There are several reasons why you might want to add grain, but the two most common are the purely esthetic ("because you think it looks good") and to lessen the effects of editing.

If you think grain might add something to an image, then it's a good idea to save two versions of it—one with grain and one without. That way, you can change your mind at a later date (grain is impossible to remove successfully once it has been applied).

You can introduce grain in both Lightroom and Photoshop using ACR, but it's also possible to add grain in Photoshop using *Filter > Noise > Add Noise.* My preference is to use ACR, as it gives greater flexibility, using just three controls:

Amount: Sets how much grain you want to add.
Size: Determines the size of the individual grains.
Roughness: Changes the consistency of the grain.

While you can experiment with the ACR grain settings yourself to find a look that you like, the VSCO Film plugin uses the same parameters to introduce grain that is based on specific black-

Above: This shot was taken with a 10-stop filter, but I misjudged the exposure and it was underexposed by about 1 stop. Because of the reduced tonal range and heavy editing in Silver Efex Pro it ended up with lots of artifacts in the sky. However, adding grain hid the effects of the aggressive edit, rescuing the image and making it worthy of printing.

Focal length: 24mm

Aperture: f/16

Shutter speed: 61 sec.

ISO: 100

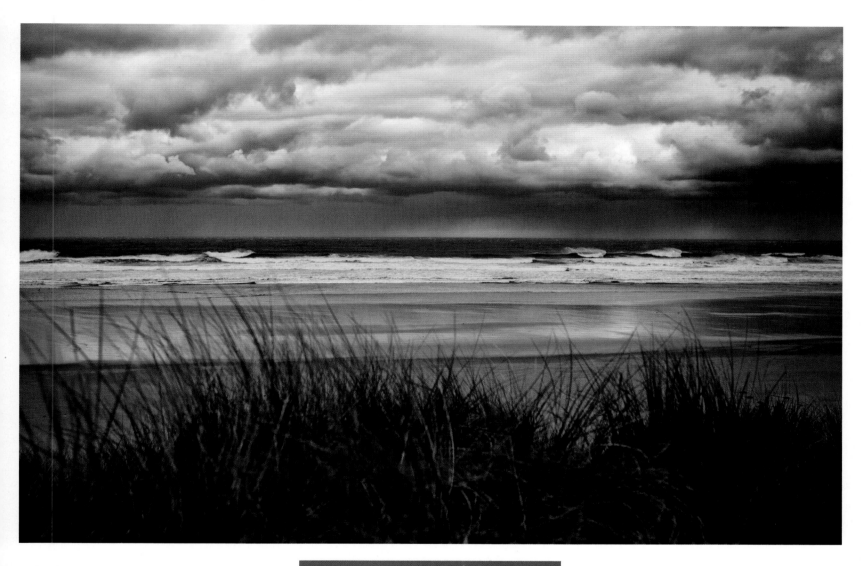

and-white films. The options include this quartet of iconic emulsions:

Ilford HP5: Amount 40, Size 15, Roughness 70.
Kodak TRI-X 400: Amount 50, Size 20, Roughness 45.
Fuji Neopan 1600: Amount 80, Size 20, Roughness 40.
Ilford Delta 3200: Amount 40, Size 15, Roughness 100.

NOTE
Images should always be sharpened before grain is added. If you add grain first and then sharpen the image, you will end up sharpening the grain, which doesn't look good.

Above: When you manipulate an image—particularly with a plugin like Silver Efex Pro—it can introduce unwanted and unattractive artifacts. Adding grain can disguise the less desirable effects of editing.

Focal length: 24mm
Aperture: f/2.8
Shutter speed: 1/125 sec.
ISO: 200

Toning

Toning an image is a traditional darkroom technique associated with black-and-white photography. Fortunately, you no longer have to deal with noxious chemicals and wear protective clothing to tint your images; it can be done simply in the digital darkroom. The most popular tones used to tint a monochrome image are sepia, which gives a warm, aged feel to a photograph, and blue, which gives a harsh, cold look. You can tone an image in both Photoshop and Elements by using a Hue/Saturation adjustment layer.

1 Open your image, or apply the effect to an existing edit.

2 Choose *Layer > New Adjustment Layer > Hue/Saturation...* from the top menu.

3 Check the Colorize box in the Hue/Saturation Properties panel.

4 Use the Hue slider to select the color you want to tone the image with.

5 Control the intensity of the color with the Saturation slider—the higher the value, the more vibrant the tone will be.

Gradient Maps

Hidden away in Photoshop's Gradient Map tool is a number of dedicated photographic toning presets that can create a more authentic look than a simple Hue/Saturation adjustment. The options include several different Sepia, Platinum, Selenium, Gold, Copper, Blue, and Cyanotype tones.

1 Open your image, or apply the effect to an existing edit.

2 Select *Layer > New Adjustment Layer > Gradient Map...* from the top menu. This will add a Gradient Map adjustment layer and open the Gradient Map Properties panel.

3 Click on the arrow at the right of the gradient preview to open the preset gradient picker.

4 As well as a range of preset gradients, a small "cog" icon will appear at the top right corner of the panel. Click on the cog to open a dropdown list of gradient "libraries."

5 Select Photographic Toning from the list and check Small List to see the names of the tones beside the colors.

6 Choose your preferred preset. If you are happy with the color, but find the effect too strong, reduce the Opacity of the Gradient Map layer using the Opacity control in the Layers panel.

Right: A Platinum preset was used to tone this image using Photoshop's Gradient Map tool.

Focal length: 24mm
Aperture: f/22
Shutter speed: 1/15 sec.
ISO: 100

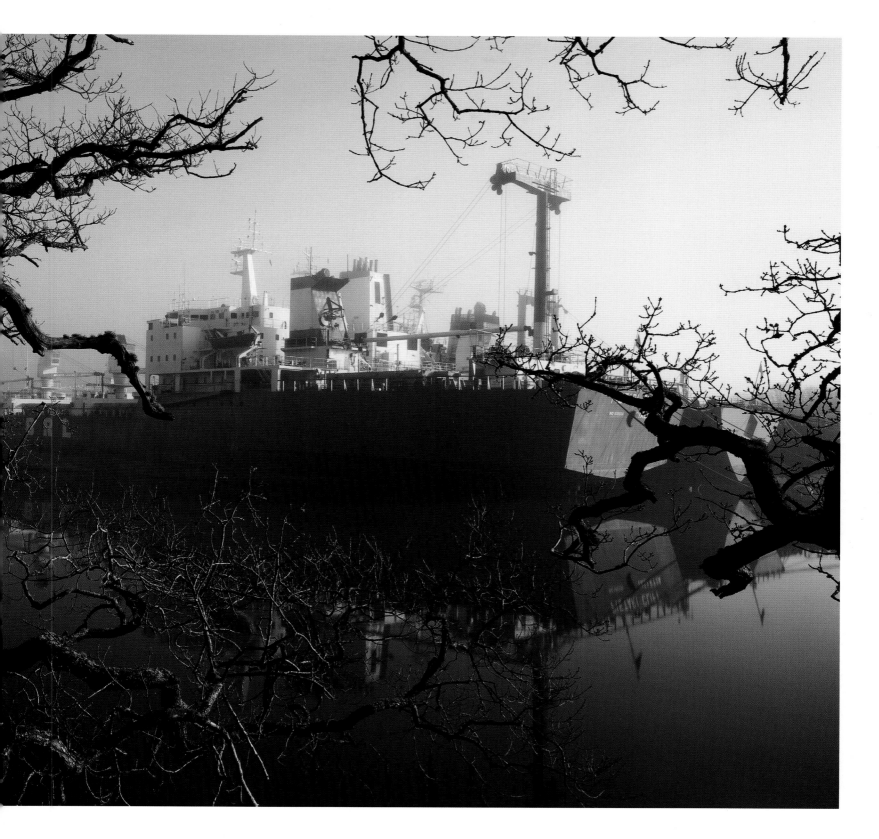

Split Toning

Split toning adds two different color tints; one to the highlights and one to the shadows. The most common combination is to add a warm sepia tint to the highlights and a contrasting blue tint to the shadows. The simplest way of split toning an image in Photoshop is to use a Color Balance layer. This allows you to apply two separate tints using the same panel.

1 Open your image, or apply the effect to an existing edit.

2 Create a Color Balance adjustment layer by selecting *Layer > New Adjustment Layer > Color Balance...* from the top menu.

3 Set Tone to Highlights in the Properties panel. Use the color sliders to introduce your desired color to the highlights.

4 Switch Tone to Shadows and use the sliders to introduce a tone to the shadow areas.

Split Tones in Elements

To split tone an image in Elements you need to use two Hue/Saturation layers; one toned for the highlights and one toned for the shadows. Having made the changes to the first layer it needs to be merged into the image (*Layer > Merge Down*). You can then apply the second Hue/Saturation layer to the other tonal area of the image.

Split Tones in Lightroom

You can create a split tone in Lightroom (and in ACR) using the dedicated Split Tone panel. As well as being very easy to use, it offers an almost unlimited range of color options that you can apply to your images.

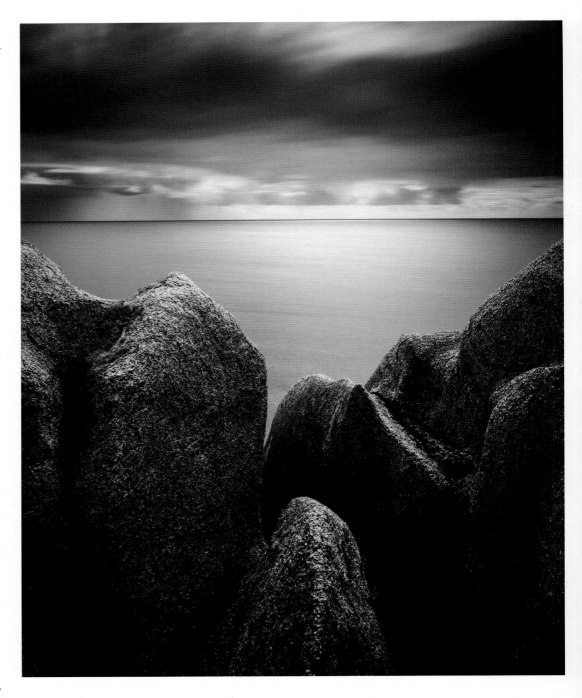

Above: I have stuck with the traditional split-tone mix of warm, sepia highlights and cool, blue shadows here. It pays not to get too carried away with split toning—it is important not to lose the black-and-white feel, while still balancing the tones.

Focal length: 24mm

Aperture: f/16

Shutter speed: 78 sec.

ISO: 100

Printing

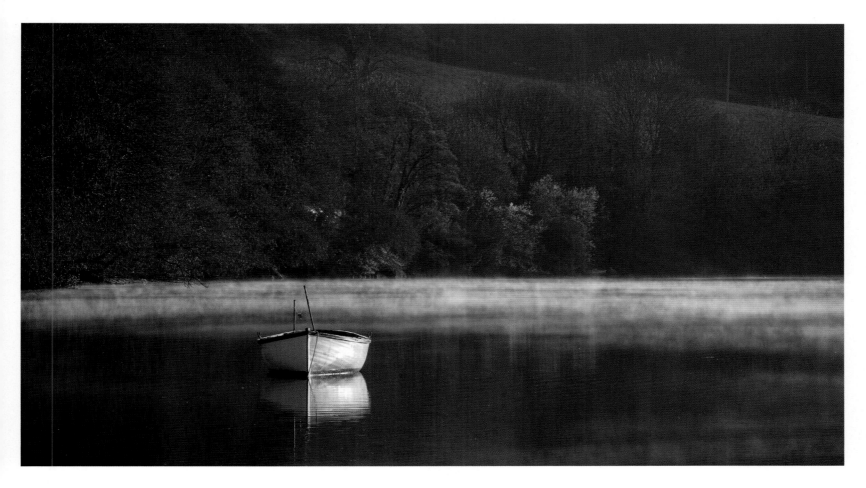

As nice as it is viewing your black-and-white photographs on screen, nothing beats a good print. This is perhaps one of the only real downsides to digital photography—many people don't print their images. This is a shame, as there is nothing quite like seeing your work printed and framed on the wall.

Home Printing

Inkjet printers have advanced significantly in the last few years. Printers specifically designed for photographic use produce excellent results, with certain models designed specifically to meet the needs of black-and-white photographers, as well as color users.

At the time of writing, my preference is for Epson Stylus Photo printers—I currently use the Photo R2880 for my black-and-white work. One of the reasons I chose this printer was that it uses a combination of eight separate inks, three of which are black. This means it is capable of delivering excellent quality monochrome prints on both gloss and matt papers.

It also benefits from being an A3-format printer, which is a good size for prints intended for exhibition, sale, or personal display. However,

Above: There are moments that deserve to be recorded and then enjoyed again and again. This is why you should print your work.
Focal length: 200mm
Aperture: f/22
Shutter speed: 1/13 sec.
ISO: 100

when choosing a printer, other factors also need to be considered, such as the initial purchase price, running costs, and compatibility with third-party inks and papers.

Ink

Inkjet printers use either dye-based inks or pigment inks. Dye-based inks are commonly found in low-end printers designed for the "mass" market. The dyes used give slightly better looking and more vibrant results in the short term, and are (usually) less expensive.

However, dyes—especially some of the ultra-low-cost third-party inks that are available—are more susceptible to UV light, which means that a print made using dye-based inks will fade faster than a print made using pigment inks. A dye-based print is therefore not ideal for exhibition images, or prints that you intend to sell. Conversely, pigment inks have a much greater longevity, and when used in conjunction with archival paper it is claimed that the prints will last in excess of 100 years. This clearly makes pigment ink the preferred choice for any print that you want to stand the test of time.

Although it was once considered that pigment inks produced inferior (less rich) blacks compared to dye-based ink, new printer designs that feature two or more black inks will make up for this.

This can be further refined if your printer allows you to choose between gloss black and matt black inks—most good printers designed for printing photographs will allow you to choose between the two. You might have to physically change the ink cartridge and flush out any remaining ink, but it will allow you to use matt paper with matt ink and achieve the most genuine looking results. Consequently, a printer that uses pigment-based inks is the best choice for producing monochrome prints.

Paper

Of course, your choice of ink is only half the story—your choice of paper is equally important. Broadly speaking, paper for printing can be split into three types: gloss, semi-gloss (also called lustre, satin, or pearl), and matt. Within each category, papers come in different weights, which is measured in grams per square meter (gsm). The simple rule here is that heavier papers will perform better when hung or framed—a heavy paper shouldn't sag or look bumpy when framed.

For strongly colored photographs, gloss paper is usually preferable, as it produces rich, vibrant colors. However, its reflective surface can be accentuated if you frame it behind glass, creating a double level of reflectance that can make a print very hard to see.

Semi-gloss paper is less reflective, which means it can be framed behind glass and still be visible. An image printed on semi-gloss paper shows an excellent level of detail and can be a good choice for monochrome.

The favorite type of paper for many black-and-white photographers—especially those looking to exhibit and/or sell their work—is matt paper, which has the highest archival rating of the three paper types. Matt papers are available in a bewildering array of finishes, ranging from those that are smooth to papers with a highly textured finish. As matt paper doesn't reflect light, blacks have a rich and dark tone that is typically not seen on gloss paper. It also makes it an ideal choice for framing behind glass.

Although the printer manufacturers (Canon, Epson, and HP) make excellent inkjet printing papers, some of the best papers for monochrome printing come from third-party manufacturers, such as Hahnemuhle, Ilford, and Permajet. Most paper manufacturers will produce a test pack containing a range of papers, which will allow you to experiment until you get the results you are after on a paper that you like.

Profiles

Whichever paper (and ink) you choose, it is important that you use the correct printer profile to ensure you get neutral black-and-white prints. A printer profile tells your computer what ink and paper you are using, so it can adjust the colors to compensate for any slight color cast (not all papers are pure white, for example). All good paper manufacturers will have profiles that you can download for a range of popular photo printers, and this is usually a good starting point.

For an even more precise profile it is possible to have bespoke profiles made for your specific printer, ink, and paper combination. There are numerous commercial profiling services who will take you through the process, or you can invest in your own printer profiling tools.

Using a Commercial Lab

If you don't want to print your black-and-white photographs at home, you can have your digital files printed by a professional lab instead. A good company will offer a wide range of paper types dedicated to black-and-white printing and will have printer profiles that you can download so you can see how your print will look before you have it printed. Many of these companies offer mounting and framing services as well, providing you with a complete black-and-white package.

In addition to inkjet printing (which is sometimes also called "giclée") some specialist labs have the ability to print digital files onto silver gelatin, fiber-based paper. This is very similar to making a print in a "wet" darkroom, in that the digital image is projected onto light-sensitive paper, which is then processed in chemicals. This process eliminates any risk of a color cast and gives strong, dark blacks. Traditional chemical archiving techniques can then be used, such as sepia or selenium toning, adding to the authenticity of the final print.

Although this is an expensive way of printing your images, if you want an exhibition quality or fine-art print, having it professionally printed on fiber-based paper will give you the best result. Indeed, it is as close as digital photography gets to replicating the traditional darkroom.

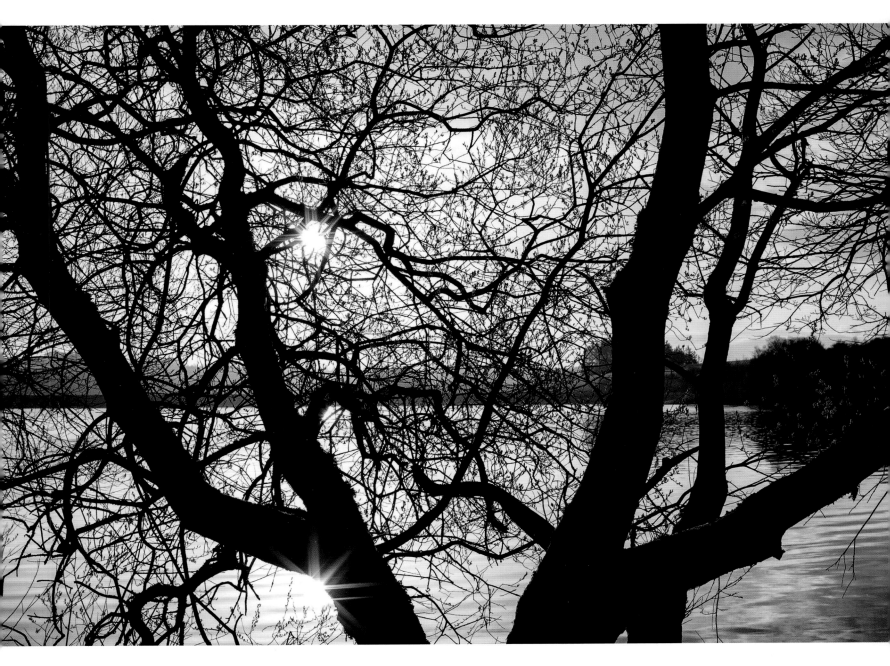

Above: An image with very dark shadow areas naturally suits a semi-gloss or matt paper.

Focal length: 50mm
Aperture: f/11
Shutter speed: 1/320 sec.
ISO: 100

Glossary

AEL (Automatic Exposure Lock) Lets you lock the exposure so you can recompose in a different light without the exposure changing. Useful for backlit subjects.

Aperture The hole in the diaphragm of a lens that allows light to pass through onto the camera's sensor. The bigger the f/number, the smaller the hole.

Aperture priority An exposure mode where the photographer chooses the aperture setting and the camera chooses the shutter speed needed to record the correct exposure.

Aspect ratio The ratio of width to height of the image. 3:2 is used in most DSLRs; 4:3 is the Micro Four Thirds ratio.

Backlighting When the light source is behind your subject.

Bracketing As well as your chosen exposure the camera takes one shot with less light and one shot with more light.

Buffer The camera's internal memory. The bigger the buffer, the more photographs the camera can record in one go.

Burnt out Used to refer to highlights that are pure white, with no recorded detail present.

Camera shake When the camera is accidentally moved during an exposure resulting in a blurred image. To avoid camera shake when handholding the camera, it is recommended you use a shutter speed no lower than 1/focal length of the lens.

Center-weighted metering The exposure is based on the whole image, but biased toward the center of the frame.

Chromatic aberration Imperfections in a lens that cause a color fringing around the edges of objects with high contrast.

Color temperature The color of light, controlled by the white balance.

Continuous focus With the focus button held down the camera continually adjusts focus to track a moving subject.

Contrast The difference between the brightest and darkest tones in an image or scene.

Crop factor The ratio of the camera's sensor compared to a 35mm negative.

Cyanotype A cyan-blue print; where the term "blueprints" originated.

Depth of field (DOF) The distance in front of and behind the focus point that appears acceptably sharp. A large depth of field is used to keep everything in the frame sharp; a narrow depth of field is used to isolate something from the background.

Distortion A loss in optical quality common in wide-angle lenses close to the edge of the frame.

dpi Dots per inch. Used to measure print resolution.

Dynamic range The number of stops of light a camera can record in a single exposure.

Exposure A measure of the amount of light recorded on the camera's sensor, controlled by three variables: ISO, shutter speed, and aperture.

Exposure compensation Allows you to override the camera's suggested exposure to make the image brighter or darker.

Field of view The viewing angle of a lens: a wide-angle lens has a wide field of view, while a telephoto lens has a narrow field of view.

Fill-in flash Flash that is used to lighten shadows, rather than act as the main light source.

Focal length The distance from the optical center of a lens focused at infinity to the sensor: the shorter the focal length, the wider the field of view.

fps (frames per second) The number of photographs a camera can take in one second.

f/stop The ratio between the focal length of the lens and the diameter of the aperture. A change of one f-stop doubles or halves the light transmission compared to the previous f-stop.

Golden hour The hour after sunrise and before sunset when the light is warm and golden.

Grain The physical structure of a film-based image; grain increases with ISO.

Gray card A card with 18% reflectance, used for gauging exposure.

HDR (High Dynamic Range) The merging of two or more exposures that allow a greater dynamic range to be recorded than the camera is capable of.

Highlights The brightest tones in an image.

Histogram A graphic representation of levels of brightness in an image, where 0 is black and 255 is white.

Hyperfocal distance The focus distance for a specific focal length and aperture that delivers the maximum depth of field; depth of field extends from half the hyperfocal distance to infinity.

Incident-light reading A measure of the light falling onto a subject (rather than reflecting off it).

Interpolation Algorithm used by image-editing programs to enlarge images.

ISO An internationally recognized unit of sensitivity. The same as ASA, formerly used for film.

JPEG (Joint Photographic Experts Group) A compressed file format. The raw image data is processed in-camera and saved in a compressed format (which loses data).

Macro lens A lens used for close-up photography. A true macro lens offers a 1:1 reproduction ratio.

Megapixel One million pixels.

Memory card A removable card on which the camera records information captured by the sensor.

Monochrome Literally, "single color." Typically used to refer to black-and-white images, but applies equally to any image that is made up of a single color.

Neutral density filter A filter that reduces the amount of light reaching the sensor, resulting in a longer exposure.

Noise In digital photography, the random spots of brightness introduced by using a high ISO setting and/or long exposure time.

Off-camera flash A flash unit that is not connected directly to the camera.

Overexposure When the sensor has been exposed to too much light, resulting in an overly bright image.

Pixel Short for "picture element," the smallest element of a digital image.

Polarizing filter Filter used in front of the lens to polarize the light, reducing reflections, and/or darkening skies.

ppi Pixels per inch. Used to measure image resolution; not to be confused with dpi.

Prime lens Lens with a fixed focal length.

Raw A file type consisting of the raw, unprocessed data recorded by the camera's sensor.

Red-eye reduction A flash feature that uses a pre-flash to make a person's iris contract so that it will not reflect back the light from the main flash when a picture is taken.

Resolution The size of a sensor (or digital image) measured in pixels.

RGB (Red, Green, Blue) The three colors used by the majority of digital cameras to create a full-color image.

Shadows The darkest tones in an image.

Shutter A mechanical (or electronic) unit that regulates how long light is allowed to reach the sensor for.

Shutter priority An exposure mode where the photographer chooses the shutter speed and the camera chooses the aperture needed to record the correct exposure.

SLR (Single Lens Reflex) A camera design that uses a mirror and prism to enable the photographer to look through the lens.

Solarization The reversal of tones, so black becomes white and white becomes black.

Soft proofing Image-editing feature that emulates on screen how the final print should look.

Specular highlight A very bright point of light that the camera's sensor will never be able to record any detail in.

Split toning Toning technique where the highlights are tinted one color and the shadows another. It is best to use opposing colors on the color wheel.

Spot metering Exposure metering pattern that takes a light reading from a very small area of the image (typically 1–3%).

Stop A measurement of exposure. An increase of 1 stop doubles the amount of light reaching the camera's sensor; a decrease of 1 stop halves the amount of light reaching the camera's sensor.

Teleconverter A tube containing optical glass elements that is positioned between the camera body and the lens to extend the focal length. A 2x teleconverter will turn a 300mm focal length into a 600mm focal length, for example.

Telephoto lens A lens with a focal length that is longer than a standard lens. Good for isolating a subject from its background.

TIFF (Tagged Image File Format) A high-quality, uncompressed image format.

TTL (Through The Lens) metering The camera bases it's exposure on the light coming through the lens.

Underexposed When the sensor has been exposed to too little light, resulting in an overly dark image.

White balance In-camera system used to adjust the color bias of the photographs you take to match the temperature of the prevalent lighting.

Wide-angle lens A lens with a wide field of view, typically between 16–35mm on a full-frame camera.

Zoom lens A lens design that covers a range of focal lengths.

Useful Web Sites

General

Photography and tuition by John Walmsley www.focusonlight.co.uk

Photographers

The work of Ansel Adams www.anseladams.com
The work of Edward Weston www.edward-weston.com
The work of Michael Kenna www.michaelkenna.net
The work of Sebastiao Salgado www.amazonasimages.com
Picture agency representing Henri Cartier-Bresson, Robert Capa, & many other great black-and-white photographers www.magnumphotos.com

Photographic equipment

Canon www.canon.com
Formatt-Hitech www.formatt-hitech.com
FujiFilm www.fujifilm.com
Hoya Filters www.hoyafilter.com
Lee Filters www.leefilters.com
Leica www.leica-camera.com
Lowepro www.lowepro.com
Manfrotto www.manfrotto.com
Metabones www.metabones.com
Nikon www.nikon.com
Olympus www.olympus-global.com
Panasonic www.panasonic.com
Pelican cases www.pelican.com
Ricoh/Pentax www.ricoh-imaging.com
Sigma www.sigmaphoto.com
Sony www.sony.com
Tamron www.tamron.com
3 Legged Thing www.3leggedthing.com
Tokina www.tokinalens.com
Zeiss www.zeiss.com

Printing

Epson www.epson.com
Hahnemuehle www.hahnemuehle.de
Harman www.harman-inkjet.com
Ilford www.ilford.com
Kodak www.kodak.com
Marrutt www.marrutt.com
Permajet www.permajet.com

Software

Adobe www.adobe.com
Apple Aperture www.apple.com
Capture One Pro www.phaseone.com
Hipstamatic www.hipstamatic.com/camera
Silver Efex Pro https://nikcollection.dxo.com/silver-efex-pro
VSCO Film www.vsco.com

Photography publications

Ammonite Press www.ammonitepress.com
Black & White Photography magazine www.blackandwhitephotographymag.co.uk
Outdoor Photography magazine www.outdoorphotographymagazine.co.uk

Index

Acknowledgments

I would like to thank Esther, my partner, for all her love and support,
and my Dad for proofreading the manuscript.

AMMONITE
PRESS

To place an order, or request a catalog, contact:
Ammonite Press
AE Publications Ltd, 166 High Street, Lewes, East Sussex, BN7 1XU, United Kingdom
Tel: +44 (0)1273 488006
www.ammonitepress.com